THE LIFE MILLENNIUM

THE 100 MOST IMPORTANT EVENTS & PEOPLE OF THE PAST 1,000 YEARS

THE LIFE MILLENNIUM

EDITOR Robert Friedman
PICTURE EDITOR Alison Morley
ART DIRECTOR Robert Villaflor
SENIOR WRITER Kenneth Miller
CONTRIBUTING WRITERS Allison Adato, Robert Andreas, Jennifer Ash, Harriet Barovick, Tom Bentkowski, Susan Bolotin, Vanessa Bush, Kerry Candaele, Cynthia Fox, David Friend, Cal Fussman, Seth Goddard, Ann Harrington, Mary Harvey, Charles A. Hirshberg, Bayard Hooper, Nancy Hooper, Marilyn Johnson, Edward Kern, Karen Ma, Vince Passaro, Ansley Roan, Michael T. Rose, Joshua R. Simon, Peter Smith, Sara Solberg, Melissa Stanton, Robert Sullivan, Vivienne Walt
ASSOCIATE EDITORS Jane Furth, June Omura Goldberg, Sasha Nyary
RESEARCHERS Hildegard Anderson, Susan Feinberg, David Fischer, Priya Giri, Anne Hollister, Rakisha Kearns-White, Deborah Moss, Adriana Piñon, Romy Pokorny, Tala Skari (Paris)
COPY CHIEF Melissa Wohlgemuth
COPY DESK Kathleen Berger, Madeleine Edmondson, Joel Griffiths, Christine McNulty, Larry Nesbitt, Albert Rufino
DEPUTY PICTURE EDITOR Vivette Porges
PICTURE RESEARCHERS Lynn Donaldson, Leny Heinen (Germany), Neal Jackson, Mimi Murphy (Rome), Gail Ridgwell (London), Hélène Veret (Paris)
DESIGN CONSULTANT Neal T. Boulton
ASSOCIATE DESIGNER Melissa Devlin

TIME INC. HOME ENTERTAINMENT
PRESIDENT David Gitow
DIRECTOR, CONTINUITIES AND SINGLE SALES David Arfine
DIRECTOR, CONTINUITIES AND RETENTION Michael Barrett
DIRECTOR, NEW PRODUCTS Alicia Longobardo
GROUP PRODUCT MANAGERS Robert Fox, Michael Holahan
PRODUCT MANAGERS Christopher Berzolla, Roberta Harris, Stacy Hirschberg, Jennifer McLyman, Daniel Melore
MANAGER, RETAIL AND NEW MARKETS Thomas Mifsud
ASSOCIATE PRODUCT MANAGERS Alison Ehrmann, Carlos Jimenez, Daria Raehs, Betty Su, Cheryl Zukowski
ASSISTANT PRODUCT MANAGERS Meredith Shelley, Lauren Zaslansky
EDITORIAL OPERATIONS DIRECTOR John Calvano
FULFILLMENT DIRECTOR Michelle Gudema
ASSISTANT FULFILLMENT MANAGER Richard Perez
FINANCIAL DIRECTOR Tricia Griffin
ASSOCIATE FINANCIAL MANAGER Amy Maselli
ASSISTANT FINANCIAL MANAGER Steven Sandonato
MARKETING ASSISTANT Ann Gillespie
SPECIAL THANKS TO Anna Yelenskaya

CONSUMER MARKETING DIVISION
BOOK PRODUCTION MANAGER Jessica McGrath
BOOK PRODUCTION COORDINATOR Joseph Napolitano

Copyright 1998 Time Inc. Home Entertainment
First Edition
ISBN: 0-8212-2557-X
Library of Congress Catalog Card Number: 98-85570

If you would like to order additional copies of any of our books, please call us at 1-800-327-6388 (Monday through Friday, 7 a.m.–8 p.m., or Saturday, 7 a.m.– 6 p.m., Central Time).

Published by

BOOKS
Time Inc.
1271 Avenue of the Americas
New York, New York 10020

We welcome your comments and suggestions about LIFE Books.

Please write to us at:
LIFE Books
Attention: Book Editors
PO Box 11016
Des Moines, IA 50336-1016

THE LIFE MILLENNIUM

THE 100 MOST IMPORTANT EVENTS & PEOPLE OF THE PAST 1,000 YEARS

CONTENTS

6 THE WORLD AS IT WAS

10 THE 100 EVENTS

168 THE 100 PEOPLE

188 THE WORLD AS IT WILL BE

190 TIME LINE

192 ACKNOWLEDGMENTS

A PICTURE WORTH A THOUSAND YEARS

Some of dates on the cover of this book might seem strange at first glance. D the sheep wasn't cloned in 1953. The atomic bomb wasn't dropped u long after 1905. And women weren't marching for suffrage in 18 Each of these photographs—and those on the following pages— chosen to represent one of the 100 events that the editors of LIFE h deemed the most important of the millennium. Devising such a list rank order, was presumptuous enough. But the challenge of illustrat 1,000 years of history using a medium less than two centuries old especially daunting. In some cases, such as the first airplane fligh the Wright brothers in 1903, documentary photographs of the eve themselves were available. In other cases, photographs of peo places, objects, even animals, were used to show how the event affe the world. So Dolly became the emblem for the discovery of the do helix structure of DNA in 1953 that opened the door to genetic resea And a dime-store gadget (made in China) became the image for the n tical compass (invented in China in the early 12th century) that m possible the age of exploration. Some of the events on the list are il trated with photographs commissioned for this book: a cemeter Paris where the remains of 1,306 men and women guillotined dur the French Revolution are buried; a church outside Prague decora with the bones of 30,000 victims of the black plague; a window Dijon through which Joseph-Nicéphore Niépce took the world's photograph in 1826—an event to which LIFE owes its existence. An er original photograph, reprinted on the facing page, appea on the cover of the special issue of LIFE on which this book is ba Picture editor Alison Morley came up with the idea of getting som the millennium's greatest figures to sit for a group portrait. Photo pher Gregory Heisler proposed setting the gathering in a replica of studio of 19th century French photographer Louis Daguerre. An crew of costume, makeup and set designers helped turn Heisler's vi into a reality. Or should I say an illusion? Actually, that's Jamie, S Francesco, Al, Dorien, Scott, Esteban and Scott, not some trick of t travel. But you probably figured that out already. **ROBERT FRIEDMAN, EDITOR**

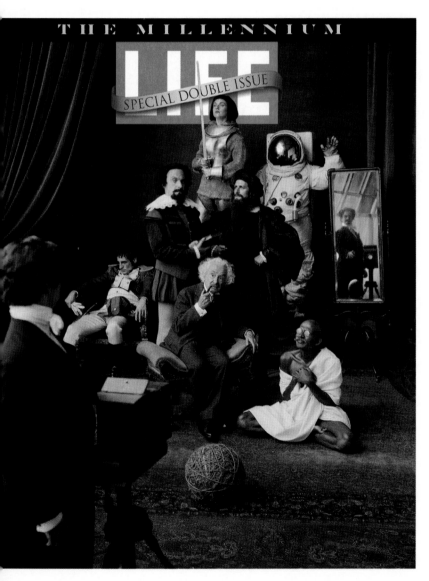

In Daguerre's studio
(top to bottom, left to right):
Joan of Arc, a moonwalker,
William Shakespeare,
Christopher Columbus,
Napoléon Bonaparte,
Albert Einstein, Mohandas
Gandhi and Louis Daguerre,
as photographed by
Gregory Heisler

1001–2000
THE WORLD AS IT WAS AND THE EVENTS THAT CHANGED IT

And so it looms, the big round number—close enough that bureau crats must begin reprogramming legions of computers or else fac meltdown when 999 turns to 000. The rest of us may be forgive for asking: So what? Why the fuss about a millennium's impendir end? It is an arbitrary milestone, after all. The standard Wester way of counting years was dreamed up early in the 6th century t a monk named Dennis the Short. Dennis determined that tr Christian era had started with Jesus' circumcision, a week after tr Nativity; bolstering guesswork with creative mathematics, he da ed the event to January 1 of the year he christened anno Domini (the year of the Lord) 1. Thus the next millennium officially begir in 2001. Historians, however, now believe the sacred surgery ha pened a few years earlier than Dennis reckoned. To non-Christia peoples, of course, all this is academic: In Israel, the year 2000 w be 5760; in Japan, Heisei 12. What's so special, then, about a tw and three zeros clicking into place on our own rather fallib odometer? Nothing, maybe. But like any anniversary, this or gives us an excuse to survey the terrain we've traveled since th

st one. The distance can be gauged statistically: World population has climbed from 300 million to 5.9 billion, life expectancy from 30 to 66. Even more striking, though, are the changes in what we expect from life. As the last millennium waned, some Europeans anticipated apocalypse. Penitents staged processions; warriors swore oaths of peace to ecstatic crowds. But when the year 1001 arrived, millions neither knew nor cared. Few could read their own names, let alone a calendar. Keeping fed was a more pressing concern. Despite an improving climate and innovations in agriculture—the horse collar, fresh from China, and the wheeled plow—harvests were barely adequate. And the feudal system, which forced peasants to share crops with their lords, made it even tougher to stave off malnutrition. Compared with the peasantry, bound by law to land they could not own, townsfolk—merchants and artisans, jugglers and thieves—enjoyed lives of giddy liberty. High walls guarded against marauding barbarians and private armies. Inspiration could be found in grand cathedrals. The air was full of lute music and the din of commerce. But it stank, too.

Some things known to the world in the year 1000:
Chess, coal, French wine, gunpowder, libraries, plows, public school, stirrups, surgery, trigonometry

Some things not yet discovered or invented in the year 1000:
Banks, clocks, coffee, eyeglasses, flush toilets, guns, novels, paper money, restaurants

Bathing was at best an infrequent ritual. The toilet was a pit, a gutter or a river. Houses sheltered farm animals and rats as well as humans. Epidemics and fires swept through the narrow lanes with gruesome regularity.

Europe, in fact, was pretty much a backwater in 1001—a collection of petty kingdoms just emerging from the chaotic Dark Ages that followed the Visigoths' sack of Rome in 410. The Greco-Roman heritage of cultural sophistication and technical knowledge had largely been lost; scholarship was confined mostly to scattered monasteries. Although nobles and the nascent bourgeoisie were taking up reading, books remained scarce.

In the Islamic empire—stretching from North Africa to Southeast Asia by way of Spain and northern India—intellectual life was brighter. Córdoba's library held 400,000 volumes. Drawing on translations of ancient Greek texts, Arab scholars broke new ground in medicine, mathematics, physics. At the start of the millennium, the Persian philosopher-physician Ibn Sina discovered that tuberculosis was contagious, but his teachings would not reach Europe for another hundred years.

The Islamic world was also absorbing ideas from a formidable neighbor—the best-organized and most techno-logically advanced society on the planet. China's civil service fanned out from the palaces of the Song dynasty to govern almost 100 million people. Survival was as precarious for Chinese peasants as for any others, but the bureaucracy provided an avenue of upward mobility. Most villages had elementary schools, and perhaps one student in 20 went on to higher education. Chinese medicine—acupuncture, herbal pharmacology—was the product of centuries of development. Chinese poets and painters created art that made the West's look crude. And Chinese workshops turned out marvels: printed books, compasses, bombs. Once Europeans finally learned to make such items (perhaps instructed by Arab traders), the repercussions would be felt on every continent.

Information passed slowly between Europe and Asia at the millennium's dawn, but it passed not at all between many parts of the world. The kingdom of Ghana was at its apex—its markets brimming with the wealth of Africa, its sculptors creating masterworks in gold—yet no one north of the Sahara knew its name. In what is now Mexico, the Toltecs were building massive pyramids, yet no one beyond a few weeks' walk knew of their existence. Leif Eriksson sailed from Greenland to North America, yet the news spread farther than Scandinavia. Still, eart far-flung cultures all shared one sential trait: They were rooted unsh ably in religion. Neither the Hin surgeon nor the Viking raider wo lift a hand before conferring with gods. Heretics risked the fiery sta and infidels faced Islam's sword. Muslim Spain, however, the sulta Jewish advisers were the Albrights a Greenspans of their day.)

How did we get from that world this? The following pages are attempt to trace the route. They rep sent the efforts of a team of two do writers and researchers who consul scores of experts to compile a list of s eral hundred events and personages took months of sometimes stor meetings to arrive at the Top 100 and rank them according to a broad ran of criteria. How many people did event affect? How different was da life after its occurrence? Like Den the Short's calendrical calculatio this project (even its timing) is an a trary exercise. It will stir arguments spirited as those that went into creation—or so we hope. For that is way with anniversaries: The more ex ing the time between has been, the m it inspires clashing stories. And the t from 1001 has been a thrill indeed.

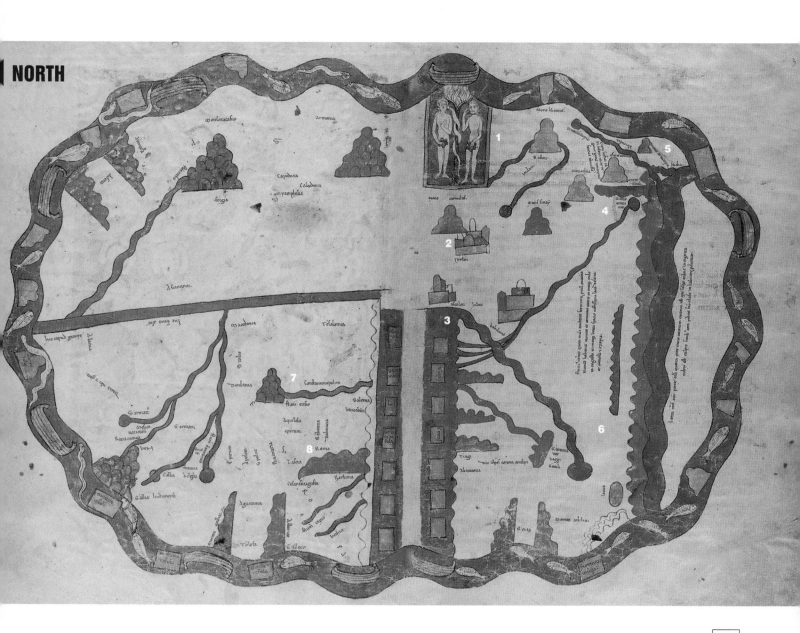

Map of the World: A 1220 copy of an 8th century Spanish priest's *mappa mundi.* Symbolism was more important than accuracy. The Garden of Eden (1) is at the top. Jerusalem (2) is roughly at the center. The Mediterranean (3) dominates the central axis. The Nile River (4) flows toward India (5). Africa (6) is at the bottom right. Europe, including Constantinople (7) and Rome (8), is at the bottom left. All is surrounded by ocean.

NORTH

100

1582 FIXING THE CALENDAR

Calendars, man's most ambitiou attempt to control time, are predicated on three astronomica certainties: the earth spinning on its axis (a day); the moon cir cling the earth (a month); and the earth revolving around th sun (a year). In 46 B.C., Julius Caesar borrowed from Egyptia and Jewish calendars by instituting a solar year of a dozen 30 day months, with five days left over and a leap year every fou years. But Caesar miscalculated, and over time the 11-minut annual discrepancy between his calendar and the solar yea became a debit of 10 days. By the 16th century, the sprin, equinox—and Easter, which was linked to it—had drifted back ward from its March mooring into winter. In 1582, Pope Greg ory XIII issued a papal bull creating the present-day Christia calendar. New Year's Day was restored to January 1 after mor than 1,000 years of being celebrated in late March. There woul be no leap years in centesimal years, except those divisible b 400. And, in his most extraordinary move, Gregory scissored 1 days off the Julian calendar. On the night of October 4, 1582 people went to bed as usual; they awoke the next morning to fin it was October 15—11 days later. **PHOTOGRAPH FROM THE SECRET VATICAN ARCHIVE**

A FOOTNOTE

The Gregorian calendar, one of 40 active calendars in the world, is not entirely accurate. It runs 26 seconds fast a year, a margin of error of six days every 10,000 years. So don't look back—the next millennium may be gaining on you.

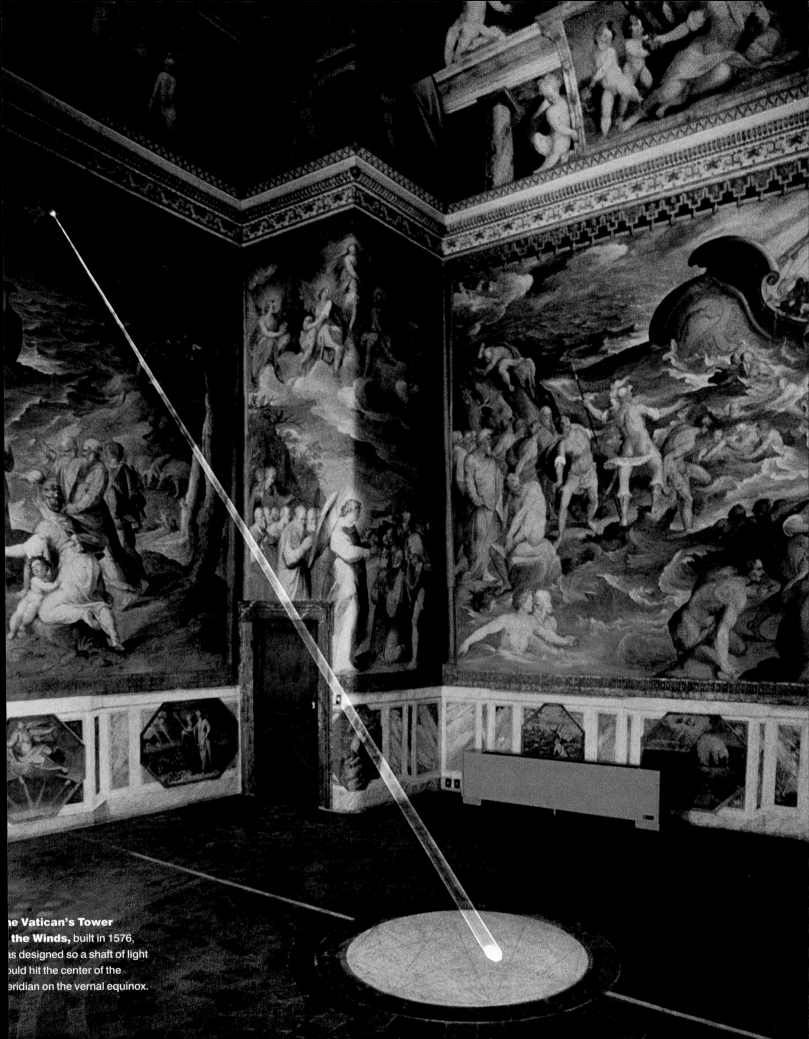

The Vatican's Tower of the Winds, built in 1576, was designed so a shaft of light would hit the center of the meridian on the vernal equinox.

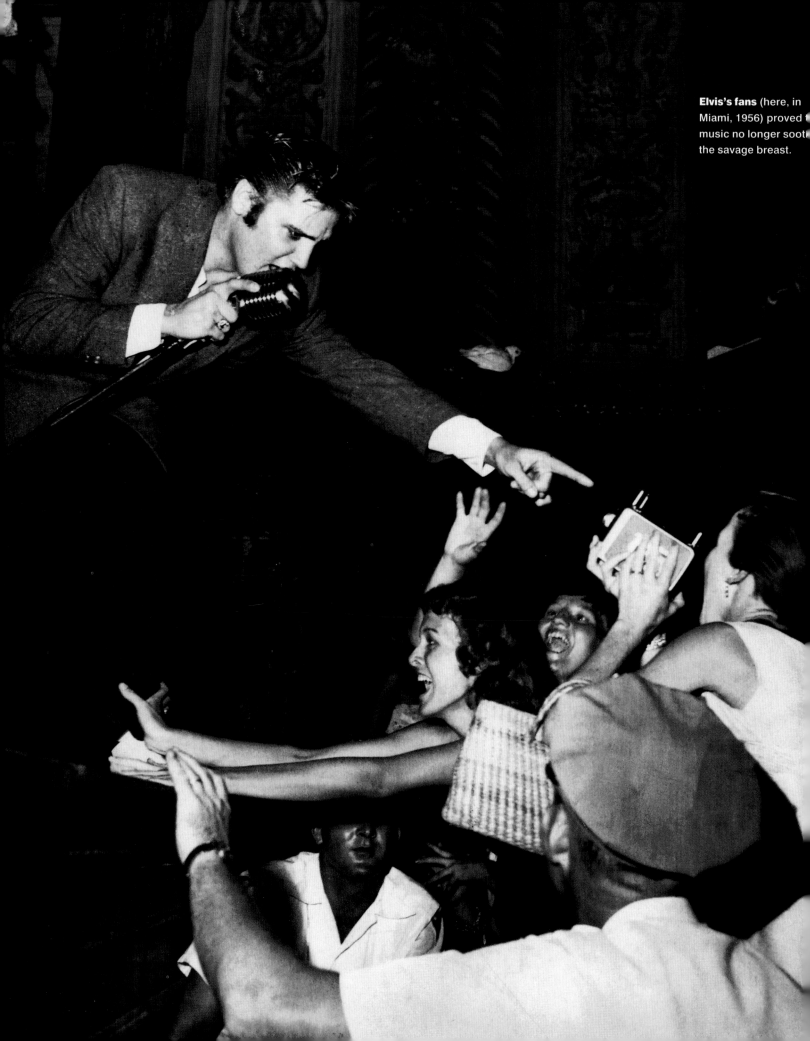

Elvis's fans (here, in Miami, 1956) proved music no longer sooth the savage breast.

99 1954 ROCKING THE WORLD

The ingredients had been added to the melting pot of American pop: base of blues, hint of jazz, some C&W, dash of gospel, pinch of swing. Cleveland deejay Alan Freed named the stew "rock 'n' roll." Sam Phillips, owner of Memphis's tiny Sun Records, sighed his soon-to-be-famous sigh: "If I could find a white man with the Negro sound and the Negro feel, I could make a billion dollars."

Heaven-sent, Elvis Presley came knockin' on Phillips's door, and on July 5, 1954, the shy but swaggering truckdriver covered Arthur "Big Boy" Crudup's "That's All Right Mama." Says Phillips: "History should record that Elvis was unquestionably the first rock 'n' roll performer."

Elvis conquered the world. Along with him went Bill Haley, Little Richard, Buddy Holly, Chuck Berry; in their wake came the Beatles, the Stones, Dylan, the Boss, Beck. Today, rock 'n' roll is a gazillion-dollar industry with a hall of fame and a global video network pushing what was already a massive cultural colonization. Rock has initiated countless trends in fashion. It has ruptured our notions of proper social behavior, promoting new attitudes toward drug use and—as Elvis haters once warned—sex. It has given Great Britain its first r'n'r knight (Sir Paul McCartney) and the United States its first r'n'r President (Mr. Bill Clinton). Rock rules. Roll over, E.P., and tell Bill Haley the news. **PHOTOGRAPH BY DON WRIGHT**

ALL-TIME BEST-SELLING ALBUMS IN THE U.S.

25 million *Thriller*/Michael Jackson/1982
24 million *Their Greatest Hits*/Eagles/1976
17 million *Led Zeppelin IV*/Led Zeppelin/1971
17 million *Rumours*/Fleetwood Mac/1977
16 million *Back in Black*/AC/DC/1980
16 million *The Bodyguard*/Whitney Houston/1992
16 million *Boston*/Boston/1976
15 million *Born in the U.S.A.*/Bruce Springsteen/1984
15 million *Cracked Rear View*/Hootie
 and the Blowfish/1994
15 million *Jagged Little Pill*/Alanis Morissette/1995

99 THE ROSETTA STONE

One of history's great intellectual adventures began on a summer day in 1799, when, near the Egyptian city of Rosetta, soldiers in Napoléon's ranks found a slab of black basalt engraved in three languages. The stone's scripts—Greek, demotic (a simplified Egyptian script) and hieroglyphics—seemed to render the same message. If linguists could match the hieroglyphs to the Greek or demotic text, all Egyptian literature would be theirs.

It wasn't until 1822 that Jean-François Champollion discovered that hieroglyphics mixed phonetic and symbolic meanings; that some texts could be read right to left, others left to right or top to bottom; and that some symbols had two different meanings. This breakthrough, and the translations it produced, led to revelations both humbling and exhilarating: The Egyptians knew medicine, astronomy, geometry. They used weights and measures. They were passionate, too: "Your voice is like pomegranate wine," read one poem.

The Rosetta stone, along with other archaeological finds at Troy and Altamira, made our most distant forebears seem more like us than we had ever imagined. **PHOTOGRAPH FROM THE BRITISH MUSEUM**

The stone's priestly decree, written in 196 B.C., honors King Ptolemy, "the ever-living."

98

DIG THIS

1738 Excavation begins at Herculaneum, near Naples
1870 Schliemann starts digging at Troy
1879 Prehistoric cave art found in Altamira, Spain
1904 Mayan sacrificial well discovered in Mexico
1922 King Tutankhamen's tomb opened in Egypt
1947 Dead Sea Scrolls fill in gaps in biblical history
1974 Army of clay soldiers unearthed in China

97

1896 THE OLYMPIC FLAME The ancient Greek Olympics were a tribute to the gods, a show of humanity's capacity for grace, speed and strength. They lasted from at least 776 B.C. to A.D. 393, when Emperor Theodosius I banned the Games, which had devolved into a crude carnival rife with pro athletes, betting, bribery and all manner of cheating.

Determined to rekindle the original ethic, a Parisian aristocrat named Baron Pierre de Coubertin founded the modern Olympic movement in 1896. His tournament has since grown into a mammoth quadrennial exhibition of money, power and sport that stands as the world's most grandiose entertainment spectacle.

Even as one of de Coubertin's most wild-eyed ideals has been realized—that of uniting the world's countries, if only briefly—the Olympics' growing importance has made them a target of abuse. Hitler pointed to the 1936 Games as proof of Aryan superiority; Palestinian terrorists used the '72 Munich Games as their stage in the massacre of Israeli athletes; President Carter called a boycott of the '80 Moscow Olympics after the U.S.S.R. invaded Afghanistan, and Moscow replied in kind four years later when L.A. hosted. In 1996 a murderous pipe-bomber, motive unclear, terrorized Atlanta. Great leaders and craven criminals realize that nothing focuses world attention like the Olympics.

Why? Because sometimes we glimpse the transcendent. Kerri Strug, Michael Johnson, Oksana Baiul (to name just a few from recent Games): You see them in their glory, and you smile. Little kids smile. De Coubertin smiles. The gods themselves smile (Nike, not least). **PHOTOGRAPH BY JACQUES-HENRI LARTIGUE**

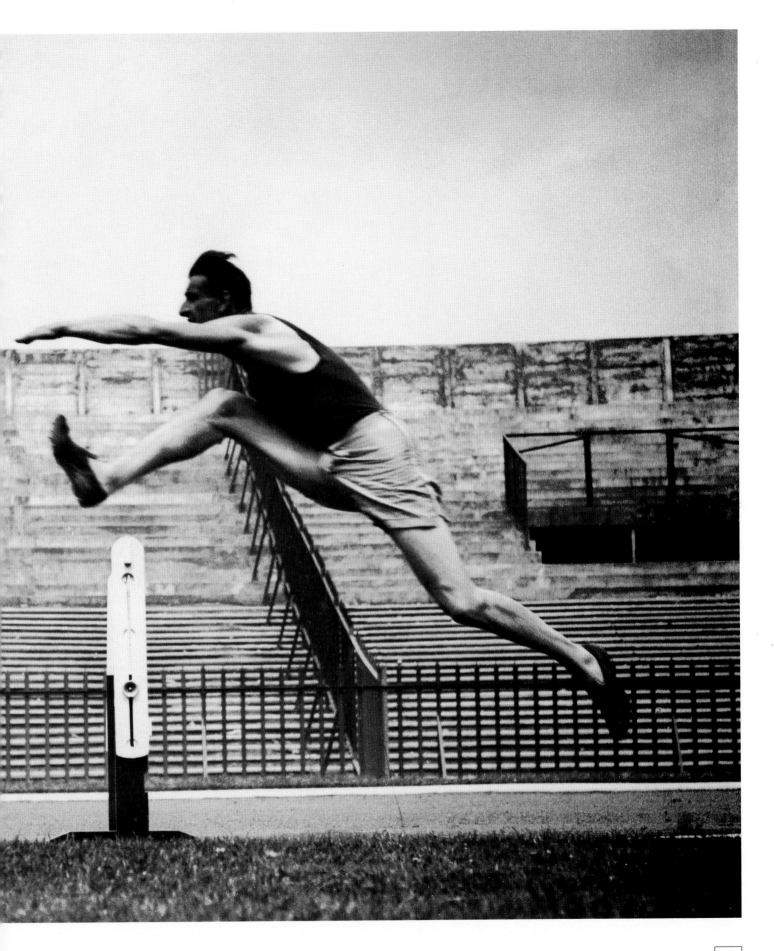

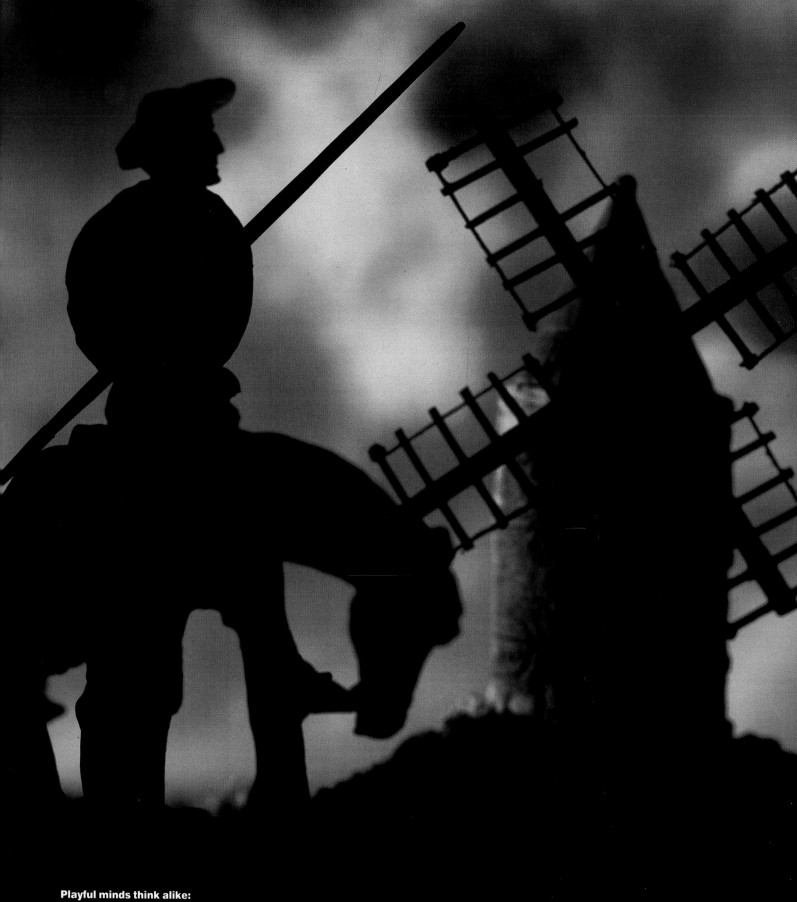

Playful minds think alike:
David Levinthal used miniatures to
bring Cervantes' comic epic to life.

05 **MAN OF LA MANCHA** Miguel de Cervantes Saavedra's comic-
mantic tale *Don Quixote* is said to have been translated into more lan-
uages than any book other than the Bible. Considered by many to be
e first modern novel and the prototype for much of the world's fiction,
e story of the deranged Don Quixote acting out the literary ideals of
ivalry and romance has inspired the imaginations of readers for near-
four centuries. Cervantes, born in Spain in 1547, the son of a poor
ctor, received a limited education and served as a soldier in Italy.
e was wounded in the battle of Lepanto, captured on his way home
1575, enslaved in Algiers and finally ransomed in 1580. Over the next
) years, he wrote a number of plays and a novel—all unsuccessful. But
1605, the first part of *Don Quixote* was published, immediately gain-
g a popularity that has never waned. Like Malory, Chaucer and Mil-
n, Cervantes embodied the essence of his time. But his language
id his vision need little interpretation to be understood by modern
aders. **PHOTOGRAPH BY DAVID LEVINTHAL**

TING AT WINDMILLS

n *Quixote* is such an Ur-text of Western literature—and pop culture—that even
se who have never read it are steeped in its images. Without the word "quixotic"
l the phrase "tilting at windmills," there would be no handy way to describe
nily heroic idealism. Sancho Panza is the ancestor of all sidekicks, from Tonto to
ney Rubble. *Man of La Mancha* (1965) is one of the best-loved musicals of all
e. And Picasso's drawing of the mad knight—symbol of an optimism that defies
n reality—hangs in dentists' offices around the world.

95

1683 THE FIRST MUSEUM

In the 16 and 17th centuries, European collectors of a and artifacts housed their exhibits—a pictu made of feathers, the head of an ape, an obje identified as the hand of a mermaid—in "cabine of curiosities" or "wonder rooms." But the mus um as we know it got its start in England in 165 when John Tradescant, a gardener to royal deeded his family's treasures—fish, weapon birds, even a stuffed dodo—to fellow collect Elias Ashmole. When Ashmole donated the c lection to Oxford University, he stipulated tha separate building be constructed for it. Oxfo complied and in 1683 opened the Ashmolean, t first public museum founded to present the gra deur of man and nature. **PHOTOGRAPH FROM THE ASHMOL MUSEUM, OXFORD UNIVERSITY**

Powhatan's mantle was put on display at the Ashmolean, though no one knew for sure if it was Powhatan's—or even a mantle.

GREAT MUSEUMS OF THE WORLD

1737 The Uffizi Gallery, Florence
1756 The Vatican Museums, Rome
1759 The British Museum, London
1793 The Louvre, Paris
1819 The Prado, Madrid
1825 The National Museum, Mexico City
1852 The Hermitage, Leningrad
1855 The Smithsonian Institution, Washington, D.C.
1870 The Metropolitan Museum of Art, New York
1871 The American Museum of Natural History, New York
1891 The Museum of Fine Arts, Vienna
1925 The Deutsches Museum, Munich
1929 The Museum of Modern Art, New York
1933 The Museum of Science and Industry, Chicago
1941 The National Gallery of Art, Washington, D.C.

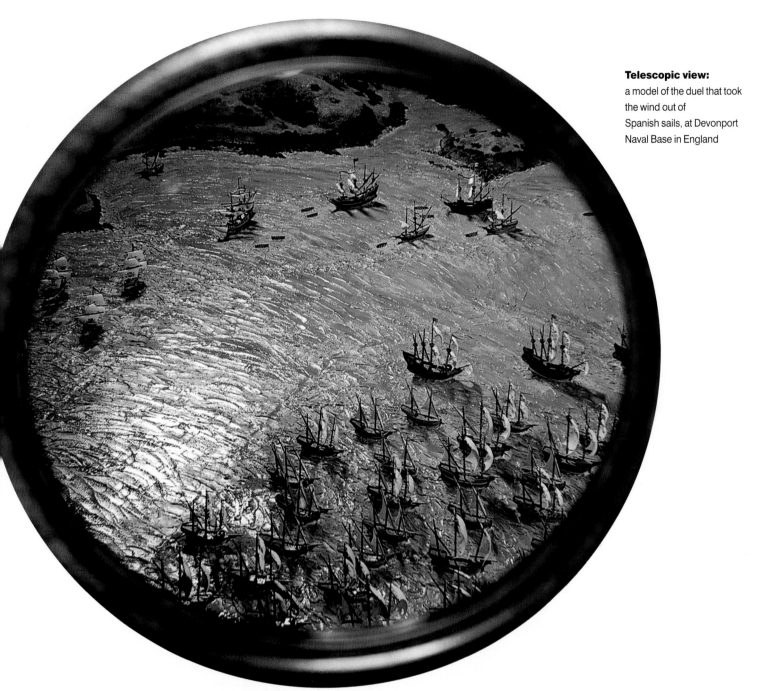

Telescopic view:
a model of the duel that took
the wind out of
Spanish sails, at Devonport
Naval Base in England

88 SINKING THE ARMADA

As the Spanish armada cruised into the English Channel, it looked like a fearsome city under sail. The mission of the most heavily armed fleet the world's greatest naval power had ever put to sea was simple: meet the British navy and crush it. Then King Philip II's ally, the Duke of Parma, would sail north from Dunkirk and invade England. His troops, Philip assumed, would be embraced by English Catholics, who would rise in rebellion and hurl Queen Elizabeth I, a Protestant, from her throne. But on July 29, 1588, an English fleet of substantially smaller ships began destroying the armada. Many of these ships were of a radical new design: low, streamlined, nimble. To exploit their advantage, the English unveiled a completely new method of naval combat, making no attempt to board the enemy ships, relying instead on long-range cannon. The Spaniards tried to escape by heading north but ran into bad weather, and only half their ships made it home.

The armada's defeat was a portent of much to come. True, the Spanish empire declined gradually, and it would be a century before Britannia ruled the waves. But the British Lion had roared.

PHOTOGRAPH BY TIM SIMMONS

94

1846 PAINLESS SURGERY

Strapped into a chair, a pale young man with a tumor in his jaw awaited his fate without showing a twinge of fear; he said he even felt "confident." Surprising remark, considering he was about to undergo surgery at a time when screams accompanied incisions and whiskey was often the best way to dull the pain. But on October 16, 1846, at Massachusetts General Hospital in Boston, dentist William Morton administered ether before the surgery, and the patient felt no pain. Morton did not discover ether. Valerius Cordus did, in the 16th century. Nor was Morton the first to use it during a surgical procedure. A Georgia physician named C.W. Long excised a tumor from a patient using ether in 1842—for a $2 fee. As for coming up with the word "anesthesia," Oliver Wendell Holmes gets the credit. But because Morton was the first to spread the news to the scientific community—an account of the operation appeared in the *Boston Medical and Surgical Journal*—he is remembered as the man who opened a new era for surgeons around the globe. **PHOTOGRAPH BY MAX AGUILERA-HELLWEG**

93

GOING UNDER

About 28 million surgeries are performed yearly in the United States.

92

Istanbul's 17th century Ottoman Blue Mosque (foreground) mimics the Byzantine Hagia Sophia (at rear), built 1,080 years earlier.

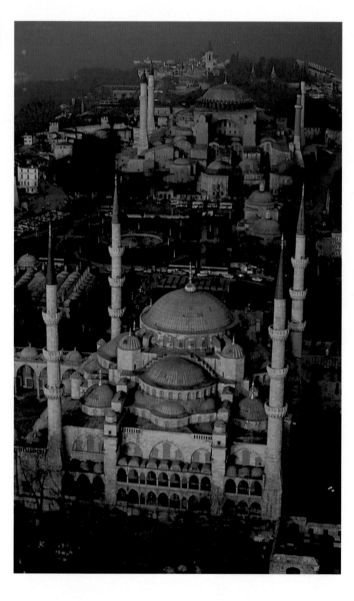

1453 THE OTTOMAN EMPI

Mehmed II Khan Gazi was only 21 wl he captured Constantinople from the Ch tians in 1453. The battle marked the lapse of the Byzantine Empire and ascendancy of the Ottoman Empire, wl would thrive through half the millenni spreading its influence across mucl Europe and the Arab world.

"Inspiring of fear rather than re ence," as one Venetian visitor said Mehmed, he nonetheless transformed C stantinople from a decrepit city int whirling hub of trade and creativity became a magnet for Islam's most an tious and talented scholars, poets, art and architects, who wrote some of the e finest literature and built spectacu mosques.

But the Ottoman influence was not benign. Straddling the Bosporus betw Asia and Europe, Constantinople wa perfect springboard for the empire's n tary conquests as far west as Moroc north into Hungary and east to Damasc Baghdad and the holy cities of Mecca Medina. The occupation of Constantino also forced Christian Europe to look new trade routes to East Asia by circu navigating Africa. The empire eventu collapsed after World War I, when Must Kemal Atatürk founded the modern rep lic of Turkey and renamed the old impe capital Istanbul. **PHOTOGRAPH BY GUIDO ALBERTO ROS**

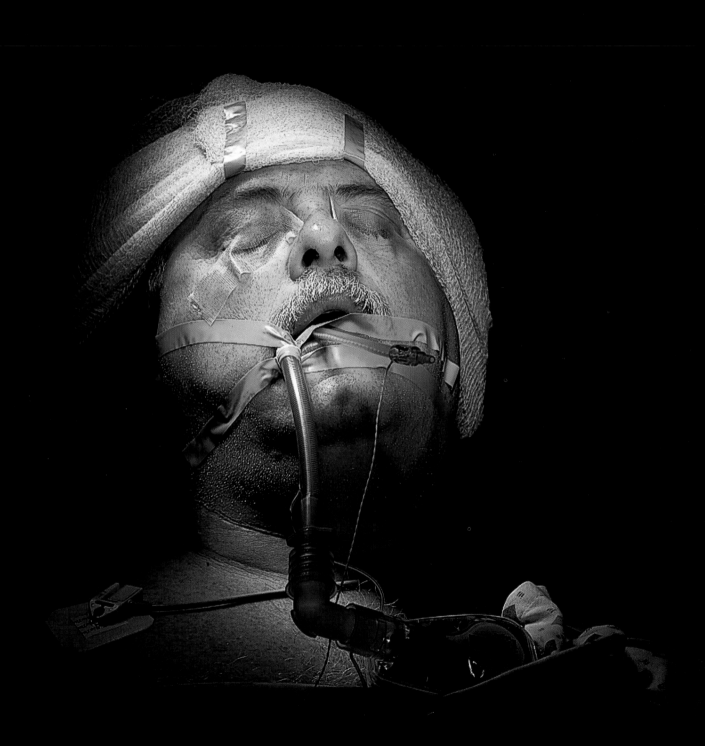

A patient
undergoing anesthesia
before a laparotomy.
The operation proceeded
like a dream.

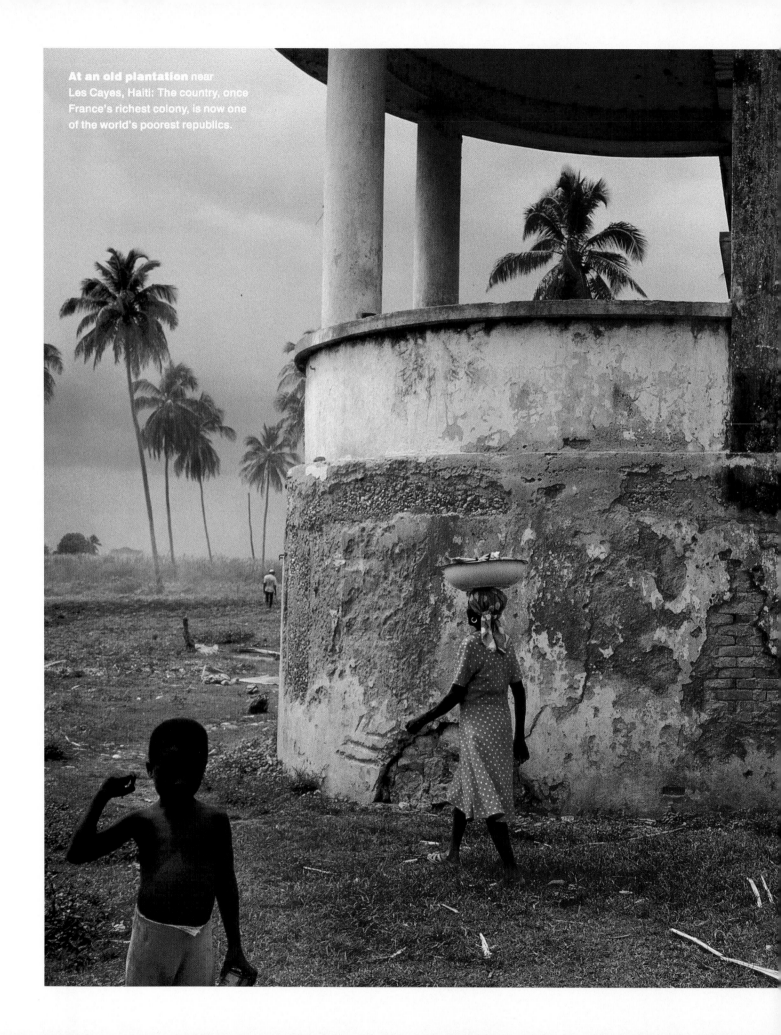

At an old plantation near Les Cayes, Haiti: The country, once France's richest colony, is now one of the world's poorest republics.

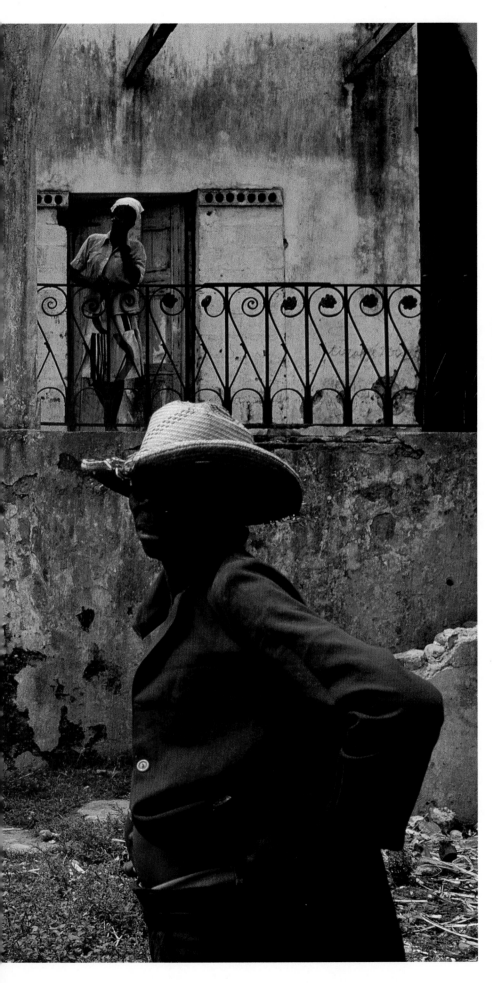

91

1804 HAITI'S FREEDOM They had simply had enough. By 1791, half a million black men and women were toiling in the coffee, indigo and sugarcane fields on this French colonial island. When Boukman Dutty, a Jamaican-born voodoo priest, implored a gathering to "throw away the thoughts of the Whitegod who thirsts for our tears," the masses listened. Armed with machetes and vengefulness, they torched plantations and took lives by the thousands as they fought for their freedom. A self-educated former slave named François-Dominique Toussaint-Louverture organized an army that withstood France's attempts to reestablish control until 1802, when he surrendered to Napoléon's troops. But the insurrection so depleted Napoléon's resources that he sold the Louisiana Territory to the United States the next year, ending France's quest for domination in the Western Hemisphere. Toussaint-Louverture didn't live to see his dream realized, but on New Year's Day, 1804, the rebels finally got their wish: Haiti became the world's first free black republic. The ripple effects were felt as far away as England and America, where news of the revolt cheered abolitionists. **PHOTOGRAPH BY ALEX WEBB**

90

1907 AS IF ON CUE: PLASTIC

Nobody was happier to learn of th[e] invention of plastic than the world's elephants. For centurie[s] ivory had been the standard for everything from knife handle[s] to billiard balls. In the 1880s, a dwindling supply of tusks and [a] billiards boom conjoined to create a crisis. The country's large[st] maker of balls, Phelan and Collender, anxiously offered $10,00[0] in gold—"a handsome fortune"—to any "inventive genius" wh[o] came up with a synthetic substitute for ivory. Pachyderms ever[y] where held their breath. And held it and held it, for it wasn't unt[il] 1907 that Leo Baekeland, a Belgian-born inventor who'd mad[e] a bundle on quick-action photographic paper, hit upon the rig[ht] combination of phenols and formaldehyde. This first entire[ly] synthetic plastic, Bakelite, was resistant to heat, electricity an[d] acid. It was a plus both for pool players and for the nascent aut[o] and electronics industries. One great asset of plastic was vers[a]tility, and it came to be used in everything from telephones t[o] toilets, ashtrays to airplane parts. By 1968 a college gradua[te] looking for a surefire profession was being urged to listen t[o] "just one word—*plastics*." Thirty years later the miracle mate[r]ial has turned into a $260 billion industry that employs mor[e] than 1.3 million people worldwide. It's a plastic world we live i[n] and that's not altogether bad. **PHOTOGRAPH BY JAMES WOJCIK**

TIME LINE PLASTICS **1910** Plastic-coated fabrics **1932** Neoprene synthetic rubber **1935** Plexiglas **1940** Nylon sto[ckings]

ese rare Bakelite
auties are worth
0 to $500 for the set.
ard balls are now
de of other plastics.

upperware **1948** Teflon pots and pans **1949** Epoxy glue **1952** Polyester clothing **1957** Polypropylene housewares **1971** Kevlar

89

1324 ACROSS THE SAHARA Fourteenth century Africans would be astonished to discover that Mali is now one of the world's poorest countries. In its day, Mali's empire was one of the largest in the world, ruled by an emperor whose lavish adventure helped spread Islam across West Africa and literally put sub-Saharan Africa on the map for cartographers in Europe and the Middle East.

Mansa Musa embarked on a holy pilgrimage to Mecca in 1324 with such opulent flourish that awestruck Egyptian writers were still recounting it 200 years later. Legend has it that Musa traveled across the Sahara with about 60,000 men, including 12,000 slaves. He brought 80 camels, each loaded with 300 pounds of gold, which he gave away so freely in Cairo that it took years for the price of gold to recover. Architects and poets he brought back from Arabia built distinctive mosques, some of which survived for centuries, and helped establish Timbuktu as a center of Islamic learning. But Musa's brazen advertisement of riches made Africa's interior a more desirable target for European exploration and conquest. **PHOTOGRAPH BY CHRIS RAINIER**

FROM TIMBUKTU TO HERE

To Westerners, Timbuktu has long been synonymous with remoteness and mystery. Explorers died trying to reach the desert city, legendary for its fabulous court, exotic markets and brilliant scholars. But by the time French troops invaded in 1894, Timbuktu had been in decline for 300 years, weakened by tribal conquests. Once a metropolis of 70,000, the town is now a shabby backwater, and Mansa Musa's palace has long since crumbled into the Sahara.

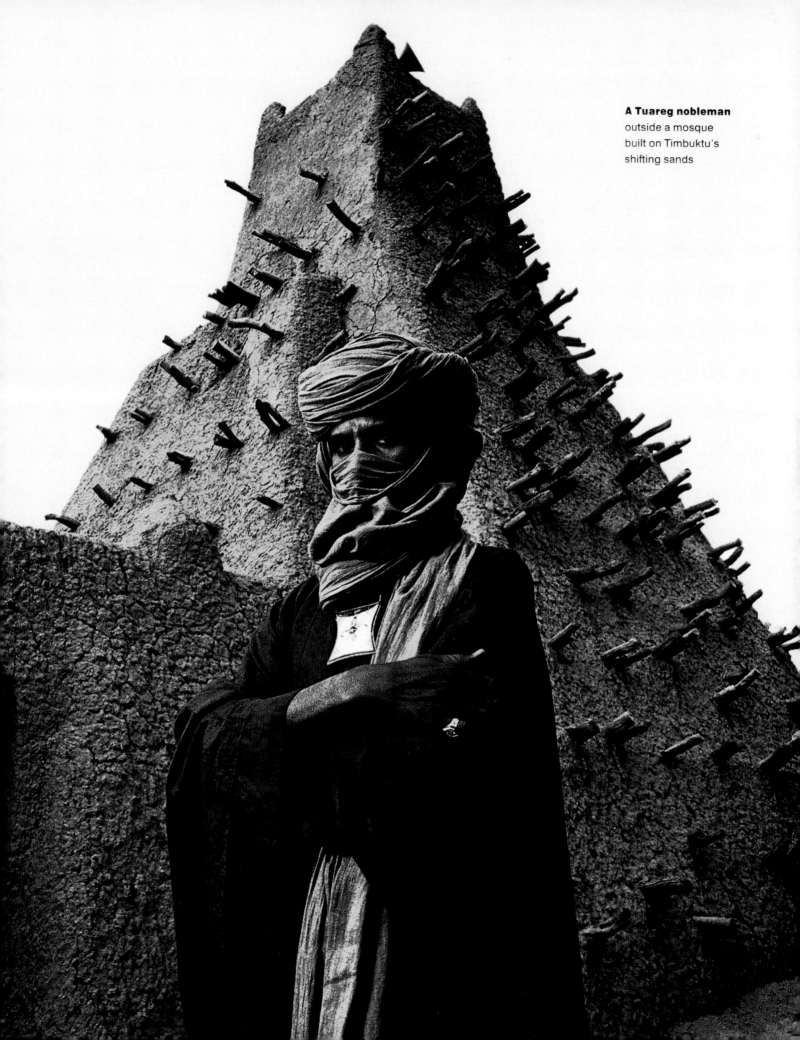

A Tuareg nobleman
outside a mosque
built on Timbuktu's
shifting sands

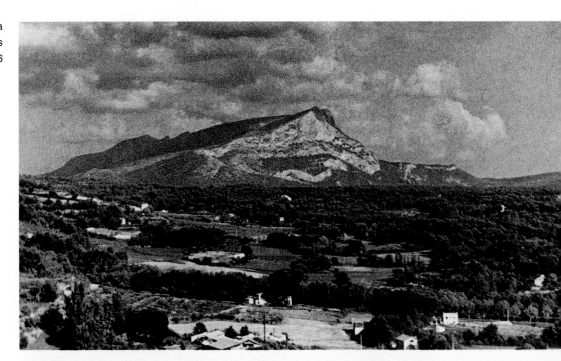

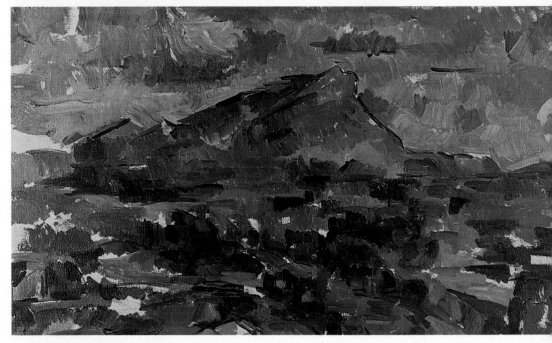

88

1880 MODERN ART In the shadow of a pile of limestone in the south of France called Mont Sainte-Victoire, art turned and faced the 20th century. There, Paul Cézanne painstakingly replaced conventional systems of light, shade, line and perspective with a new visual vocabulary. The mountain was his favorite subject, and he painted it more than 60 times. In works from 1880 on, the near and the far merge, transforming spatial voids into animate planes, transforming static reality into a network of visual energy.

Cézanne exchanged the perspective cre[ated] by line for a backward-forward pulsatio[n] color that made the two-dimensional can[vas] vibrate with the three-dimensional fullnes[s] nature. The surface of a painting would [no] longer be merely a window through which r[eal]ity could be observed: Cézanne would mak[e] a reality unto itself, one he saw as both clas[sic] and transcendent. Artists would now be f[ree] to develop new modes of expression. As Pa[blo] Picasso later observed, he was "the fathe[r of] us all." **PHOTOGRAPH BY JOHN REWALD**

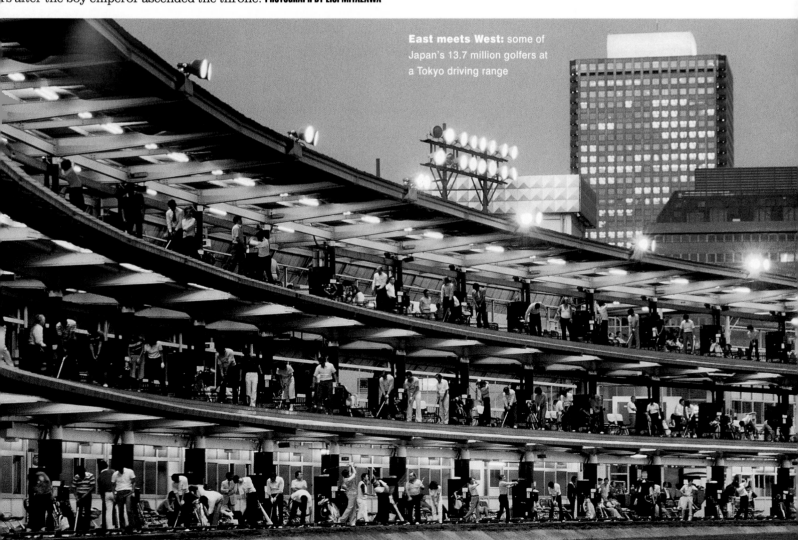

68 **JAPAN OPENS ITS DOORS** For more than 250
rs the shoguns, Japan's military rulers, had kept their country
sed to the world. Then, in 1853, U.S. Commodore Matthew Perry
ived in Tokyo Bay with four gunships, demanding that Japan open
ports to trade. Some of the country's leaders realized they had
choice. By 1868, power had shifted back from the shoguns to the
peror—the 15-year-old Mutsuhito—and the imperial seat moved
n Kyoto to Tokyo. Known as the Meiji Restoration (Meiji, or "Enlight-
d Rule," was the name taken by Mutsuhito), this period saw the
nsformation of Japan from an inward-looking, agrarian, feudal king-
m to a world power. Mutsuhito's chief counselor, Prince Ito Hirobu-
sent emissaries to Europe and the United States and brought back
hnology, medical and scientific knowledge, constitutional models
military and naval expertise.

Sufficiently confident to challenge larger players on the world stage,
an went to war with China in 1894 and won Taiwan, the Pescadores,
thern Manchuria and free access to Korea. It went on to sink the
ssian navy in 1905, annex Korea in 1910 and join the Allies against
rmany in 1914. The country's successes inspired nationalist upris-
s in India, Iran and Turkey during and after World War I but stirred
entment and fear in the 1930s when Japan waged bloody campaigns
China. Its military expansionism, which peaked during World War II,
s stopped only by two atomic bombs.

A prolonged period of recovery, increasing productivity, prosperity
steady economic expansion has made Japan the only Asian nation
nted among the world's richest industrialized powers—just 130
rs after the boy emperor ascended the throne. **PHOTOGRAPH BY EIJI MIYAZAWA**

87

JAPAN INC.

Rebuilt and democratized with
American help after World War II,
Japan made such astounding strides
that by the 1980s its former patrons
feared being left in the dust. Toyota and
Honda gave Detroit a beating; after
cornering the electronics market, Sony
bought a Hollywood studio; and Tokyo
lectured Washington on the virtues of
thrift, as Yankee businessmen tried to
mimic the management style that
powered the "Japanese miracle."
Although Japan faltered in the '90s, it
remained the world's second-largest
economy—a Godzilla that could shake
the global economy with a flip of its tail.

East meets West: some of
Japan's 13.7 million golfers at
a Tokyo driving range

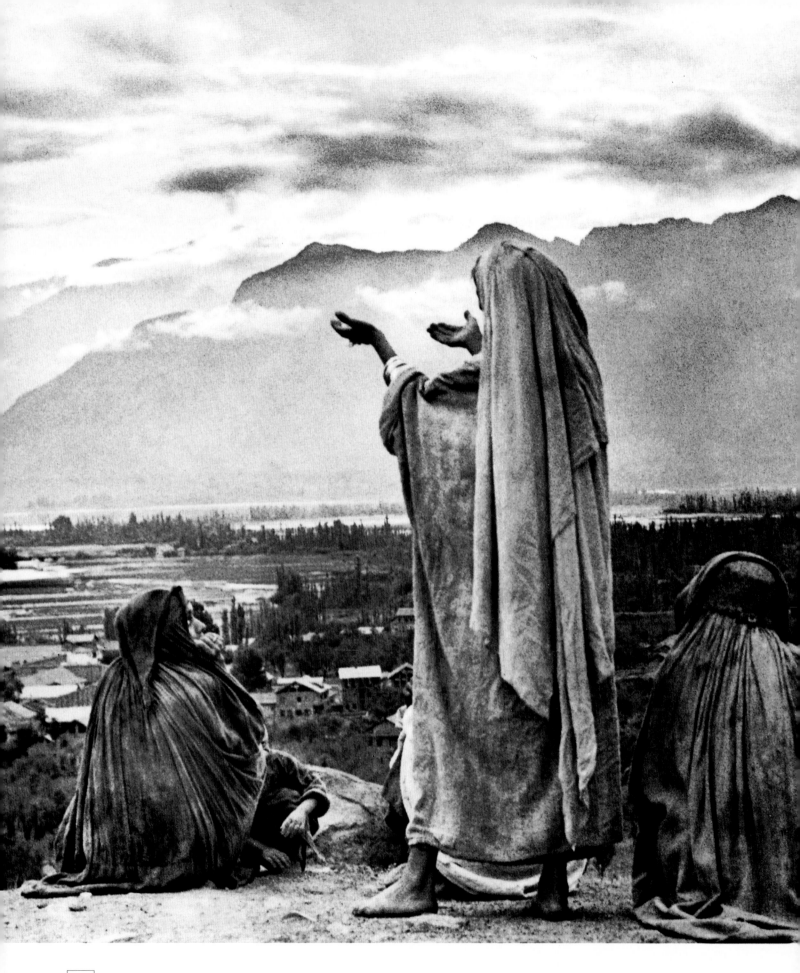

TIME LINE BRITISH DECOLONIZATION **1948** Palestine **1956** Sudan **1957** Ghana **1960** Nigeria **1962** Trinidad and To

Muslim women praying at dawn in Srinagar, Kashmir, in 1948, one year after the end of British rule

86

1947 INDIA'S INDEPENDENCE

"The jewel in the crown," the British called their most prized possession, to which they first traveled for spices and silks 300 years ago. And once it was no longer theirs, in 1947, the world's most powerful empire began to unravel.

Colonial rule of the vast South Asian subcontinent didn't officially begin until 1857, after Indian soldiers led an unsuccessful revolt against the British East India Company, which had effectively controlled the country. But India's Western-style schools only fired the nationalist movement, creating a middle class that questioned its dependent, "racially inferior" status.

In 1930, Mohandas Gandhi, who preached non-violent resistance, led thousands of followers on a 200-mile march to the sea, where they made salt in defiance of British tax laws. By the mid-1940s, Britain's resources had been sapped by World War II, and the slogan "The sun never sets on the British Empire" had lost its moral certainty. After India gained its independence, there was little to stop Britain's dominoes from toppling: Palestine in 1948; Ghana, the first of its African colonies to go, in 1957; and in 1997, its last significant outpost, Hong Kong.

Fifty years after winning their independence, more than 900 million Indians—many still mired in poverty—make up the world's largest parliamentary democracy. **PHOTOGRAPH BY HENRI CARTIER-BRESSON**

Kenya **1966** Guyana **1970** Fiji **1973** The Bahamas **1980** Zimbabwe **1981** Belize **1991** Brunei **1997** Hong Kong

31

85

MUSLIM MINDS

Greek philosophy wasn't the only gift medieval Europe received from Muslim scholars. They also translated Greek scientific texts into Arabic, sharing knowledge that had been lost to the West since the fall of Rome. They passed along Hindu mathematical ideas, such as the concept of zero. And the discoveries of Ibn al-Haytham in optics, Ibn Sina in medicine and Umar Khayyam in mathematics pointed the way for generations of Western thinkers.

1169 SAVING ARISTOTLE

The Muslim philosopher and scientist Ibn Rushd was a translator not only of books but also of civilizations. Córdoba was his laboratory, the works of Aristotle the materials he used for his experiments. The result: a 12th century European renaissance.

Since the 6th century, classical scholarship had been neglected or suppressed by the Catholic Church. Centers of Islamic learning, however, had preserved the works of philosophers of antiquity, giving pride of place to Aristotle. In 1169, Ibn Rushd, a polymath also known as Averroës, began translating and commenting on Aristotle's works. His surroundings were perfect for the task. For several centuries, Spain had been controlled by Muslims, whose literary and artistic culture far surpassed that of medieval Europe. Córdoba's library contained 400,000 volumes—more, it is said, than all the other libraries of Europe combined.

For 26 years, Ibn Rushd put his mind to rescuing Aristotle, translating his works from Greek to Arabic. They soon found their way into Latin and into the bloodstream of European intellectual life. Philosophy was transformed, East to West, from arid dogmatism into a robust new synthesis of reason and faith. **PHOTOGRAPH BY SHAUN EGAN**

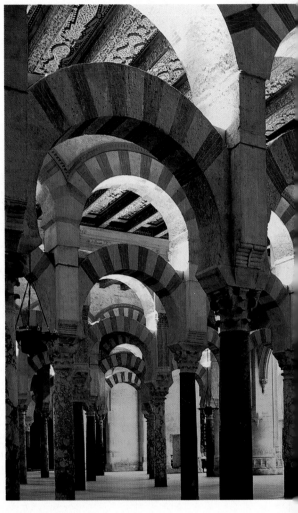

This church in Córdoba, Spain, home of Muslim scholar Ibn Rushd, was once a mosque.

1407 CHECKING ACCOUNTS

Coins as currency have been traced back to the 7th century B.C. Paper money was printed in China as early as the 11th century. But no economic institution has shaped the world like the bank. (The word stems from the Italian *banco*, or bench, from which money changers did business at medieval fairs.) Before the first public banks appeared—Casa di San Giorgio, founded in Genoa in 1407, was the most prominent—merchants conducted business using bills of exchange that functioned as IOUs; banks, operated by wealthy families, often went bankrupt when distant kings reneged on loans. Casa di San Giorgio lasted only 37 years, but its innovations led all the way to the credit card. The bank served as the model for public banks that "cleared," or transferred, balances between accounts. And it established an unprecedented trust: The government had an incentive to repay its debts so it would have a continuing source of funds. These developments gave rise to the modern clearing bank—Amsterdam's Wisselbank was the first, in 1609—which made it possible to use bills of exchange like money. Today we can move millions across continents with the touch of a keyboard. **PHOTOGRAPH FROM THE H. ARMSTRONG ROBERTS COLLECTION**

84

Paying a debt owed to someone in another city used to take weeks. Now 90 percent of all financial transactions are made electronically—in seconds.

irst overdraft account/Scotland **1890** First traveler's check/U.S. **1947** First credit card/U.S. **1967** First automated teller machine/U.S.

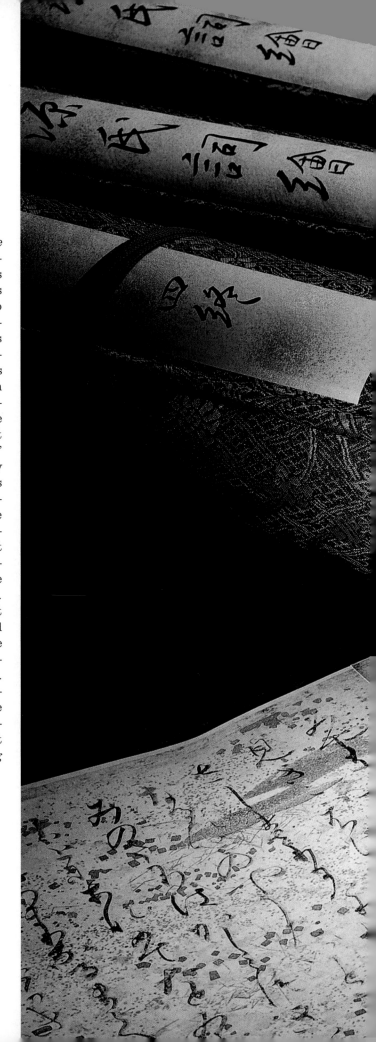

83

1008 THE FIRST NOVEL *The Tale of Genji,* the crown jewel of Japanese literature, is widely regarded as the world's first fully realized novel. Its author, Murasaki Shikibu, was a Kyoto aristocrat, the center of a group of brilliant women who competed for status through their literary skills. Her masterpiece, finished about 1008, concerns the colorful life of the royal court, with its many political and romantic intrigues. Hundreds of characters fill the book, but at its center is an elegant prince known as "the shining Genji." The novel's complex plot, its sympathy with the plight of women at court, its subtlety of language and its penetrating psychological insights—all were unprecedented. *The Tale of Genji* remains a surprisingly modern work; it has recently been translated and recognized outside Japan as one of the great contributions to world literature. Its influence has been broad, not just in Japan, where it remains a principal source of stories for Noh drama, the Kabuki stage and contemporary cinema, but throughout the Western world. Any serious discussion of the structures, forms and intentions of the novel—the most significant new literary genre of the millennium—must take into account Murasaki's stunning achievement. **PHOTOGRAPH BY KENRO IZU**

MAKING BOOK
Best-selling novelist of all time:
Agatha Christie (1890–1976), whose 78 crime novels have sold more than two billion copies in 44 languages

An illustration from one of the 54 chapters of a 1688 edition of *The Tale of Genji*

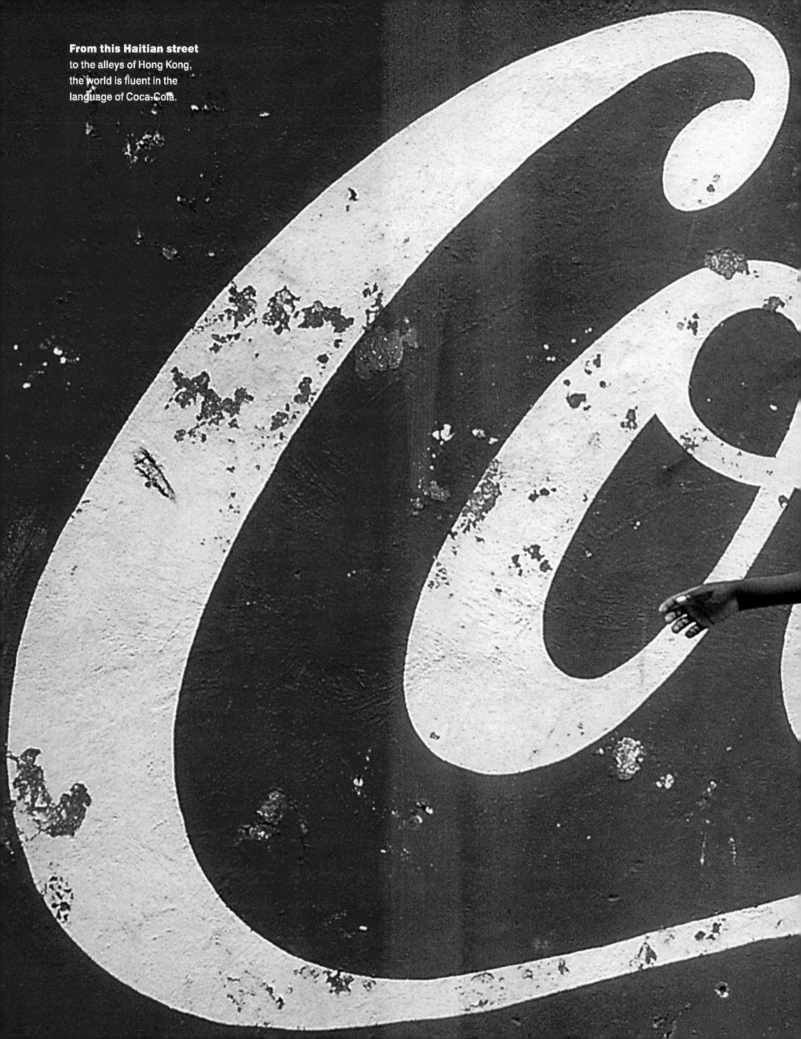

From this Haitian street to the alleys of Hong Kong, the world is fluent in the language of Coca-Cola.

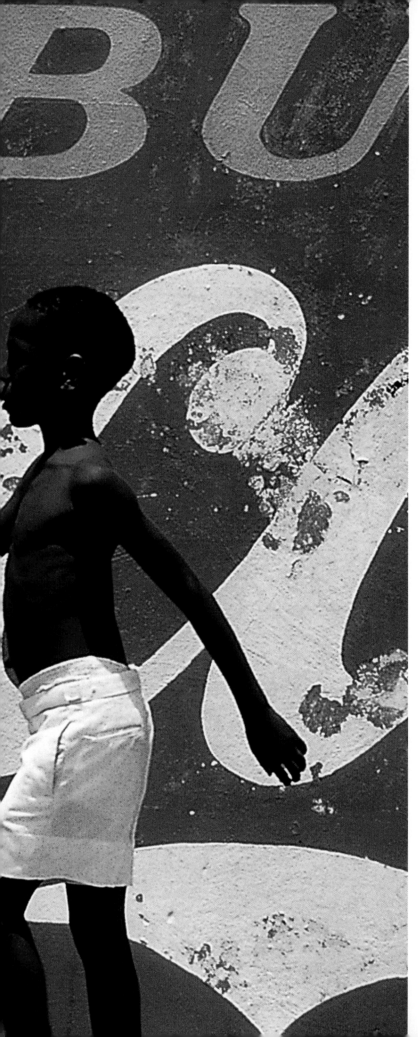

82

1886 SELLING THE WORLD A COKE

Two thirds of the earth is covered by water; the rest is covered by Coke. If the French are known for wine and the Germans for beer, America achieved Global Beverage Dominance with fizzy water and caramel color. But Coca-Cola's success has less to do with ingredients than promotion. The coca leaf and kola nut blend cooked up by Atlanta druggist John Pemberton in 1886 was released into a market saturated with self-medications. Pemberton positioned his nonalcoholic tonic as the Great National Temperance Drink, and soon folks were buying Coke just for the taste of it.

Asa Candler bought the company for $2,300 and retooled the drink's secret formula. He spent lavishly on advertising—as much as a quarter of the company's revenue. When Robert Woodruff took the helm, he vowed to put a Coke "within an arm's reach of desire." Feeling that he'd like to buy the world a Coke, he established a foreign department in 1926. After Pearl Harbor, the U.S. military footed much of the bill for the company's bottling plants at the front lines. Not coincidentally, millions of people in nearly 200 countries have been introduced to the pause that refreshes.

Today, 606 million Cokes (including diet, caffeine-free and other versions) are consumed each day. A rich man can buy a better wine or beer than a peasant, but not a better Coke. That they both want the same soda is a testament to the power of advertising—and perhaps that secret formula. PHOTOGRAPH BY ERIC MEOLA

DRINK ME

Country with highest annual per capita consumption of Coca-Cola: Iceland, 417 eight-ounce servings
U.S. city with highest annual per capita consumption of Coca-Cola: Rome, Ga., 608 eight-ounce servings
Number of Coca-Cola vending machines in Japan: 870,000
Number of Coca-Cola soft drinks consumed every second, worldwide: 10,450

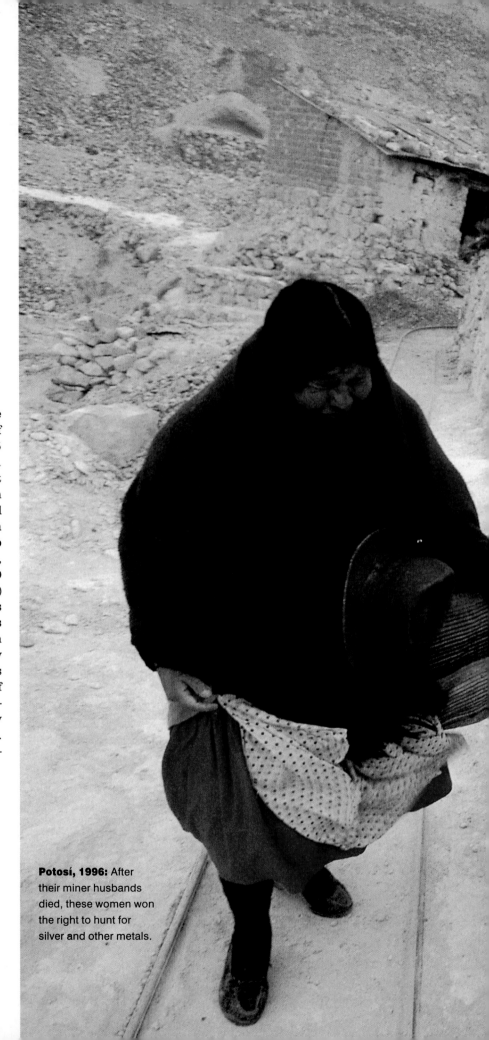

81

1545 SILVER FEVER Long before California's gold rush, the discovery of silver in the Andes Mountains in 1545 sparked an explosion of wealth for Spain. Entrepreneurs flooded Potosí, then part of Peru, conscripting Indians to unearth the precious ore. Thousands perished each year, an estimated eight million over the next three centuries. (To numb themselves against hunger and fatigue, miners chewed on as many as 95,000 baskets of coca leaves in one year alone.) Between 1550 and 1650, Potosí's veins provided up to 60 percent of the world's silver, opening trade between Latin America, Europe and Asia, particularly China, where silver was worth twice as much as elsewhere. By 1640 the price of silver in China had bottomed out—hastening the demise of the Ming dynasty and the decline of the Spanish empire. Potosí's mountain is now mined primarily for tin. **PHOTOGRAPH BY STEPHEN FERRY**

Potosí, 1996: After their miner husbands died, these women won the right to hunt for silver and other metals.

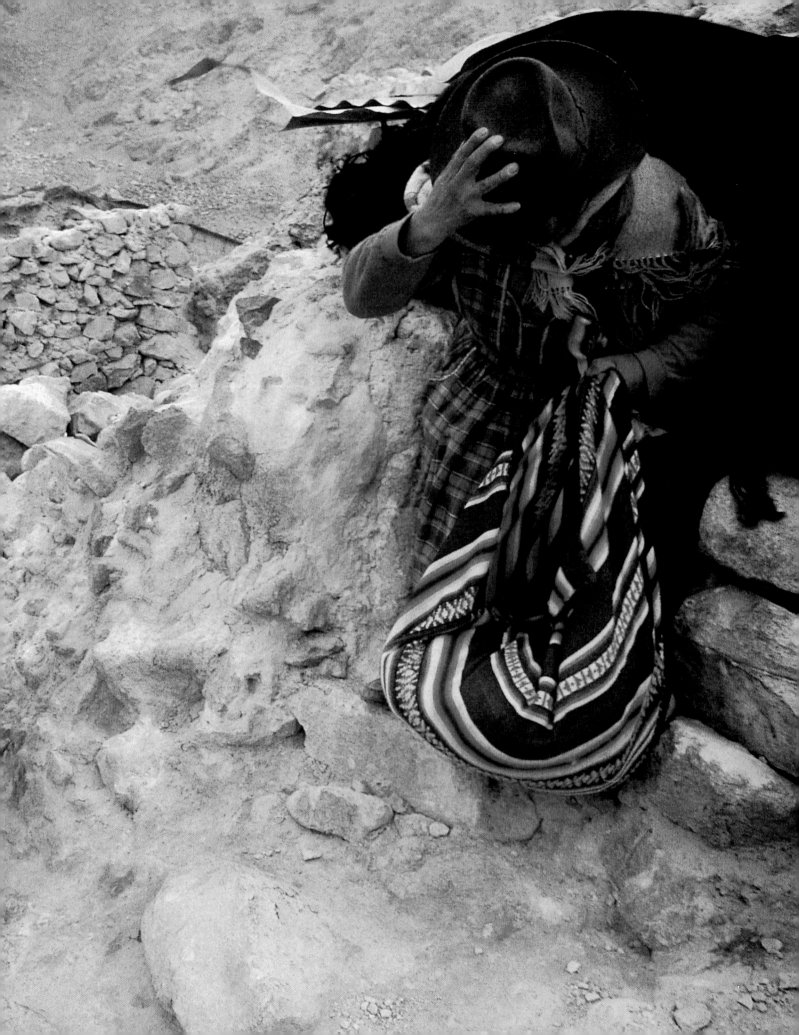

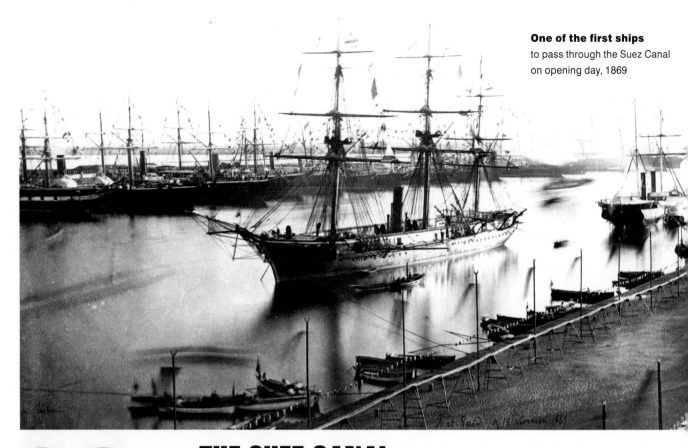

80

1869 THE SUEZ CANAL When the Suez Canal opene[d] in 1869—after a decade of excavation by 1.5 milli[on] men, thousands of whom died—it was hailed as t[he] Eighth Wonder of the World. About 100 miles lon[g] it shortened the sea route from Europe to India b[y] 6,000 miles. Vessels no longer had to circumnav[i]gate Africa, and the wealth of nations soon passe[d] through it. Oddly, the British left development to [a] Franco-Egyptian consortium until they realized th[e] canal's importance and bought out Egypt's share[.] An Anglo-French commission then ran the canal un[til] 1956, when Egypt's President Gamal Abdel Nass[er] expropriated it. **PHOTOGRAPH FROM THE ROGER-VIOLLET COLLECTION**

1601 THE RISE OF THE WELFARE STATE

Before England adopted a formal antipoverty program, the destitute relied on begging, thievery and the Catholic Church's ample coffers for survival. But by the late 16th century, the Church, stripped of its holdings by Henry VIII, was no longer in a position to help. The rising demand for wool, then England's leading export, further inflated poverty rolls as greedy landlords forced tenants off their property in favor of more profitable sheep. It was left to the government to lend a hand. As codified in the Poor Law of 1601, though, it was not to be a handout. In exchange for financial assistance, the able-bodied were obligated to labor in workhouses. Children were assigned to apprenticeships. Even the sick and infirm, in poorhouses, had to do piece-work. Those who did not work were whipped, imprisoned and, in some cases, put to death. The meager earnings these institutional safety nets provided were not enough to pull people out of despair. But the premise behind the law—that a government has a responsibility to its poor—and the resulting public policies affected the future of social welfare. Germany's national insurance plan for dealing with illness and old age in the 1880s, Britain's public-housing policies of the early 1900s and America's Social Security Act of 1935 were all descendants of the Poor Law. Yet, as recent reforms of the American welfare system illustrate, the public's ambivalence toward the poor continues to this day. PHOTOGRAPH BY MARGARET BOURKE-WHITE

79

...d victims in ...sville, Ky., wait ...e for food at a ...f center, 1937.

WELFARE ROLLS
Households receiving public assistance, 1990
Britain: 26 percent
France: 24 percent
Germany: 19 percent
United States: 15 percent
Australia: 11 percent

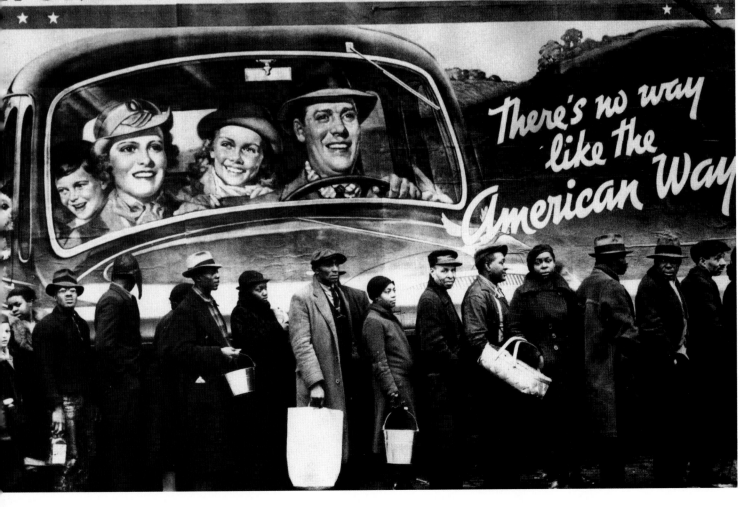

WORLD'S HIGHEST STANDARD OF LIVING

There's no way like the American Way

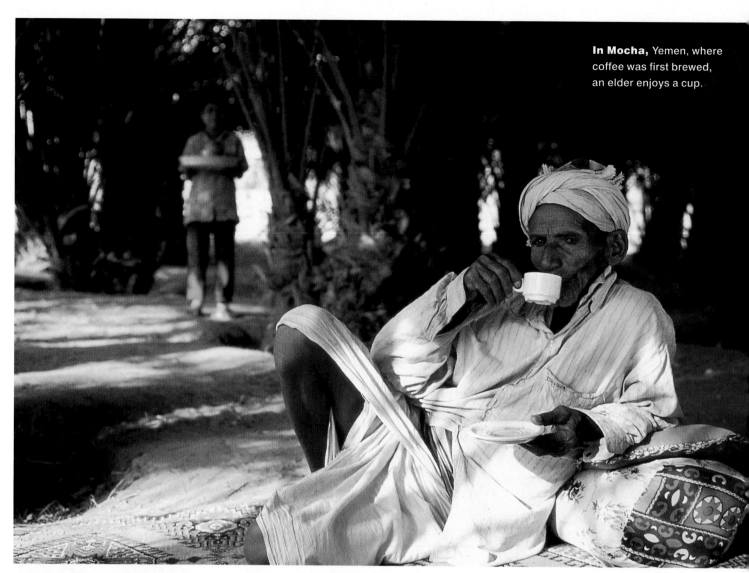

In Mocha, Yemen, where coffee was first brewed, an elder enjoys a cup.

78

c.1450 COFFEE BREWS IN YEMEN Although legend has it that an Ethiopian goatherd, whose animals became hyper from eating the berries, first noticed coffee's stimulating effects, 15th century Sufis in Yemen were the first to drink it. The Muslim mystics valued coffee's ability to keep them alert during nighttime worship. Out of their communal services, coffee drinking evolved as a group activity that carried over to the general Muslim population, which shunned alcohol.

Where coffee brewed, so did radical thought. Presaging the Beat cafés of the 1950s, early coffeehouses were magnets for artists and writers and served as hubs of information. Eventually, the political nature of coffee klatches made Muslim clerics nervous, leading them to ban coffee in Mecca in 1511. But the bean survived and, in the next century, caught on in Europe. By 1700 there were 2,000 cafés in London, one of which, Lloyd's, became the giant insurance brokerage. Later, in Paris, Marat and Robespierre saw the first stirrings of the French Revolution over a couple of cups of joe. Between 1880 and 1980—before there was a Starbucks on every corner—coffee was second only to oil as the world's most traded commodity. **PHOTOGRAPH BY FRANÇOIS PERRI**

CUPPA FACTS

Percentage of U.S. population 10 and over drinking coffee daily: 47.2

Annual per capita consumption of coffee in U.S.: 584 cups

Percentage of Americans who drink their coffee black: 37

Percentage of Americans who use electric drip coffee makers: 75

Country with biggest annu[al] coffee crop: Brazil, 2.5 billion pounds

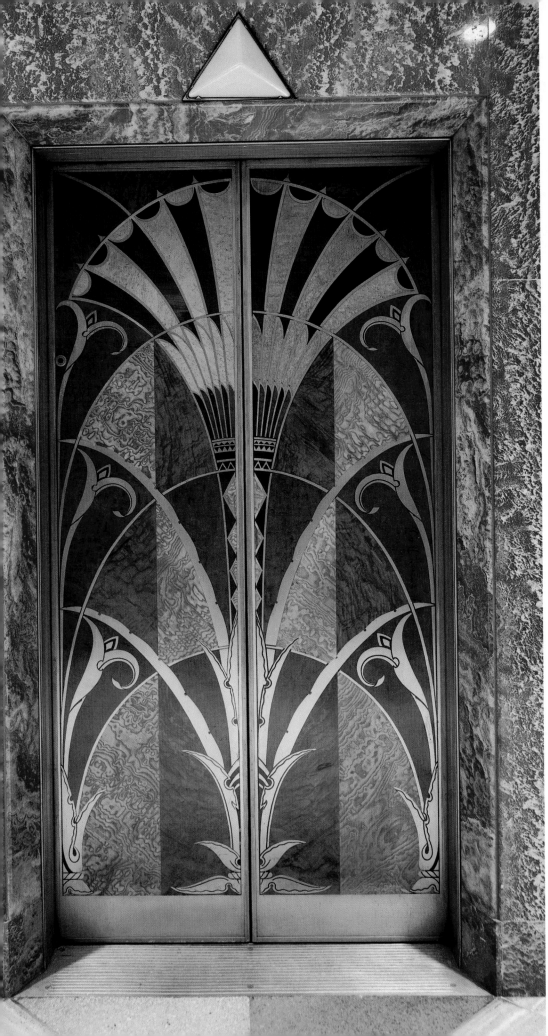

77

1854 GOING UP In a top hat and with a beard trimmed level as a ruler, an unsuccessful 42-year-old mechanic stood on a platform that, by means of a rope coiling around a power-driven drum, was hoisted high above a mass of onlookers at an 1854 New York City fair. Suddenly the mechanic, Elisha Graves Otis, ordered the rope slashed. The crowd gasped. The platform fell a few inches, then stopped. Otis doffed his hat and cried: "All safe, gentlemen, all safe!" And the city as we know it was born.

Elevators had existed before Otis. But by designing a spring that set two iron teeth into notches in the guide rails when tension in the rope failed, Otis created the world's first safe elevator. A pity he died seven years later, $3,000 in debt, before seeing his invention alter the urban landscape. Its ultimate symbol: the Empire State Building, which, with 10 million bricks, 6,400 windows and 102 stories, can be seen 50 miles out to sea—and ascended in no time at all.
PHOTOGRAPH BY NORMAN MC GRATH

OTIS HIGH POINTS

1880 Washington Monument, Washington, D.C.
1889 Eiffel Tower, Paris
1931 Empire State Building, New York City
1997 Petronas Towers, Kuala Lumpur, Malaysia

This Otis elevator with inlaid wood is in the 1930 Chrysler Building in New York City.

43

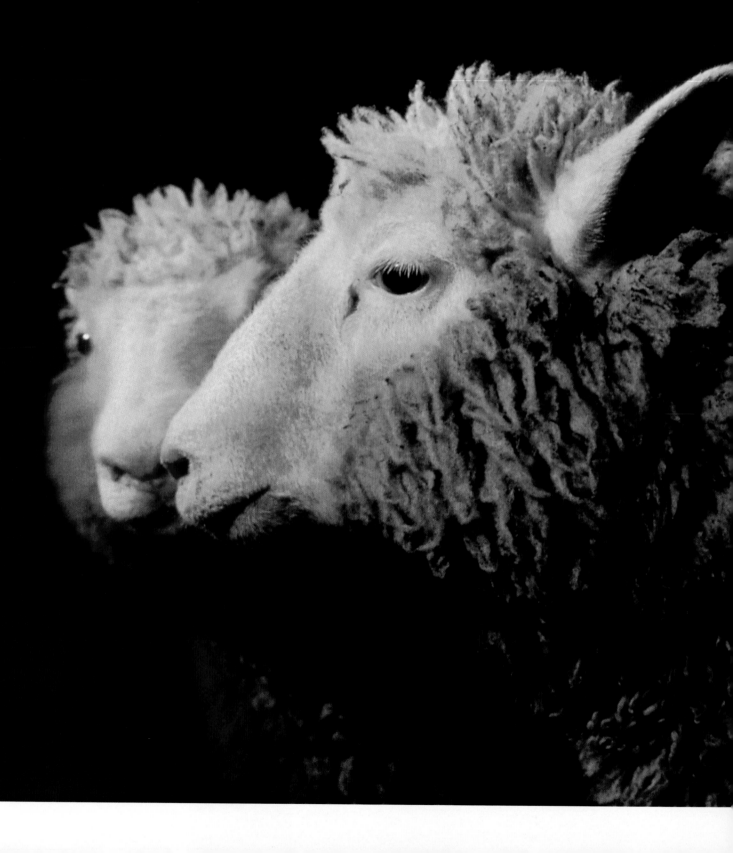

Dolly, the first cloned mammal, has been joined by Polly, a sheep with human genetic material, and Gene, a cloned calf.

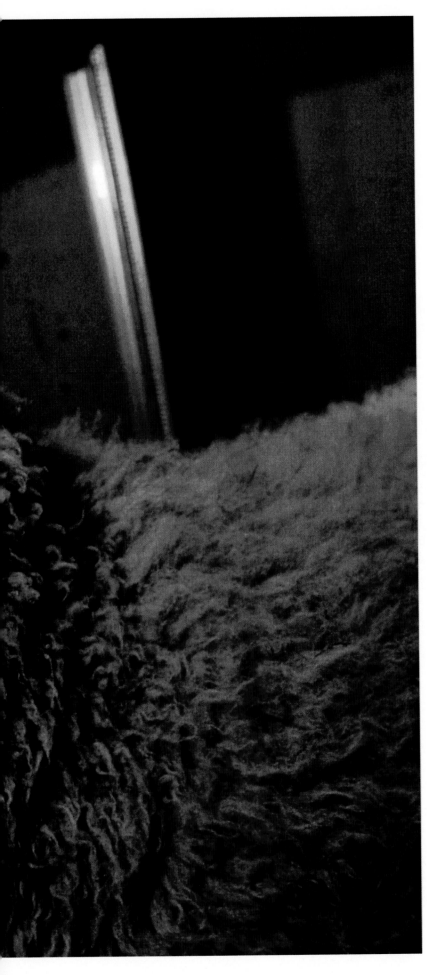

76

THE DOUBLE HELIX The outer edge of a vast, largely unmapped frontier looks a lot like a field in Scotland. The frontier is the human genome, and browsing in that field is a sheep who, for all she can tell, is like any other. The truth is she's exactly like another sheep—the one who provided the mammary cells from which she was cloned—and that's what makes Dolly different. She was created in a lab supported by a company that plans to manufacture animals able to secrete drugs in their milk. Is this what James Watson and Francis Crick had in mind?

In 1869, before even a rough topography existed, Swiss physician Friedrich Miescher confirmed the presence of deoxyribonucleic acid in the nucleus of every living cell. But scientists believed that protein, not DNA, controlled heredity until Martha Chase and Alfred Hershey proved otherwise in 1952, setting off a race to figure out how DNA functions. Crick and Watson, a physicist and a biologist who had never experimented with DNA, began building models of what they thought was the acid's molecular structure. On February 21, 1953, Watson, then 24, noticed the similar shapes of the two complementary pairs of basic molecules that make up DNA, requiring two helices to wrap around its core, a revelation that also suggested how DNA might replicate itself. (Rosalind Franklin, a British crystallographer, came to the same conclusion that month but didn't publish her work until later.) Knowing DNA's design would lead to the identification of specific genes and their functions—and to a new understanding of who we are. **PHOTOGRAPH BY STEPHEN FERRY**

MAPPING THE GENOME

Launched by the U.S. government in 1990, the Human Genome Project was hailed as the most ambitious exploration program since the space race—a 15-year, $3 billion effort to decipher the three billion chemical "letters" that form the alphabet of human DNA. In 1998 two bioengineering entrepreneurs stole the project's thunder, forming a company dedicated to finishing the job by 2001. Sooner or later, genome mappers are likely to find the causes of—and cures for—all inherited diseases. Will custom-designed humans be next?

75

1260 CHARTRES

Among the great cathedrals of Europe, none more purely set the tone for High Gothic architectural style than the cathedral at Chartres. And while its competitors—Amiens, Reims, Notre-Dame—take the breath away, none is more beautiful. Chartres was the quintessential expression of the idea of a cathedral during the 12th and 13th centuries, a time in Europe when faith and money came together to erect structures such as the world had never seen. There was more stone quarried in France between 1050 and 1350, it is said, than in all of ancient Egypt.

The very location of Chartres is holy, an early center for the cult of Mary and the site of at least four other churches. But this cathedral, dedicated in 1260, is a soaring feat of architecture in which church builders literally raised the roof: The vaults are 116 feet high. Chartres's stained glass windows are considered the most magnificent in Europe, and the play of sapphire light across the sacred spaces and towering walls of stone makes the cathedral preeminent among those places on earth where, as T.S. Eliot put it, "prayer has been valid." **PHOTOGRAPH BY SONIA HALLIDAY AND LAURA LUSHINGTON**

The labyrinth at Chartres was built over 12th century sacred wells visited by women before childbirth.

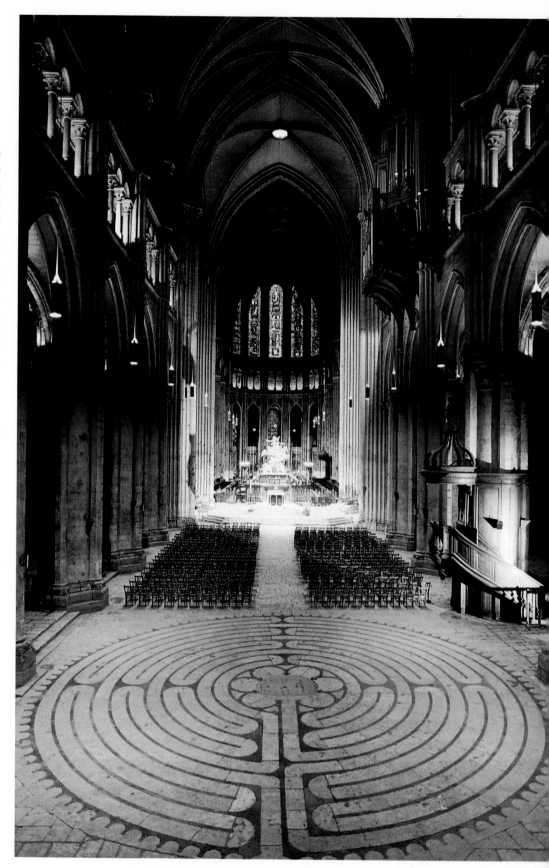

1819 EL LIBERTADOR Like many a wealthy kid before and after him, Venezuelan coffee scion Simón Bolívar took a trip to Europe. There, in 1799, inspired by Voltaire, Locke and Rousseau, the young idealist resolved to liberate his homeland from 300 years of Spanish rule. His dream? A "society of brother nations . . . powerful to resist the aggressions of the foreigner." Spurred by Napoléon's invasion of Spain in 1810, Bolívar—who would soon become known as the liberator of northern South America—embarked on a series of bloody campaigns. In 1819 he freed Colombia and over the next six years banished the Spaniards from Venezuela, Ecuador, Peru and Bolivia. Though his united *Gran Colombia* did not last—civil war erupted and Venezuela seceded in 1829—*El Libertador* left an indelible mark on the region and set a precedent (only sporadically followed) for modern Latin American democracies. **PHOTOGRAPH BY MARK ANTMAN**

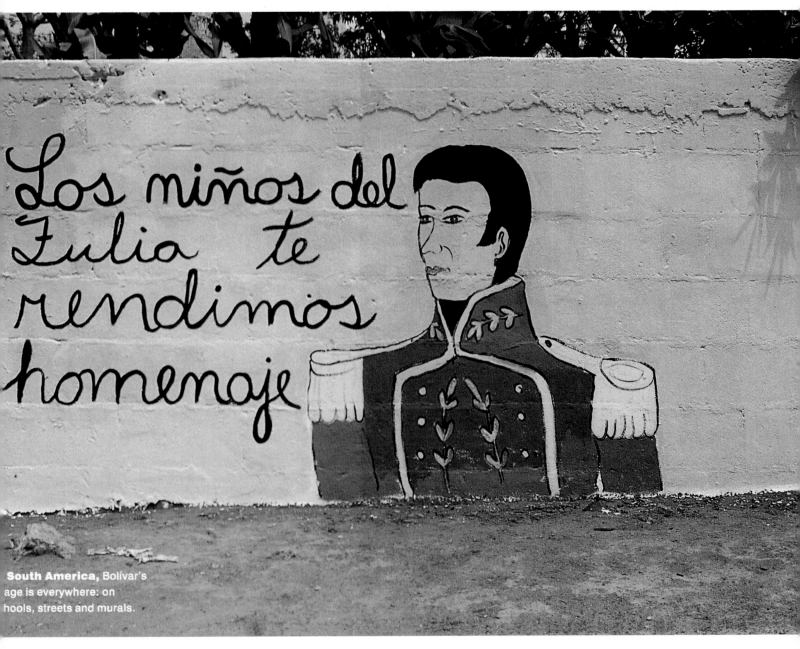

South America, Bolívar's image is everywhere: on schools, streets and murals.

73

c.1350 FASHION COMES FORWARD

Before the Middle Ages, attire was a matter of national costume, consisting of creatively draped, baglike garments. Fashion—which links clothing more closely to time than to place—was reinventing itself annually by 1350. "To be a good tailor yesterday is of no use today," lamented a craftsman in 1380. "Cut and fashions alter too quickly." The change was the result of several factors. One was the return of Crusading soldiers with a novel item: the button, which they had seen used by Turks and Mongols. Court tailors used buttons to fasten clothes tightly, accentuating the difference between men's and women's bodies. (Fashion's first scandal followed. One gown, wrote a naysayer, was "nothing other than the devil's snare.") For knights, plate armor imitating the musculature of the wearer replaced droopy chain mail. Another factor, the rise of mercantile capitalism, allowed a new moneyed class to dress like nobility. The rate at which styles became obsolete was a measure of royalty's desire to stay ahead of the bourgeoisie. But none of this explains the wild enthusiasm for early fads like severely pointed shoes, sleeves that grazed the floor or tunics that failed to cover a gentleman's private parts. Dressing moved from a form of group identification to one of self-expression; clothing wasn't simply functional or ritually significant—it was fun. Today people alter their appearances with Wonderbras and shoulder pads. Now Armani is our armor. **PHOTOGRAPH BY JOSEF ASTOR**

48

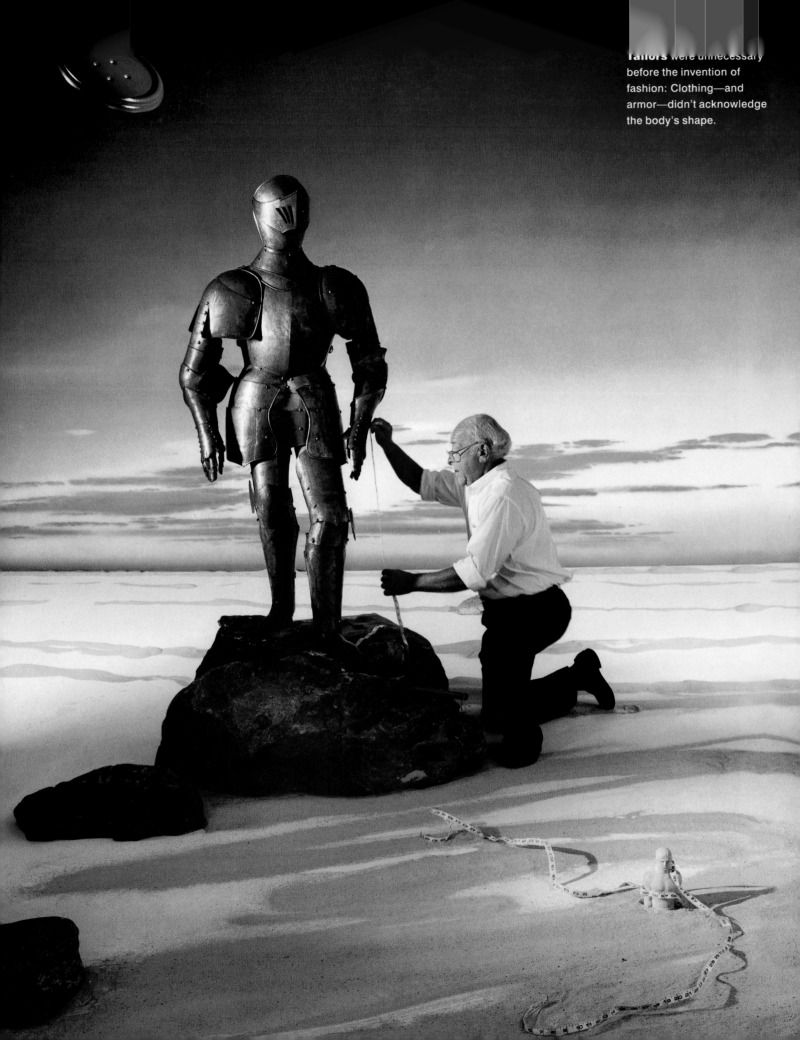

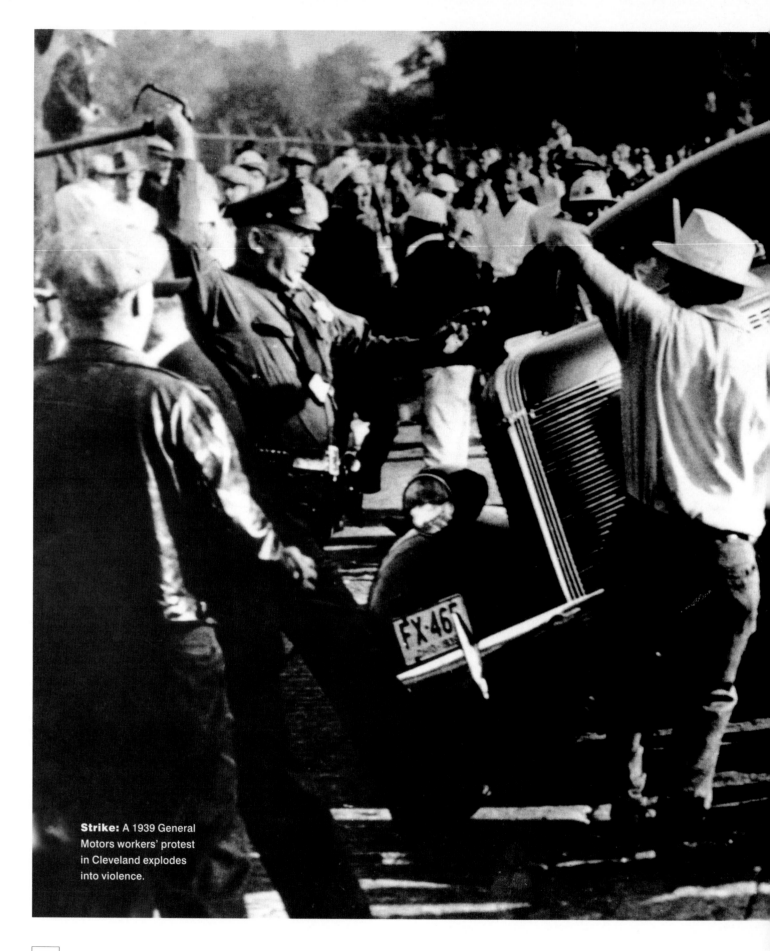

Strike: A 1939 General Motors workers' protest in Cleveland explodes into violence.

TIME LINE **LABOR** **1833** First significant child labor law/England **1850** First industrial safety legislation/England **1856** First e

72

1838 WORKERS' RIGHTS

Labor unions are almost as old as factories. One of the first, organized by craft workers, was the London Working Men's Association, which held its first national convention in August 1838. The rank and file passed a People's Charter promoting voting rights for unlanded workers. Though the British Parliament rejected the Charter, it eventually acted on some of its ideas, sparing England the violent class warfare that gripped Paris, Rome, Vienna and Berlin in 1848.

In time, the Chartists were weakened by arrests and internal power struggles, but not before they had influenced a generation of English workers. Children from Chartist homes later became important players in the U.S. labor movement, most notably cigarmaker Samuel Gompers, founder of the American Federation of Labor.

The changes unions have brought—the eight-hour workday, reforms in occupational safety, the minimum wage, child labor laws—have not come without pain, violence, even loss of life. But cries of "Solidarity forever!" can still be heard around the world. **PHOTOGRAPH FROM THE INTERPHOTO COLLECTION**

workday/Australia **1884** First workers' compensation law/Germany **1964** First national workplace discrimination legislation/U.S.

51

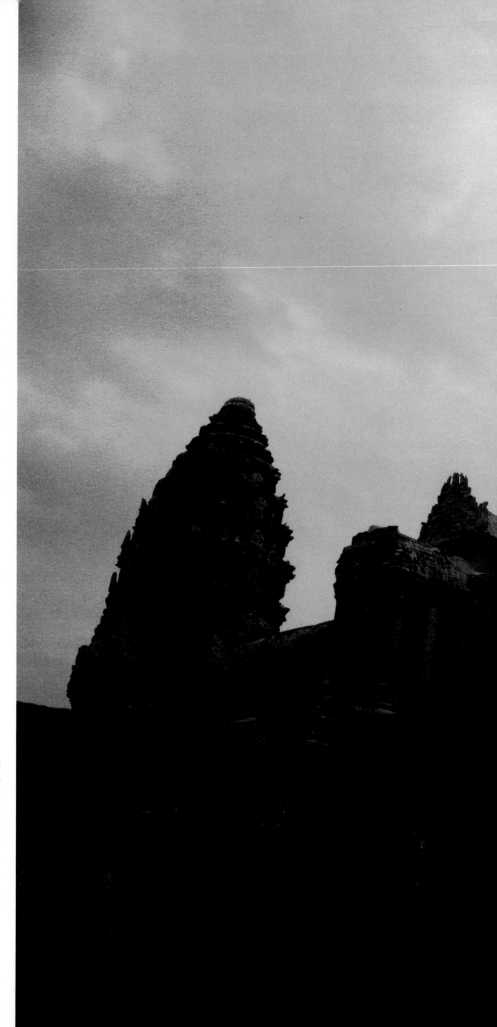

71

c.1150 ANGKOR WAT More than eight centuries ago a king named Suryavarman II tried to construct heaven on earth. He did not succeed. But the temple-mountain that his people built in what is now Cambodia is nothing short of miraculous. It would be an architectural feat even today to erect a seamless edifice with stones weighing as much as 8,000 pounds apiece. Angkor Wat, the largest religious monument in the world, completed around 1150, was built without the use of mortar; it is held together by weight and friction. The complex is a sculpture of roughly a square mile. Its sandstone relief carvings—of Hindu legends and Khmer battle scenes—are among the world's finest. Perhaps its artistic influence would have been greater had the Khmer empire, which once controlled much of Southeast Asia, not been weakened by its building frenzy and invaded by Thai forces in 1431. But Angkor Wat, now a Buddhist temple, still has as much power to transfix as a landing on Mars. **PHOTOGRAPH BY KENRO IZU**

A RUIN IN DISTRESS

For centuries, Cambodians kept the jungle from overrunning Angkor Wat. But in the 1970s the Khmer Rouge did what time could not. Among the million people killed by the regime were almost all of the temple's caretakers. Soon tree roots and fungi began engulfing the stones. In recent years, UNESCO has taken over preservation efforts, and workers are removing thousands of land mines around Angkor. Now a new threat looms: looters who sell the precious carvings on the black market.

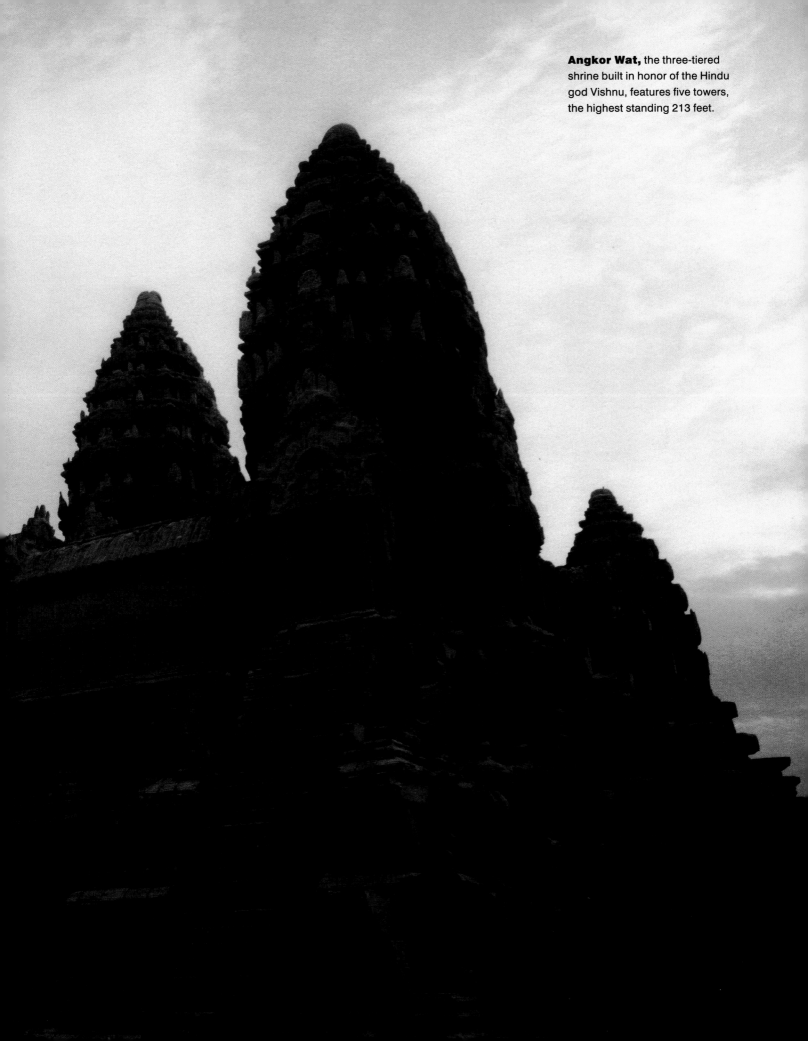

Angkor Wat, the three-tiered shrine built in honor of the Hindu god Vishnu, features five towers, the highest standing 213 feet.

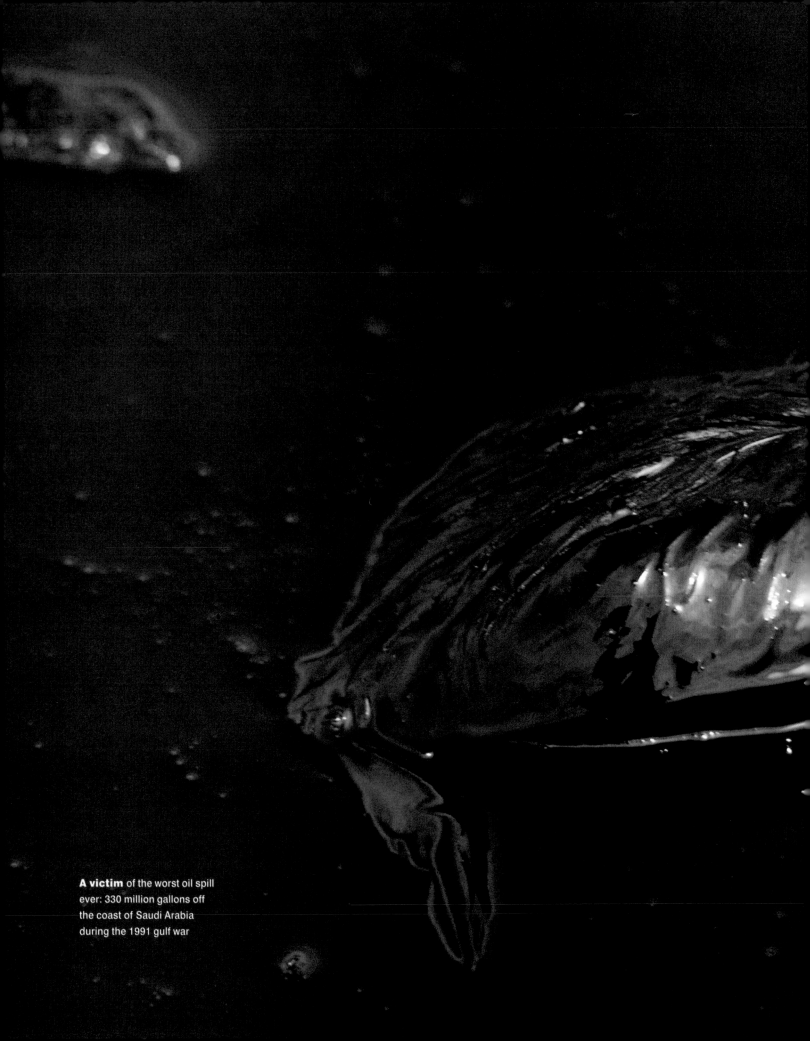

A victim of the worst oil spill
ever: 330 million gallons off
the coast of Saudi Arabia
during the 1991 gulf war

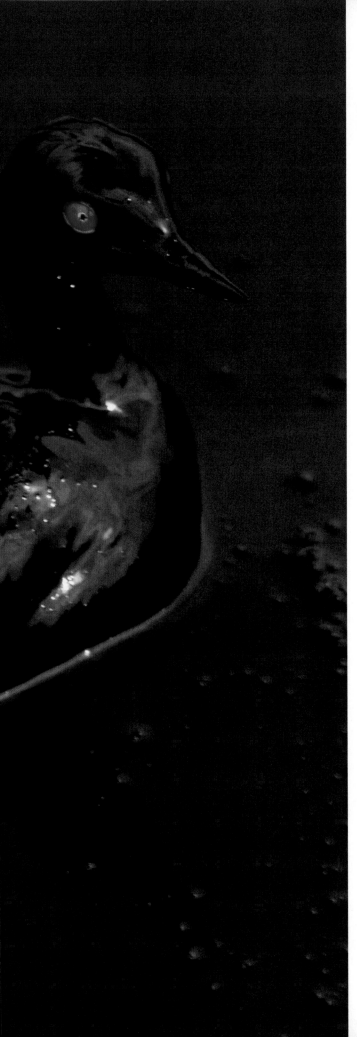

70

1962 SILENT SPRING Rachel Carson's 1962 best-seller, *Silent Spring*, which jump-started the modern environmental movement, almost didn't happen. The self-effacing marine biologist wanted someone else to write about the dangers of pesticides. No one would, so Carson began the four-year project that, according to Vice President Al Gore, "changed the course of history."

The success of DDT in the 1940s prompted an American love affair with the pesticide. But its application killed fish and birds and put humans at risk of illness. "Every human being," Carson warned, "is now subjected to contact with dangerous chemicals, from the moment of conception until death."

Her book, a passionate, meticulously researched argument for pesticide control, enlightened the public and toppled America's blind faith in science and industry. Change soon followed: 1970—the EPA, Earth Day, the Clean Air Act; 1972—the Clean Water Act, a ban on DDT; 1987—the first global environmental agreement to stop producing ozone-depleting chemicals. In 1992 the U.S. joined a U.N.-sponsored alliance to slow global warming. If not for Carson's descriptions of springs "without voices," we might still be ignoring the fact that "man, too, is part of this balance." **PHOTOGRAPH BY STEVE MCCURRY**

ENVIRONMENTAL DISASTERS

1953 Sixty-eight dead and hundreds crippled by eating mercury-tainted fish in Minamata, Japan
1957 Nuclear explosion in Chelyabinsk, Russia, exposes 270,000 people to high doses of radiation
1978 Toxic wastes, including dioxin, discovered in Love Canal neigborhood, near Niagara Falls, N.Y.
1984 Gas leak at Union Carbide plant in Bhopal, India, kills 10,000 in worst industrial accident ever
1986 Meltdown at Soviet nuclear power plant in Chernobyl releases radioactive materials
1989 *Exxon Valdez* runs aground off the coast of Alaska, spilling 11 million gallons of oil

69

1543 THE ANATOMY LESSON

As a boy, Andreas Vesalius dissected cadavers of stray dogs and cats he found on the streets of Brussels. Eventually, his passion for anatomy became a compulsion to dissect the human body in order to present exact descriptions of all its parts. At the University of Padua, where he taught surgery, he realized that many prevalent theories about anatomy—most handed down from the Greek physician Galen—were wrong. As he sliced muscle from bone, Vesalius learned that the jaw is one bone, not two; that the thigh bone is not curved like a canine's; that men and women possess the same number of ribs. The 29-year-old doctor, in collaboration with artist Jan Calcar, created an astonishingly detailed seven-volume work called *On the Structure of the Human Body*, published in 1543. It marked the beginning of the modern science of anatomy. But it also created a furor. Vesalius' views were attacked by the Catholic Church, his colleagues and society at large. Stung by the criticism, he burned his notes. He went to work as court physician to Emperor Charles V and didn't perform any dissections for 20 years. After he resumed cutting bodies open—including, as one legend has it, that of a nobleman whose heart was still beating—the emperor sent him on a pilgrimage to the Holy Land. Shipwrecked, Vesalius starved to death on the island of Zante. **PHOTOGRAPH FROM THE SCALA COLLECTION**

A VIRTUAL CADAVER

If Vesalius were alive today, he could satisfy his curiosity without bloodying a scalpel. Instead, he could use a cutting-edge cybertool: the National Library of Medicine's Visible Human Project. Since 1994, surgeons, animators and crash-helmet designers have been able to download cross sections of a virtual cadaver—an executed murderer from Texas who was frozen to –94°F, then cut into wafer-thin slices, each of which was photographed and stored electronically, filling 23 CD-ROMs.

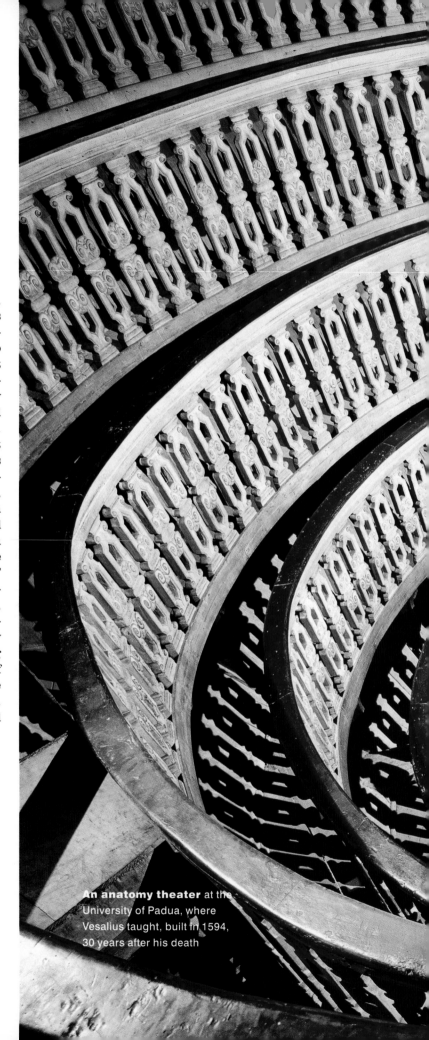

An anatomy theater at the University of Padua, where Vesalius taught, built in 1594, 30 years after his death

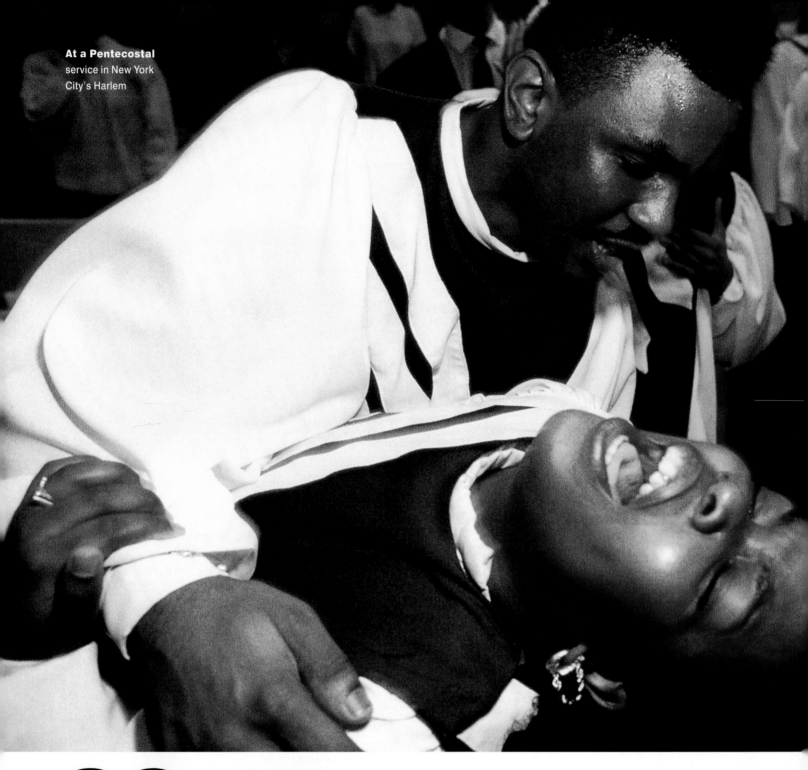

68

1906 PENTECOSTALISM

The flame of Pentecostalism was first lit when Charles Fox Parham declared in 1901 that speaking in tongues was a sign of baptism in the Holy Spirit. It might have sputtered if not for William Joseph Seymour, a black preacher who listened through an open door to Parham at his Houston Bible school. Soon Seymour set out for Los Angeles, where his own baptism in the Spirit in 1906 brought him an enthusiastic following. He founded a mission in an abandoned church on Azusa Street, and within two years his multicultural ministry had sent missionaries to 25 countries.

Pentecostalism is a religion of the heart. Since a personal experience of God is as important as doctrine, it is an adaptable faith; by the end of the 196[] Protestants and Catholics had both begun [] embrace the gifts of the Spirit in Charismatic rene[]al movements. Worship services may feature spea[]ing in tongues, shouting and swaying, and spirit[] healing. Today about half a billion people call the[]selves Pentecostal or Charismatic, and Pentecost[] alone outnumber Anglicans, Baptists, Lutherans a[] Presbyterians combined. The Yoido Full Gos[] Church in Seoul, South Korea, is now, at 700,0[] strong, the largest Christian congregation on ear[]

PHOTOGRAPH BY ARLENE GOTTFRIED

67

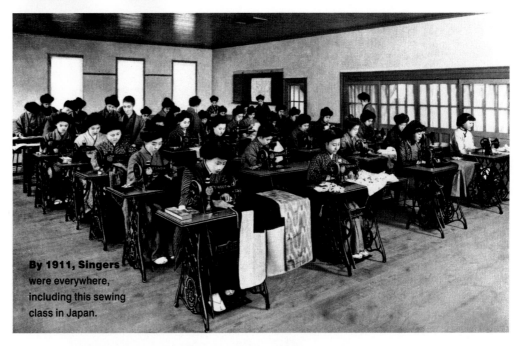

By 1911, Singers were everywhere, including this sewing class in Japan.

1851 A STITCH IN HALF THE TIME

The sewing machine suited up the armies of the U.S. Civil War in record time and stitched the wings for the Wright brothers' plane. But in 1830, when French tailor Barthélemy Thimonnier patented the first one, few of his colleagues foresaw any benefit. Rather, they feared they would be rendered obsolete: This new device made 200 stitches per minute, while a man made only 30. In 1841 they ransacked Thimonnier's Paris shop. The credit for automating the garment industry would instead go to the son of a German immigrant to America, Isaac Merritt Singer, who in 1851 improved on an earlier design by Elias Howe. Then, in 1856, Singer made sewing machines affordable by offering the first layaway plan. For five bucks down, one could take home a $125 machine and pay off the rest in monthly installments with interest.

The "iron seamstress" also led to ready-made clothing: A woman could walk down Fifth Avenue in Manhattan and—horrors!—run into someone wearing an identical garment. But even as ready-to-wear liberated those with spending power, it enslaved immigrant women and children in sweatshops. Despite the formation in 1900 of the International Ladies' Garment Workers' Union, clothing today is available thanks not only to Singer but to people around the world operating his machines for little pay. **PHOTOGRAPH FROM THE CORBIS-BETTMANN COLLECTION**

SEW WHAT?

1,433,954,000 women's blouses were manufactured for sale in the U.S. in 1996.

AJOR DENOMINATIONS

,830,000: Assemblies of God
500,000: Church of God
00,000: United Pentecostal
urch International
22,000: International Church
he Foursquare Gospel
500,000: Pentecostal
semblies of the World

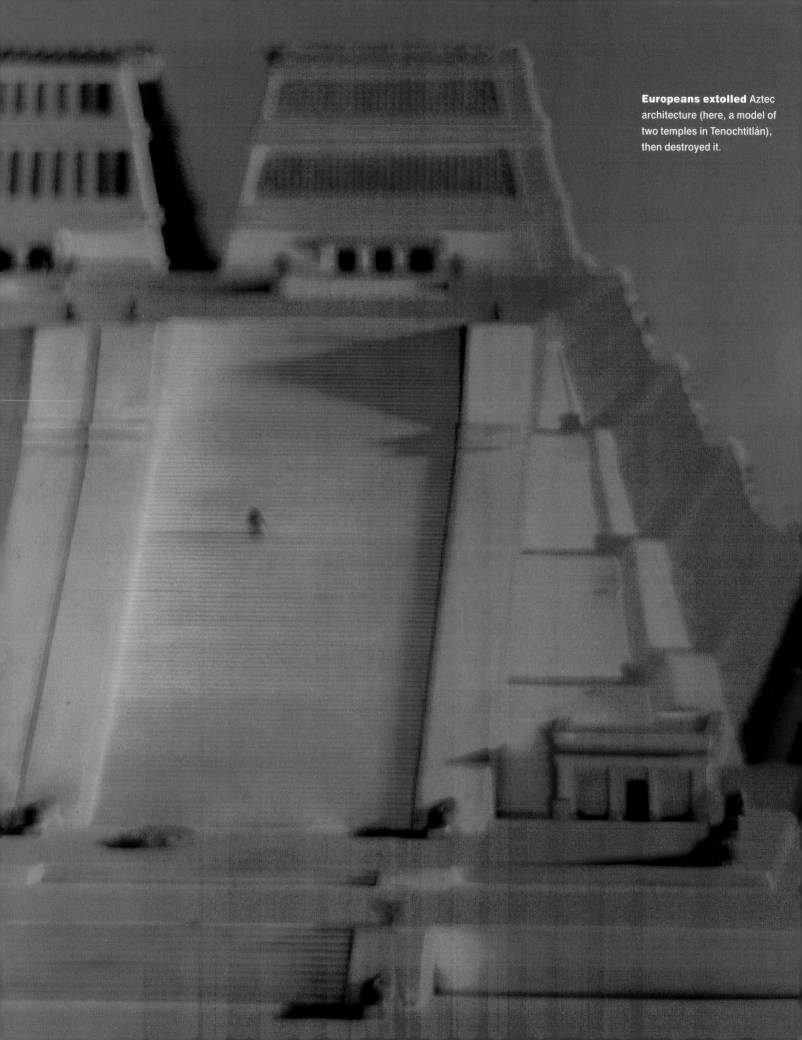

Europeans extolled Aztec architecture (here, a model of two temples in Tenochtitlán), then destroyed it.

325 THE SPLENDOR OF TENOCHTITLÁN The most sophisticated ty in the pre-Conquest Western Hemisphere was founded in 325 by a warlike people who had nowhere left to go. The Aztecs ad wandered for generations, skirmishing with neighbors, ntil they found themselves marooned on a marshy island in Iexico's Lake Texcoco. Within little more than a century, enochtitlán, population 250,000, rivaled any capital of its time. uilt without the help of beasts of burden or the wheel, it boastd palaces, pyramids, grand plazas and a superb network of anals, dikes and bridges. While Europe's city streets were teandering cow paths, Tenochtitlán's were a rational grid nd—because of efficient drainage, garbage barges and an army f sweepers—far cleaner than their counterparts. When the conuistadores arrived in 1519, they were astounded, as Hernán ortés wrote, by "the strange and marvelous things of this great ty." But the Spaniards regarded the Aztecs, whose religion ivolved human sacrifice, as heathens. After slaughtering ost of Tenochtitlán's inhabitants, pillaging its riches and razig its buildings, they erected their own capital on the ruins. oday it is called Mexico City—the second-largest metropolis in le world. **PHOTOGRAPH BY BARBARA KASTEN**

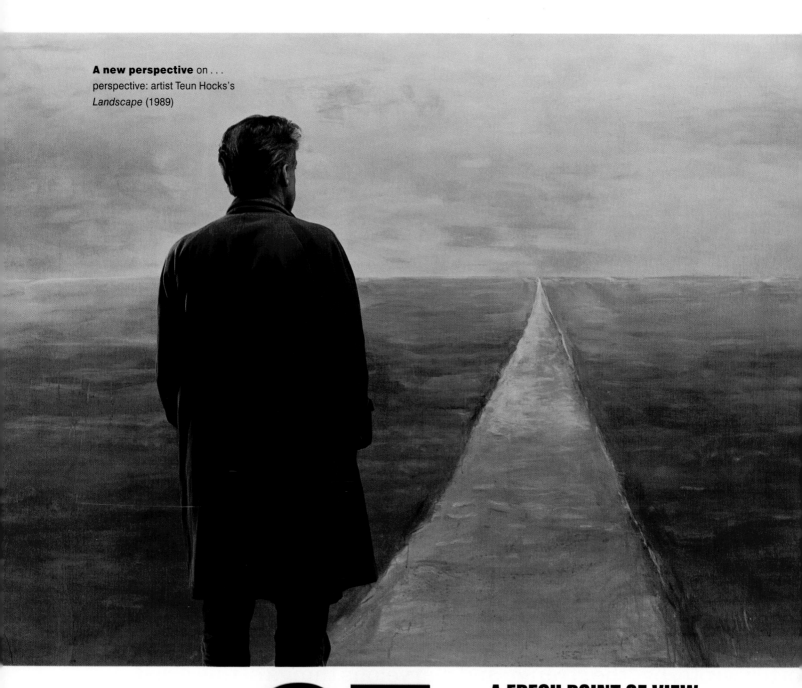

65

1413 A FRESH POINT OF VIEW

All he did was inv
infinity. Or at least the illusion of infinity that can exist i
painting. Before Filippo Brunelleschi's 1413 painting of
Baptistery in Florence, artists placed their subjects in a worl
theoretical space on the surface of a wall or a canvas. Buildi
and figures and trees and saints danced laterally on a flat pla
free of the laws of physics and optics. But by harnessing
powers of observation to a precise set of mathematical calc
tions, the Florentine architect-sculptor-engineer codified
way objects appear smaller as they recede in space.

Brunelleschi's ideas transformed the contrivance of a pa

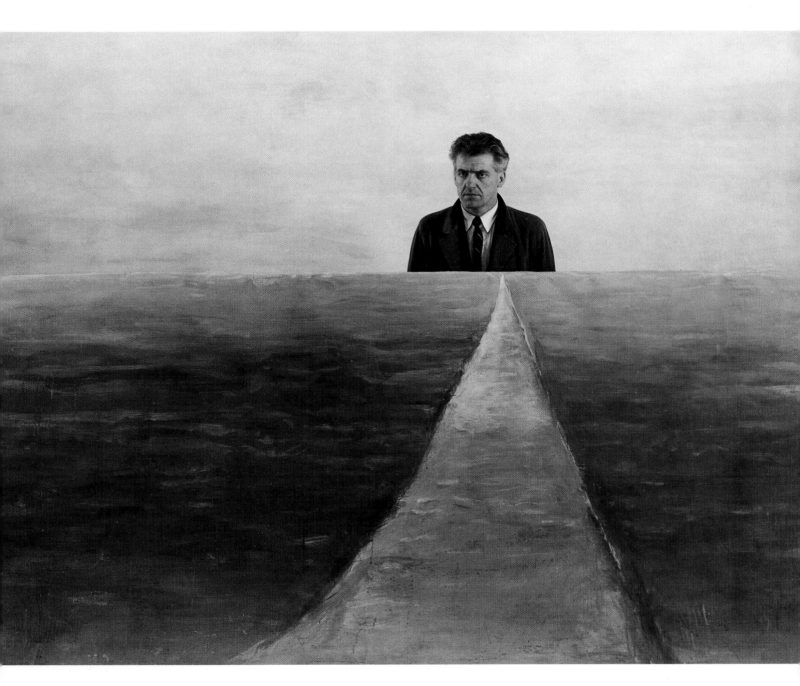

into a window onto the wondrous world of the Renaissance.
the same time, his work focused attention on the religious
intellectual issues of the time.

The notion that all reality converges at some focused end
t in space may be as much an expression of the belief in
omnipotent Creator as it is an exercise in optical mathemat-
The rules of perspective also made the viewer of the scene—
his case, Renaissance man—a participant in the process of
ception. The eye of the beholder became the center of the
ble world for people just discovering their power to experi-
e it. **PHOTOGRAPHS BY TEUN HOCKS**

THE RENAISSANCE

Discovering new ways of seeing was what the Renaissance
was all about—and not only in art. As scholars revived
the classics of Greece and Rome, those texts inspired
scientists and theologians, merchants and explorers, to try
to equal, even outdo, the accomplishments of antiquity.
Some, like da Vinci, strove to do so in several fields at once.
The Renaissance was an age of individualism, pitting
independent thinkers against entrenched dogma. Its
revolutionary creed was humanism, which stresses the
importance of secular learning over religious studies. Its
daring spirit persists to this day, as do its innovations—from
the telescope to double-entry bookkeeping.

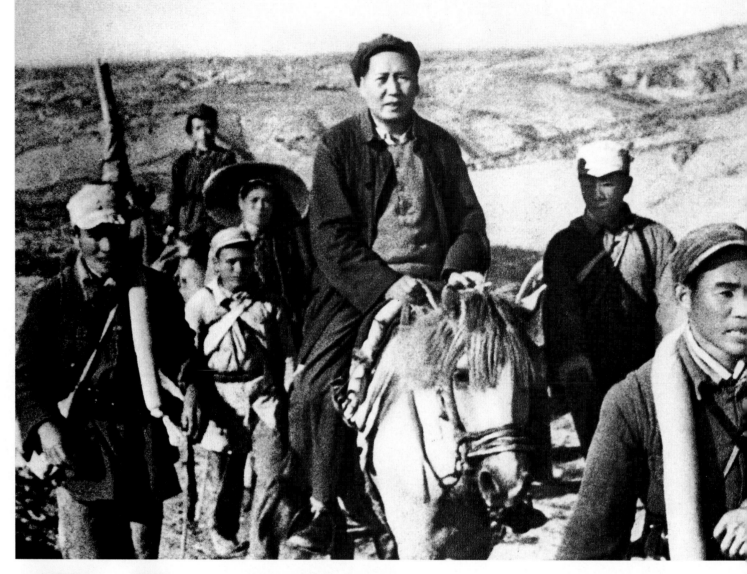

"**Peasants and soldiers** don't like big shots oppressing them": Mao Zedong, on horseback, during the Long March

64

1934 THE LONG MARCH

Fleeing the Kuomintang's forces in southern China in 1934, a young communist leader named Mao Zedong took 100,000 soldiers and headed north. For 12 months they marched across 18 mountain ranges and 24 rivers, turning a 6,000-mile trek into the longest political workshop on record. In remote villages they drew lessons in the dirt with twigs, exhorting peasants to organize against landlords. When he got to Shaanxi province, Mao had only 8,000 soldiers left, but the march was a badge of honor for its survivors. They helped lead Mao to victory in 1949, when the People's Republic of China brought one fifth of humankind under communism. The triumph of peasants over centuries of imperial rule touched millions around the globe. **PHOTOGRAPH FROM THE SOVFOTO/EASTFOTO COLLECTION**

A GREAT LEAP BACKWARD?

Mao's victory may have liberated the masses from what he called feudalism, but it led to new horrors. During the Great Leap Forward (1958–1960), a bungled attempt to boost farm and steel production, an estimated 20 million Chinese starved to death. During the Cultural Revolution (1966–1976), another 400,000 perished and millions more were persecuted. Mao's death in 1976 brought economic liberalization, but political freedom still was not forthcoming—a fact driven home 1989 when troops crushed a pro-democracy rally in Tiananmen Square, massacring hundreds of unarmed students.

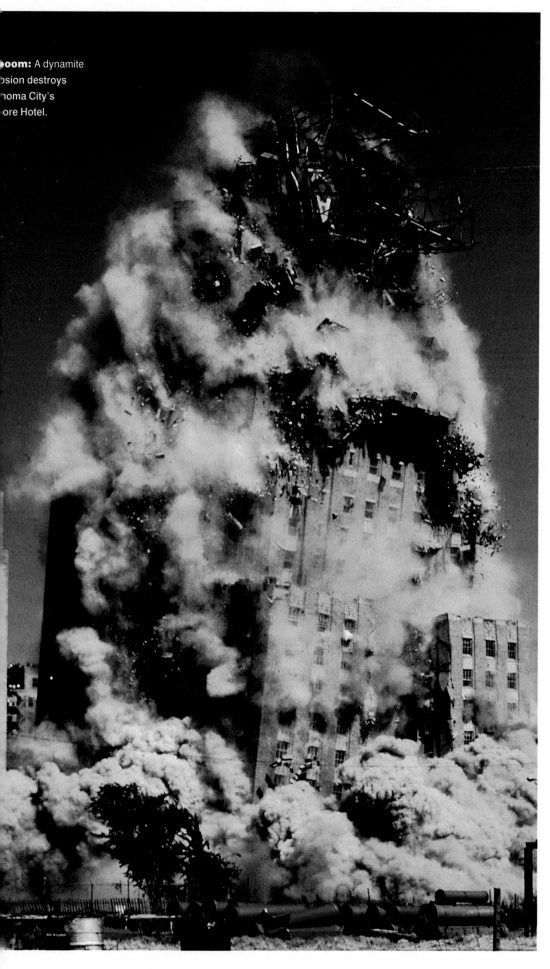

Boom: A dynamite [explo]sion destroys [Oklah]oma City's [Bilt]more Hotel.

63

1867 DYNAMITE! It might have taken centuries to dig the 92 miles of tunnels feeding water to Los Angeles had Alfred Nobel not invented dynamite in 1867. Instead, it took just seven years. With dynamite, dams, railways and roads were built; the Panama Canal was dug; and the earth was cracked open to yield mineral riches. Nobel's invention—mixing nitroglycerin, an explosive liquid, with an absorbent sand and molding it into sticks—made it possible to ship the explosive safely to battlefronts and building sites everywhere. Suddenly man could remap his environment, then obliterate his handiwork. The ironies were not lost on Nobel, whose brother died in an accidental blast at their factory in Sweden. Called by some "the merchant of death," Nobel left his fortune to establish the prizes that bear his name. Too late for comfort, though: He died sad and alone, taking nitroglycerin for an ailing heart. **PHOTOGRAPH FROM THE CDI COLLECTION**

BLASTING FACTS

Pounds of dynamite used to build the Hoover Dam: 3,500,000

Number of blasting caps used to sculpt George Washington's head on Mount Rushmore: 40,000

62

1854 BESSEMER'S BLAST

Civilizations can be traced through steel—those who made it won the wars. The Arabs had their Damascus swords, tempered in blacksmiths' forges. The Swedes had been making small amounts of steel since the 13th century by melting iron ore in crucibles. But it was not until 1854, when English inventor Henry Bessemer set out to build a better cannon for French Emperor Napoléon III, that anyone figured out how to produce steel strong enough to withstand an explosion or hold up a bridge. The problem was impurities. Bessemer's method used a blast of oxygen to burn off excess carbon in molten iron ore, and from that moment the Steel Age was in gear. (American William Kelly made the same discovery at roughly the same time but didn't hurry fast enough to the patent office.) Soon steel framed tall buildings and stenciled skylines. It supported bridges over rivers, laid railroad tracks around the world and put America on wheels. By 1900, American mills were rolling out 8.5 million tons of steel a year. Space-age alloys have tarnished steel's luster, and some cars are now mostly plastic, but the demand for steel remains enormous. **PHOTOGRAPH BY FRITZ GORO**

TOWERS OF STEEL

A lofty building can be erected without a steel frame, but its weight-bearing walls would be prohibitively thick. The first true skyscraper—10 stories high, with a part-steel skeleton—was Chicago's Home Insurance Building, completed in 1885. By 1920, when urban dwellers in the U.S. began to outnumber country folk, American cities had dozens of such structures. Instead of sprawling outward, a metropolis could now spurt upward. Skyscrapers eventually colonized the globe. Today's tallest: the 1,483-foot Petronas Towers in Kuala Lumpur, Malaysia.

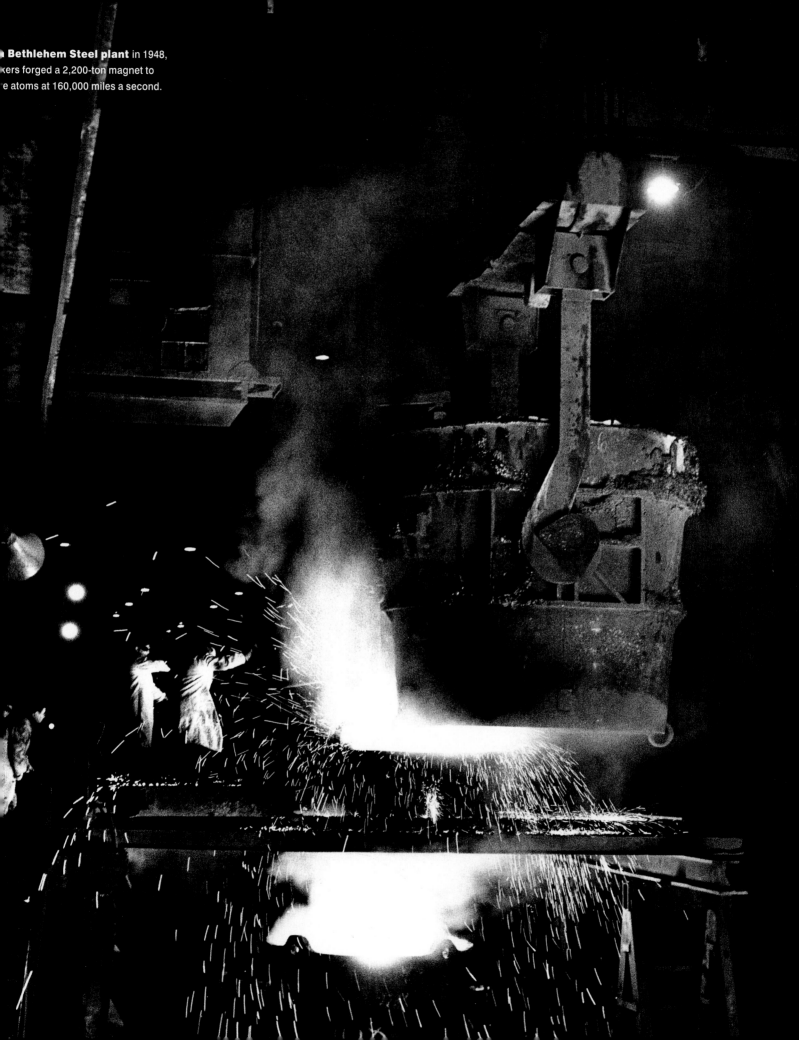

Bethlehem Steel plant in 1948, [wor]kers forged a 2,200-ton magnet to [accelerat]e atoms at 160,000 miles a second.

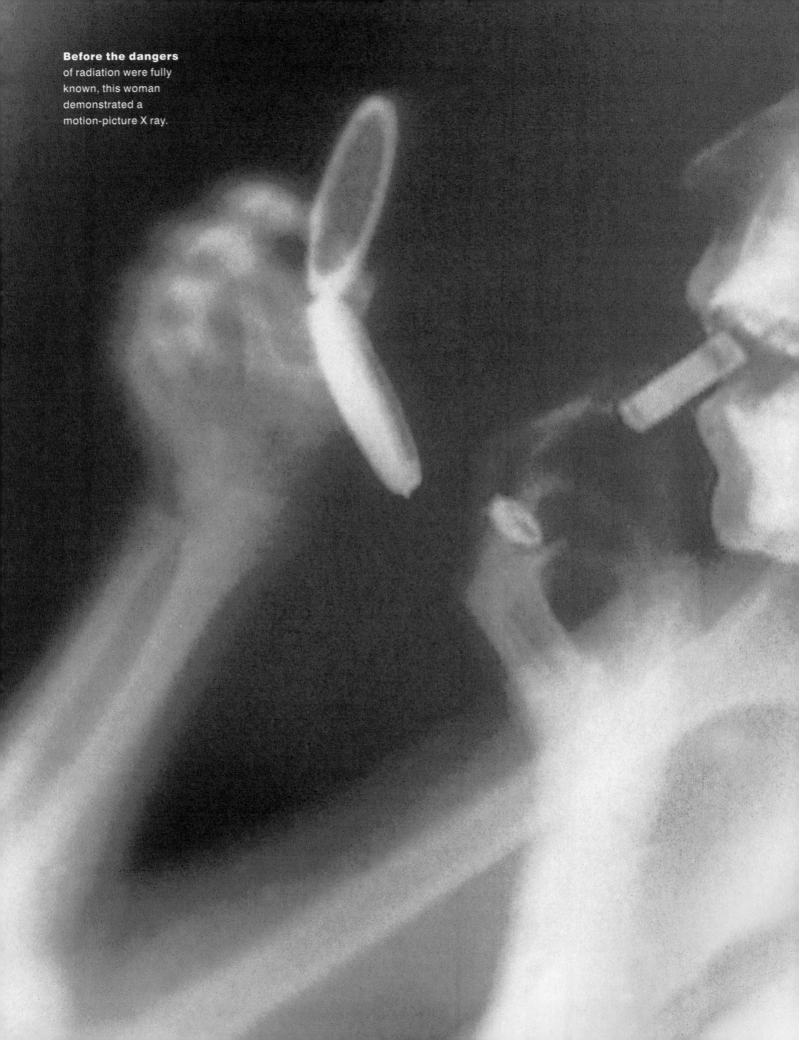

Before the dangers of radiation were fully known, this woman demonstrated a motion-picture X ray.

61

1895 **SHADOWS INSIDE US** As with so many scientific breakthroughs, the discovery of X rays happened by accident. A German physicist named Wilhelm Röntgen was investigating the properties of electricity when, on November 8, 1895, he learned more than he bargained for. He placed a vacuum tube with a wire attached to either end inside a black box, switched off the lights in his lab and turned on the electrical current. A mysterious fluorescence began emanating—not from the tube in the box but from a cardboard screen nearby that had been treated with barium. Röntgen could see that the screen was glowing in response to something coming from the tube. It was not cathode rays or any other emission he was familiar with. Experimenting further, he discovered that these rays of unknown origin— "X rays," he called them—could penetrate thick books and blocks of wood. Holding up his hand before a screen, he became the first person to see the shadow of bones.

Röntgen's announcement of his discovery caused an immediate sensation. Magazines published poems about X rays. Stores in Victorian London advertised X-ray-proof clothing. Soon physicians were using the new technology to look at broken bones and bullets in wounded soldiers. Eventually, improved equipment lessened side effects, such as burns and hair loss. By the 1970s, xeroradiography reduced exposure time and cancer risk. Along with related technologies, from CAT scans to MRIs, X rays have opened a window into the body. **PHOTOGRAPH FROM THE UNIVERSITY OF ROCHESTER MEDICAL CENTER**

LOOKING DEEPER

Ordinary X-ray cameras are better at seeing solid bones than squishy organs. Devices that provide detailed images of soft tissue—crucial for diagnosing many illnesses—didn't appear until the 1970s. In a CAT (computerized axial tomography) scan, a computer synthesizes a single cross section from a series of sweeps by X-ray beams. Magnetic resonance imaging uses radio waves to do the same thing, eliminating the health dangers of X-ray exposure. Multiple CAT scans or MRIs can now be stacked into a hologram—a portrait of a patient's innards in three dimensions.

Every day Americans flush an average of 18.3 gallons of water down their toilets.

60

1596 A ROYAL FLUSH

We're not eager to talk about toilets—our euphemisms are many, including throne, thunder box, privy and head—but as the title of one surprisingly popular children's book puts, *Everyone Poops*. Which is why it's not at all surprising that rudimentary toilets date back to 2000 B.C., in the Minoan palace at Knossos on Crete. But until 1596, when British nobleman John Harington invented the first practical "water closet"—a wooden seat with a cistern and a valve for flushing—waste disposal hadn't begun to move into the modern age. Before the WC, the most common place to go was the nearest tree, hole or river. (In outhouses, still in use among 10 percent of the population in America, at least one gets a seat.) Indoors, the top choice was the chamber pot, which city folk emptied out their windows onto the street. The French warning that accompanied the dumping—*"Gare l'eau!"* ("Watch out for the water!")—may have inspired another favorite euphemism, "the loo." Though Harington's water closet was installed in Richmond Palace, inadequate sewage systems prevented its widespread use, and 265 years passed before British plumber Thomas Crapper made his name marketing an advanced water-saving flush system. By the 1920s the toilet had become a standard fixture in most newly built homes—though in developing nations, a staggering 2.9 billion people still don't have access to one. **PHOTOGRAPH BY NEIL WINOKUR**

59

1609 THE FIRST NEWSPAPER

Among the items appearing in Issue 47 of *Relation,* the first regularly printed newspaper in history, was this understated news flash: "Signor Gallileo [sic] . . . found a rule and visual measure, by which one can . . . look at places 30 miles away, as if they were close by." That year's papers would also include reports of a ne'er-do-well lieutenant general and two men prohibited from playing ninepins, demonstrating the mix of groundbreaking and trivial that still defines a newspaper. The weekly four-page *Relation,* first published in Strassburg, Germany, in 1609, wasn't much to look at—no headlines, no ads, no catchy graphics. It attracted a readership consisting mostly of the wealthy, powerful and well educated. The first print daily was published in Leipzig in the mid-17th century, but it wasn't until the debut of the "penny press" in the U.S. in 1833 that news was transported to the general public. Then, as now, the free press filled an important role: campaigning for reform, focusing public attention on political and social problems, and stirring up trouble when trouble was needed. **PHOTOGRAPH FROM THE GRANGER COLLECTION**

THE FOURTH ESTATE

Thomas Jefferson: "Were it left to me to decide whether we should have a government without newspapers, or newspapers without a government, I should not hesitate a moment to prefer the latter."

Charles Dickens: "They are so filthy and bestial that no honest man would admit one into his house for a water-closet doormat."

Thomas Macaulay: "The gallery in which the reporters sit has become a fourth estate of the realm."

Napoléon Bonaparte: "Four hostile newspapers are more to be feared than a thousand bayonets."

Oscar Wilde: "In America the President reigns for four years, and Journalism governs for ever and ever."

Dwight D. Eisenhower: "I, like every soldier in America, will die for the freedom of the press, even for the freedom of newspapers that call me everything that is a good deal less than being a gentleman."

72

TIME LINE NEWSPAPERS **1650** First daily newspaper/Leipzig **1690** First American newspaper/Boston **1791** Bill of Rights guar

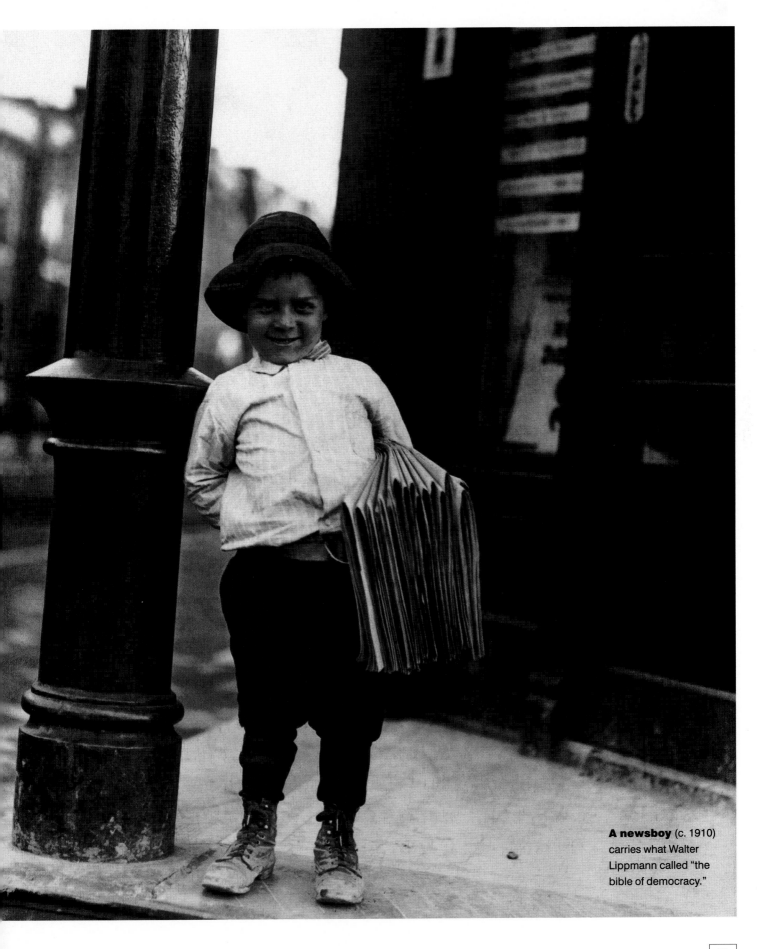

A newsboy (c. 1910) carries what Walter Lippmann called "the bible of democracy."

om of the press/U.S. **1848** First wire service/U.S. **1873** First newspaper photograph/U.S. **1914** First offset printing/U.S.

73

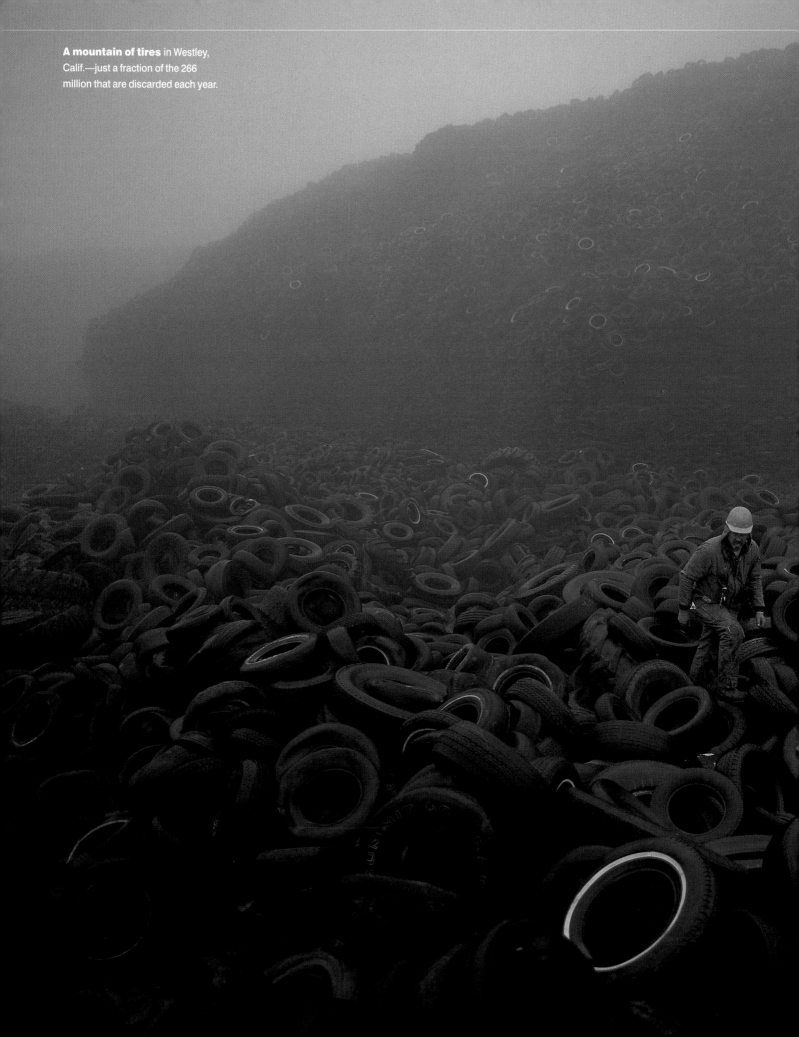

A mountain of tires in Westley, Calif.—just a fraction of the 266 million that are discarded each year.

58

1839 RUBBER BARON

"Who can examine it," asked Charles Goodyear of rubber, his lifelong obsession, "without glorifying God?" Whether or not we share the 19th century inventor's fanaticism, the object of his passion—the basis for some 40,000 products, including electrical casings, tennis balls, condoms, erasers and, most of all, tires—is indispensable to our modern lives. Made from latex, a gum first found in South American trees, the substance had been around at least since Columbus watched natives bounce rubber balls in Hispaniola. But by the early 1800s, when a small industry developed, manufacturing mostly boots and life preservers, it became clear the stuff did not hold up: In winter it would harden like rock and in summer ooze into a sticky mess.

A Connecticut native not known for his financial prowess, Goodyear was determined to make rubber commercially viable. While in debtors' prison, he began combining raw rubber with everything from witch hazel to cream cheese. In 1839 he accidentally spilled a drop of rubber mixed with sulfur on his hot stove. He had discovered the process of vulcanization, named for the Roman god of fire, and set the stage for the business boom spurred by the advent of cars. But Goodyear failed to secure the rights to his discovery. When he died, $200,000 in debt, he left behind scores of suggestions for rubber's applications—the inflatable tire, alas, not one of them. **PHOTOGRAPH BY JOSÉ AZEL**

TIME TO RE-TIRE?

1,921,856,000: Number of automobile tires produced in the U.S. for domestic use and export, 1988–1997

57

1914 A WOMAN'S CHOICE

Birth control was a taboo subject in the early 20th century, but that didn't stop Margaret Sanger. As a nurse and as the sixth of 11 children, she had seen the strains childbearing put on women, particularly the poor. So in March 1914 she defiantly published *The Woman Rebel,* an exhortation for women to challenge the pro-conception climate. Facing an obscenity charge (later dropped) for her audacious act, Sanger fled to Europe. Upon her return in 1916, she was more determined than ever to spread the gospel of voluntary motherhood. Her first effort, a Brooklyn-based birth control clinic, was raided by the police after only nine days. Undeterred, she founded the Birth Control Clinical Research Bureau in 1923, the first doctor-staffed birth control clinic in the United States, where diaphragms and advice were dispensed. By the time of her death in 1966, the birth control pill—one of whose developers, Dr. Gregory Pincus, dedicated his research to Sanger's "pioneering resoluteness"—had become an accepted (and openly discussed) method of contraception. **PHOTOGRAPH FROM THE SOPHIA SMITH COLLECTION**

FREEDOM IN A PILL

When the U.S. Food and Drug Administration approved the birth control pill in 1960, women gained unprecedented control of their biological destinies. Cheap, convenient and reliable, the pill—a blend of progesterone and estrogen hormones—uncoupled the pleasure of intimacy from the fear of pregnancy, giving new life to the feminist movement and sparking a sexual revolution. Today, despite the threat of AIDS, users of oral contraception (100 million worldwide) outnumber condom users two to one.

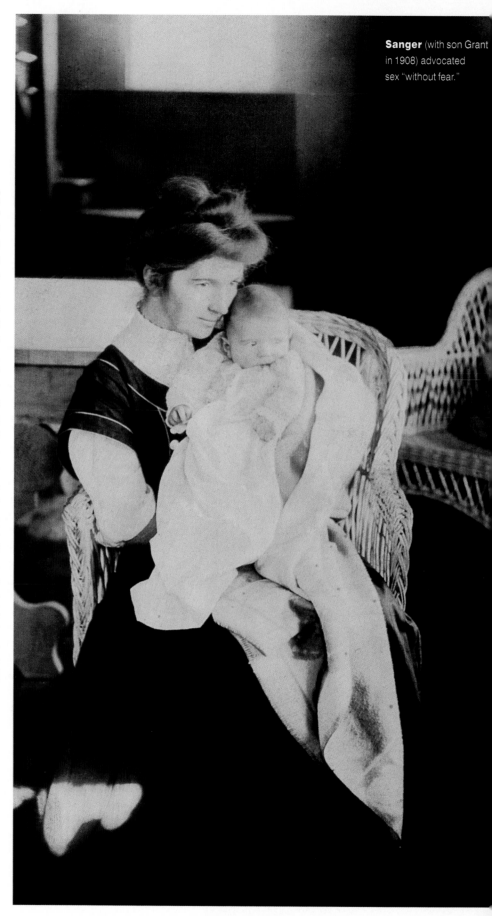

Sanger (with son Grant in 1908) advocated sex "without fear."

Chinese food—the first restaurant cuisine—can be found in many of the 350,000 places to dine out in the U.S.

FAST FOOD

After eight centuries of relative pokiness, the restaurant trade went supersonic in 1948, when brothers Dick and Mac McDonald retooled their San Bernardino, Calif., drive-in for assembly-line production. Boasting under-a-minute service and an air of standardized wholesomeness, the newfangled burger joint was so successful that it gave rise to a new way of eating. Bought in 1961 by former milkshake-mixer salesman Ray Kroc, McDonald's has become the planet's biggest franchise operation, with 25,000 branches in 111 countries. From Casablanca to Beijing, Paris to Moscow (where the largest outlet seats 900), the Golden Arches symbolize the ascendancy of global capitalism—and American grub.

1120 THE FIRST RESTAURANT Long ago, inns sold food and drink to travelers far from their home kitchens. Cookshops offered take-out food, and banquets were showy affairs for special occasions. But nowhere before 1120 is there evidence of what we think of as restaurants, places to purchase a sit-down meal primarily for social and gustatory pleasure. The journal of 12th century Chinese bureaucrat Meng Yuanlao—arguably the first restaurant reviewer—offers a meticulous account of an emerging restaurant culture in Kaifeng, the capital during the Northern Song dynasty (960–1126). The city of one million had plenty of adventurous eaters. Laborers slurped noodles in humble shops, shopkeepers frequented dumpling houses, and according to Meng's journal, begun around 1120, night markets served fried liver, goose pears and tripe with blood pasta to people on the late shift. In Small Sweetwater Alley many establishments specialized in southern Chinese foods, one of the first regional cuisines. The people of Kaifeng also demanded attentive service. "Even the slightest mistake," noted Meng, "was reported to the head of the restaurant, who would curse the waiter or dock his salary or, in extreme cases, drive him from the place." **PHOTOGRAPH BY PETE MCARTHUR**

56

77

Modern kids (here, at a 1986 picnic) can thank Comenius, who instructed parents "never to allow their children to be without delights."

55

1633 CHILDHOOD FOUND

"You know more than you think you do." With these eight words, Benjamin Spock opened his *Baby and Child Care*—and turned attitudes toward parenting upside down. But Spock has to take a backseat to Moravian bishop Johan Amos Comenius, who lived 300 years earlier. When he advised in *The School of Infancy* that babies should have their spirits stirred "by kisses and embraces," Comenius was moving into new territory (at least for Europe), a place where affectionate behavior was seen as important to a child's well-being. And when he wrote that kids need to play to learn, he was giving voice to the unimaginable.

Picture the Europe of 1633. The Thirty Years' War was devastating villages; food was scarce; Protestants like Comenius were running for their lives. It was a difficult world, and children worked hard and died young. But Comenius was a utopian who believed the pathway to an earthly Eden was education. If children were not loved, not educated early and well, their souls could be lost.

After Comenius's death much of his work was forgotten. Then, a hundred years later, Jean-Jacques Rousseau advised parents to let children savor nature. Soon Swiss reformer Johann Heinrich Pestalozzi was running the first infants' school. By 1837, Friedrich Froebel had opened a kindergarten in Germany. Attitudes toward childrearing swing through history like a drunken pendulum, but these days we hope children are treated as children.

PHOTOGRAPH BY SYLVIA PLACHY

54

1535 TOBACCO CATCHES FIRE When French explorer Jacques Cartie[r] first partook of the mysterious weed he had observed the Iro quoians smoking along the St. Lawrence River, he could not hav anticipated the impact tobacco would have in centuries to com "When we tried to use the smoke," Cartier wrote in 1535, "we foun it bit our tongues like pepper." Cartier's description is the earlie definitive account of a European experimenting with tobacco i the New World. For thousands of years the native people of th Americas had used tobacco for medicinal and spiritual purpose Explorers brought the plant back to Europe, where it was promo ed as a panacea for everything from gonorrhea to flatulence. It wa even used as a dentifrice to whiten teeth. By the beginning of th 17th century, rising demand led England's struggling settlemer in Jamestown to grow the Colonies' first successful crop. Tobacc use spread across the globe, becoming an important part of ever culture it touched. But only after cigarettes became popular in th mid-1800s and rolling machines enabled mass production in th 1880s were health concerns raised. In 1964 the U.S. Surgeon Ger eral warned that cigarette smoking is a cause of cancer and othe diseases. Today, about three million people a year die of tobacc related illnesses. **PHOTOGRAPH BY IRVING PENN**

SMOKE SIGNALS

Country with highest annual per capita consumption of cigarettes: Poland (3,620)

Country with 11th highest annual per capita consumption: U.S. (2,670)

Percent of men who smoke, worldwide: 47
Percent of women: 12

Number of cigarettes smoked in U.S. in 1996: 487,000,000,000

Irving Penn's *Cigarette No. 17,* from 1972. The world's 1.1 billion smokers put out 5.3 trillion butts a year.

Frozen feats: American families visit their 100 million refrigerators an average of 45 times a day.

1834 **THE COOLEST INVENTION** Humans have been keeping them-selves and their food cool for eons. The Chinese placed ice in cellars as early as 1000 B.C. An 8th century Baghdad caliph packed import-ed snow between the walls of his summer home. But it wasn't until 1834, when Jacob Perkins, a 68-year-old Massachusetts inventor living in London, received a patent for a compressor, that anyone figured out how to make ice artificially. Perkins's machine ran on the same principles used in household refrigerators today: A com-pressed fluid—ether in his case, later ammonia or Freon—was evaporated to produce a cooling effect, then condensed again. It took 17 years before the first commercial refrigerators were installed in an Australian brewery. By the end of the century they were being used to ship beef around the world, chill wine in Paris restaurants and build indoor skating rinks. In 1902, Willis Carrier installed the first air conditioner in a Brooklyn printing plant—it not only cooled but also controlled humidity—and before long his machines were showing up in department stores and movie theaters. The first safe and quiet kitchen refrigerators appeared in the early 1930s. Fewer than 1 percent of the homes in America are now without one, and most contain frozen foods—thanks to a process developed in 1925 by Clarence Birdseye—another marvel of the Cool Age. **PHOTOGRAPH BY IRVING PENN**

HOLE IN THE OZONE

Could our fondness for frostiness lead to a case of planetary sunstroke? Chlorofluorocarbon gases, used until recently in millions of refrigerators and air conditioners, play havoc with the ozone layer, which protects Earth from ultraviolet radiation. The safety blanket has been thinning since the 1970s, and for the past few years a hole twice the size of China has opened over Antarctica each spring. Environmentalists forecast rising rates of skin cancer and cataracts in the next millennium, as well as damage to crops and sensitive ecosystems.

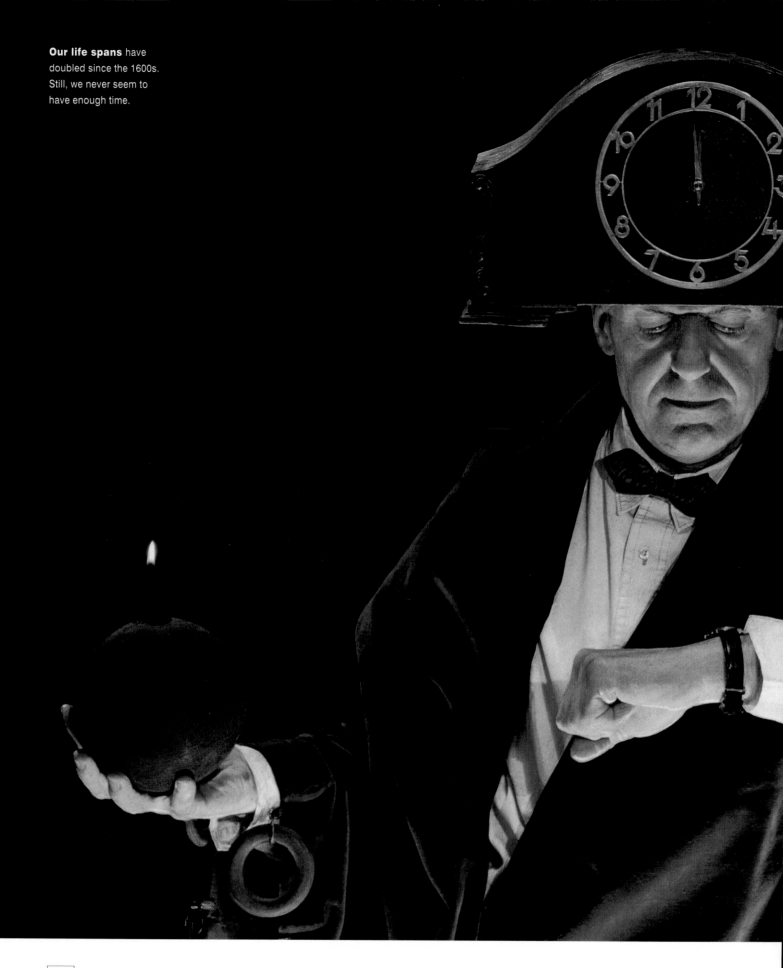

Our life spans have doubled since the 1600s. Still, we never seem to have enough time.

TIME LINE **CLOCKS** **1670** First second hand **1735** First marine chronometer **1780** First self-winding watch **1829** First electroma

52

1656 TICK, TOCK For centuries, sundials and water clocks—none too accurate—told us all we needed to know about time. Mechanical clocks, using deadweight-powered gears, first appeared on towers in Italy in the 14th century, but their timekeeping was less impressive than their looks, wandering up to 15 minutes a day.

By the 17th century a who's who of geniuses, including Galileo and Pascal, had theorized about, but failed to build, better timepieces. Then, in 1656, Dutch astronomer Christiaan Huygens constructed the first pendulum clock, revolutionizing timekeeping.

The precision of Huygens's clock allowed scientists to use it for their physics experiments, shopkeepers to open and close at fixed hours and workers to be paid by the hour. Time discipline permeated private life, too: Punctuality became a virtue. In 1761, Englishman John Harrison perfected a clock that worked at sea and put accurate time—and thus longitude—in a navigator's pocket. At last man knew where he was. **PHOTOGRAPH BY TEUN HOCKS**

1906 First battery-operated clock **1927** First quartz clock **1948** First atomic clock **1970** First liquid-crystal-display watch

85

51

1865 LIBERTY FOR ALL

The U.S. Civil War, which ended in 1865, not only transformed the lives of millions of black Americans, it fixed the nation on a new course. The wealthiest and most powerful slaveholding class in the world was destroyed, and an agricultural slave society was crushed by a rising industrial North. But the crucial moment in the four-year struggle that claimed 600,000 lives had really come two years earlier, when President Lincoln issued the Emancipation Proclamation, turning a war for the restoration of the Union into a war of liberation.

Abolitionists had encouraged Lincoln to issue such a document from the start of the war. Ever since a handful of Quakers in England launched a public campaign against the slave trade in 1787, abolitionists had kept the slavery question in public view. Women there boycotted sugar produced by slave labor, and thousands signed petitions to Parliament. In the U.S. such well-known figures as Elizabeth Cady Stanton, Lucretia Mott and William Lloyd Garrison vigorously insisted that the conscience of the nation could find rest only with the abolition of slavery.

Slaves would celebrate January 1, 1863, as the Day of Jubilee. But their actions had long been instrumental in advancing emancipation. They worked as spies and laborers and volunteered their lives to fight in the Union Army. By the end of the war, 179,000 African American men had served in the U.S. military, constituting almost 10 percent of the Northern armed forces. For the nation's 3.5 million slaves, for its abolitionists and for some of its politicians, the crucible of civil war would allow the U.S. to live up to its best traditions, expressed in the Declaration of Independence, as a land of liberty and equality for all. The foundation was laid for the emergence of the United States as a great world power. **PHOTOGRAPH BY ALEXANDER GARDNER**

A DREAM DEFERRED

For African Americans, the end of the Civil War was just the start of a long struggle for justice. Reconstruction governments tried to enforce the 14th Amendment (1868), which promised all citizens equal protection. But after Northern troops left, Southern blacks were barred from voting, consigned to segregation and terrorized by lynch mobs and the Ku Klux Klan. The civil rights movement of the 1950s and '60s defeated Jim Crow laws, but economic inequality persists—as do slavery's deeper scars.

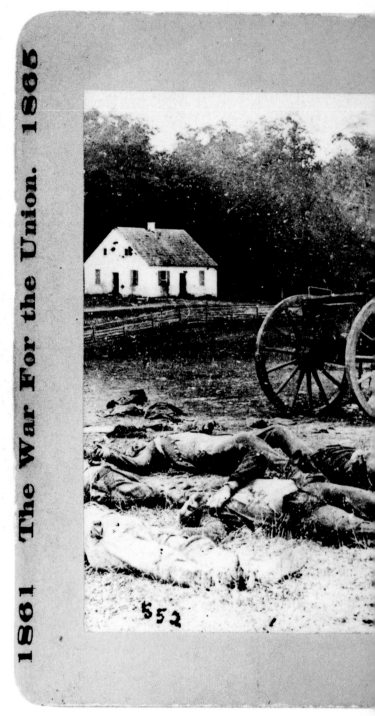

1861 The War For the Union. 1865

552

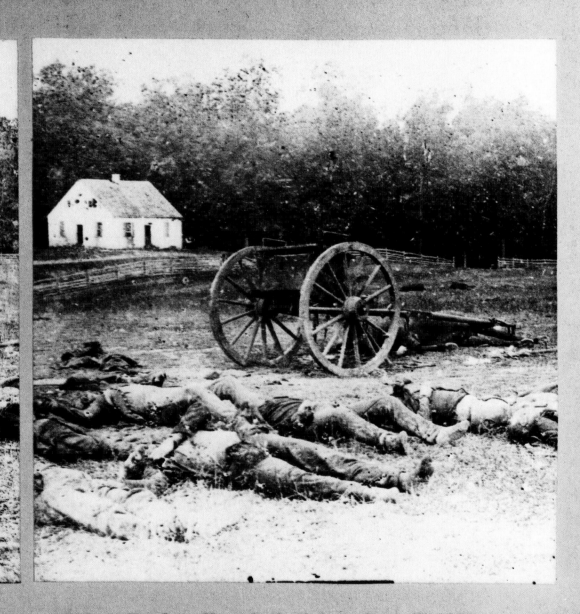

1861 Photographic War History. 1865

552. Dunker Church, Antietam, Sept. 17, 1862.
[FOR DESCRIPTION OF THIS VIEW SEE THE OTHER SIDE OF THIS CARD.]

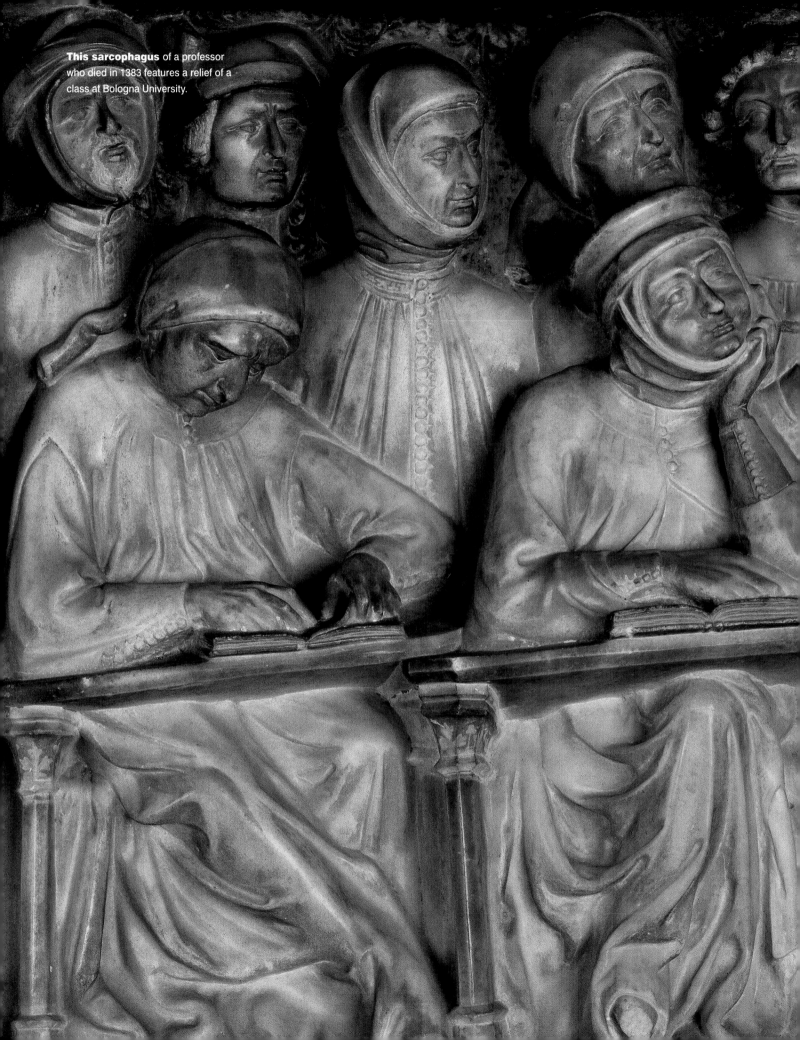

This sarcophagus of a professor who died in 1383 features a relief of a class at Bologna University.

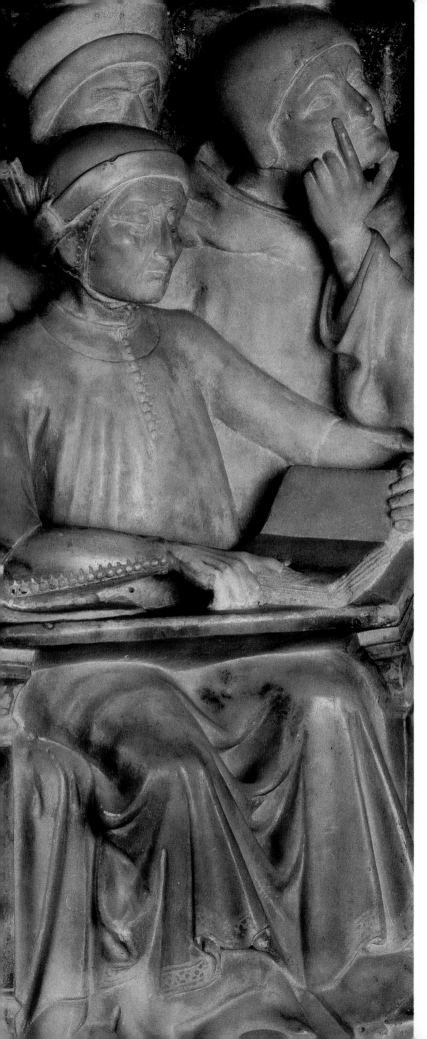

50

1088 A UNIVERSITY EDUCATION The modern university is a sanctuary for the learned, a place where the wise can pass on knowledge to the next generation. It is also a zoo, full of loudmouths and know-it-alls. And it was ever thus: The first university was founded not only for students but also by students.

There had always been centers of learning—schools of philosophy in Greece, medicine in India, literature and art in China. But the university as we know it today—a secular degree-granting institution with at least one professional school attached—began in Bologna, Italy, in 1088. First came the law school: Scholars pored over Roman law, adapting it to contemporary needs—a vital contribution to the organization of European society. Next came recognition of the institution itself: When Bolognese landlords threatened to raise scholars' rents, student protests led Emperor Frederick Barbarossa to award them protection from exploitation in 1158. Students also made professors sign contracts to deliver lectures on particular subjects—and promise to remain at the school until the end of the term. Soon professors needed a license to teach (the earliest academic degree), and a real university took shape.

Those 12th century campus hotheads could never have imagined what they were building. By the middle of that century, the University of Paris had taken root, and not long after, Oxford was up and running in England. Today, throughout the world, universities are places where students can discover their callings—and themselves. **PHOTOGRAPH FROM THE PONZANI/FMR COLLECTION**

THE LEARNING CURVE

Founding dates of some of the world's leading universities

1150 University of Paris
1187 University of Oxford
1209 University of Cambridge
1636 Harvard University
1755 Moscow State University
1810 University of Berlin
1877 University of Tokyo
1898 Beijing University

Staying in shape helps the human heart pump a steady five quarts of blood per minute.

9 — 1628 THE CIRCULATION OF BLOOD

It took roughly 2,000 years of medical sleuthing to unlock the secrets of the circulatory system. Aristotle started the search, hypothesizing that the liver was the source of blood. But not until the 16th century did physicians begin uncovering enough clues about arteries, veins and the heart to propose new theories and to challenge professional doctrine. Ignoring the threat of ostracism, British physician William Harvey spent 20 years researching the circulatory system and writing *An Anatomical Study of the Motion of the Heart and of the Blood in Animals,* published in 1628. In it he demonstrated for the first time that the heart controls circulation. His conclusions were met with scorn. But his description of how blood flows away from the heart in arteries, then back through veins—still valid nearly 400 years later—remains one of the most significant medical discoveries of the millennium, a testament to observation, accurate description and mathematical proof. **PHOTOGRAPH BY HOWARD SCHATZ**

HEARTBEATS

2,649,024,000: Times an average human heart beats in 70 years

50,000,000: Gallons of blood pumped in 70 years

60,000: Miles of blood vessels in a human body

11: Ounces the average adult heart weighs

960,592: People who died of cardiovascular disease in the U.S. in 1995

The world's oldest surviving can, which held seven pounds of roast veal, helped feed Arctic explorers in 1823.

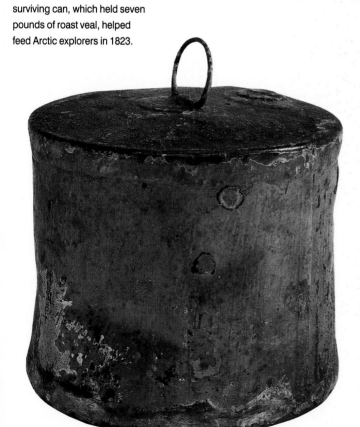

48 — 1812 YES, WE CAN

The first canned foods appeared in 1812, the first can opener in 1885. Hard as cans were to open initially, they were culinary time capsules providing the bounty of summer in the dead of winter. Napoléon reportedly offered a reward to anyone who could supply his troops with food that would keep. In 1795, French brewer Nicolas Appert, without knowledge of bacteria or the principle of sterilization, preserved food by sealing and heating it in airtight jars. By 1809 his factory was supplying the ports of France. The London company Donkin, Hall and Gamble soon applied his methods to tin cans, which became the preferred method of storage. **PHOTOGRAPH FROM THE SCIENCE MUSEUM OF LONDON**

CANNED FACTS

34,202,000,000: Beer cans produced in the U.S., 1997

8,654,448: Cans of Campbell's Soup sold every day, worldwide

4.8: Per capita consumption of canned pineapple in the U.S. in 1996, in pounds

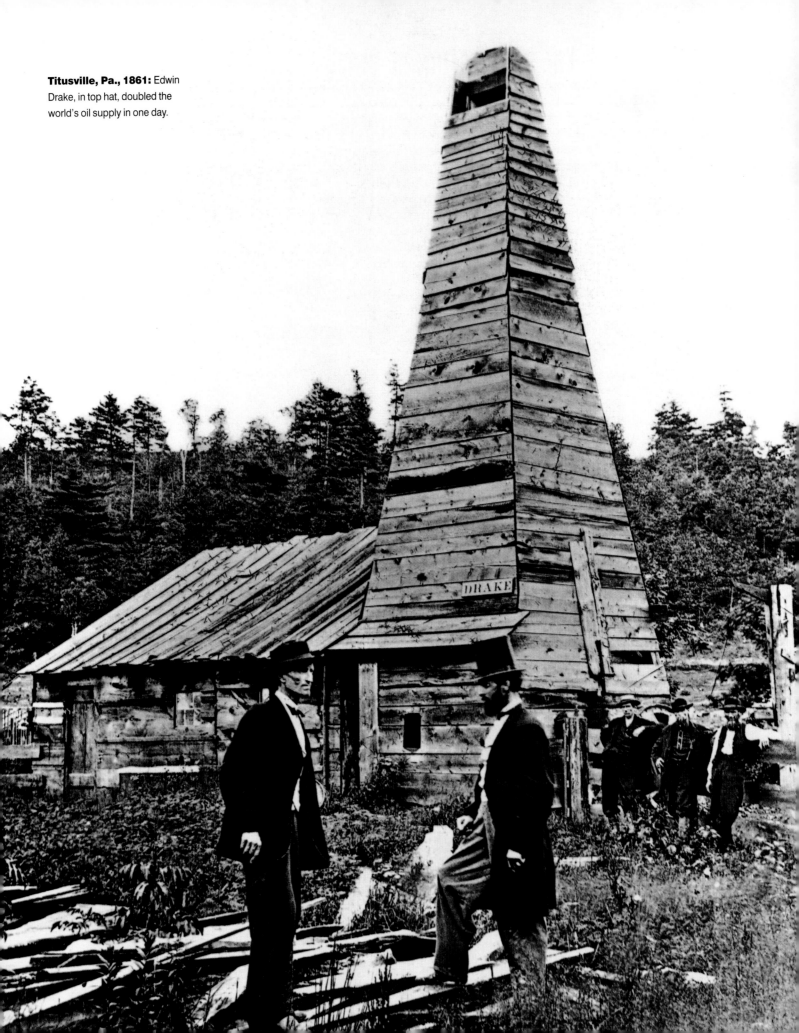

Titusville, Pa., 1861: Edwin Drake, in top hat, doubled the world's oil supply in one day.

7

1859 STRIKING OIL

The story of oil has been one of high-risk wildcatting, boom-or-bust land deals, robber barons and international intrigue. People had known of the combustible properties of surface oil for centuries, but it was only in 1859 that a band of American entrepreneurs, led by retired railroad conductor Edwin Drake, stumbled on a way to pump it from a shallow well in Titusville, Pa. They didn't even want oil—it was a derivative, kerosene, they were after. By the end of the Civil War, 3.6 million barrels a year were being pumped from around Titusville and derricks were going up all over the U.S. Then the bottom fell out of the market. Enter John D. Rockefeller. Starting with one kerosene refinery, he gobbled up his competitors and integrated them into his company, Standard Oil, adding storage facilities and a transportation network. Oil fueled Rockefeller's fortune and—with the invention of the gasoline-powered internal combustion engine—the machines that made the world run. **PHOTOGRAPH BY JOHN MATHER**

PETRO-POLITICS

In an oil-driven global economy, one petroleum by-product is geopolitical power. That became clear in 1973, when the Organization of Petroleum Exporting Countries, angered by Western support for Israel in the Yom Kippur War, quadrupled the price of oil and hit the U.S. and other countries with an embargo. The results: gas lines and inflation for oil-consuming lands; riches for once-poor producers. After Iran's 1979 revolution, prices tripled. Oil money enabled Arab sheiks to buy up U.S. businesses. But it also caused rivalry in the Islamic world, sparking Iraq's invasion of Kuwait in 1990. The U.S. and other nations, bonded by petro-politics, sent troops to expel the aggressors.

46

1829 WATER PURIFICATION

A person consumes 16,000 gallons of water in a lifetime. But before 1829, when the Chelsea Water Works of London installed its landmark slow-sand filter on the Thames River, no public supplier had effectively cleaned it. Even after 1829, most drinking water in London and elsewhere remained unfiltered, and epidemics of cholera and typhoid were common. Finally, in 1854, physician John Snow, though he didn't know that bacteria were carried in water, traced an outbreak of cholera to a pump near a sewer. The filtration of drinking water (plus the use of chlorine, introduced in 1909) is probably the most significant public health advance of the millennium. **PHOTOGRAPH BY NEIL WINOKUR**

WATER BUGS

While most industrialized nations had adequate water-treatment and sewer systems by 1910, a quarter of Earth's population still lacks access to safe drinking water. Waterborne diseases remain among the world's top killers. Each year, 3.3 million children die of diarrheal illnesses, including cholera. Typhoid strikes 16 million people—one out of 360 on the planet—costing 600,000 lives a year.

ean drinking water cut
phoid deaths in U.S. cities 79
rcent from 1910 to 1924.

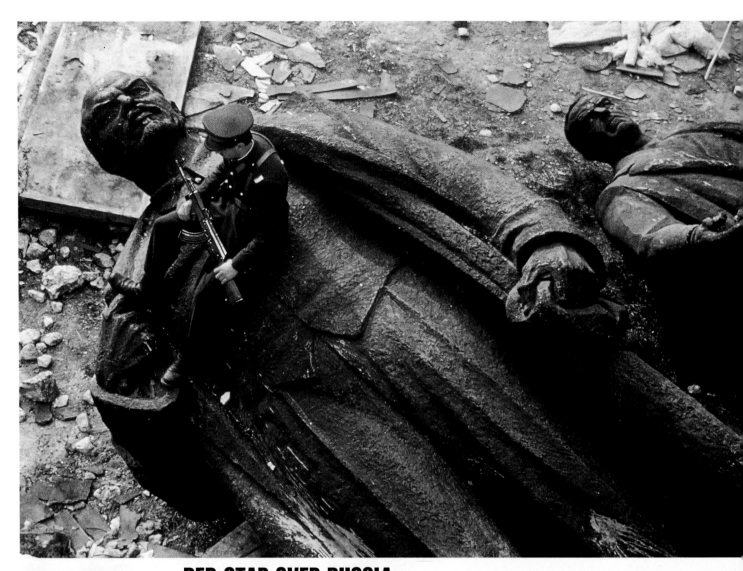

45

Lenin and his Romanian follower Petru Groza lay in pieces by 1990—symbols of a failed revolution.

1917 RED STAR OVER RUSSIA The first country to pursue Karl Marx's dream of a workers' state was a poor land where peasants vastly outnumbered proletarians. Battered by the military disasters and food shortages of World War I, Russia exploded in February 1917. Rebels seized the capital, St. Petersburg, and the Duma (the Senate) deposed the inept and repressive Czar Nicholas II. But the new government, headed by socialist Aleksandr Kerensky, refused to pull Russia out of the war. In October it was overthrown by the militant Bolsheviks. Their leader, Vladimir I. Lenin, quickly made peace with Germany. He moved Russia's capital to Moscow, abolished private property, suppressed the Church. His forces

murdered Nicholas and his family. By 1920, a three years of civil war, the Communist Pa rule was absolute.

The Soviet Union (as the new nation known) modernized with terrific speed. The m es got free education and medical care. But price was staggering: millions dead in botc economic experiments and purges; a gulag fu political prisoners; a culture shackled by total ian ideology. The country's rivalry with the dominated global politics, triggered wars threatened nuclear Armageddon. It ende 1989, when the Soviet bloc collapsed—done i Marx had predicted capitalism would be, b: own "internal contradictions." **PHOTOGRAPH BY GAD GROS**

THE COLLAPSE OF COMMUNISM

Assuming power as Soviet leader in 1985, Mikhail Gorbachev declared twin policies of *glasnost* (openness) and *perestroika* (restructuring). But once the screws were loosened, the system fell apart. Moscow lost its satellites one by one in 1989. Poland's Solidarity labor movement ended the Communist monopoly on power. In Czechoslovakia playwright Václav Havel led a peaceful Velvet Revolution. Romanians toppled dictator Nicolae Ceauşescu. And Berliners tore down the wall that divided East from West. By 1992 the U.S.S.R. itself was history.

44

1674 SMALL WORLD

It was only a tiny lens, smaller than a postage stamp. It was not the first microscope, nor the most powerful. Its creator, Antonie van Leeuwenhoek, a Dutch linen merchant, had heard that by grinding a lens out of clear glass, one could see things bigger than with the naked eye. First he used it to peer at the stinger of a honeybee, the leg of a louse, the brain of a fly. Soon he was making more-powerful lenses, using diamond dust scooped from the floors of local eyeglass makers. With these he became the first person to see bacteria and spermatozoa. In August 1674, while examining a drop of lake water, Leeuwenhoek saw "animalcules" with tiny heads, limbs and fins, one-celled animals later called protozoa. On that day the science of microbiology was born. Leeuwenhoek's work unlocked doors for Pasteur, Fleming, Darwin and others. Today, microscopes, which can magnify to the millionth power, are essential not only to medicine but to fields as diverse as criminology, metallurgy and archaeology—all because of a curious shopkeeper. **PHOTOGRAPH BY ALFRED PASIEKA**

THE ELECTRON MICROSCOPE

Humanity's ability to see the infinitesimal increased enormously in 1933 when German engineer Ernst Ruska developed a microscope that used electrons instead of light. Focusing these subatomic particles through magnetic-coil "lenses," the strongest electron microscopes are a thousand times more powerful than their optical rivals, providing clear images of objects as tiny as two tenths of a nanometer (one nanometer=one billionth of a meter). Thanks to Ruska's invention, scientists have gained insight into the structure of cells, viruses, crystals—and even glimpsed atoms.

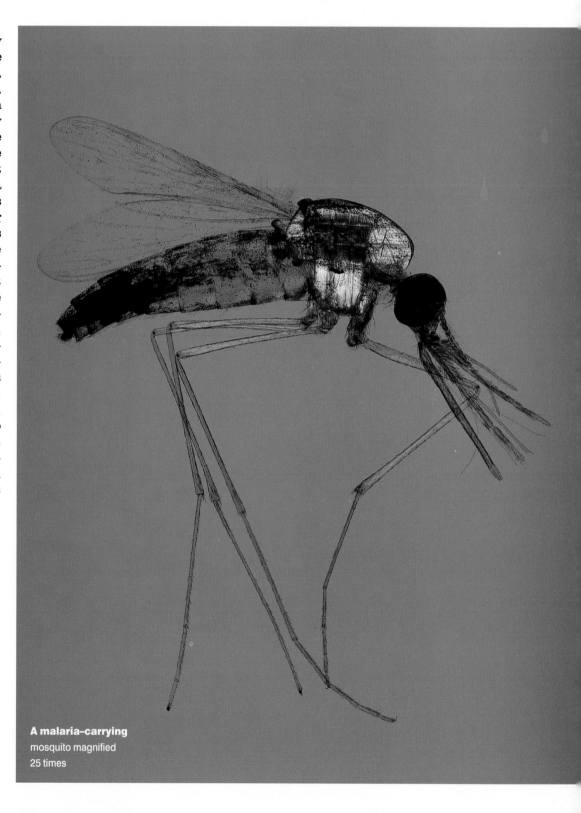

A malaria–carrying mosquito magnified 25 times

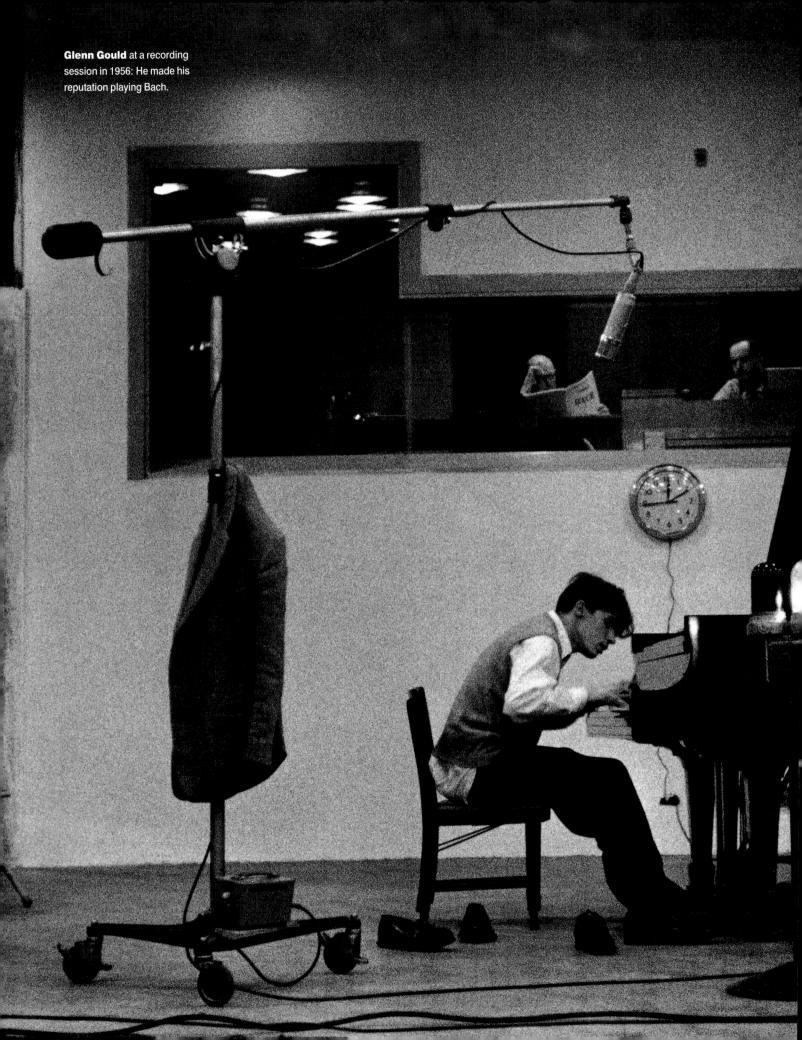

Glenn Gould at a recording session in 1956: He made his reputation playing Bach.

43

1722 THE WELL-TEMPERED SCALE

Johann Sebastian Bach wrote in every known musical genre except opera. But it was a collection of keyboard pieces, written in 1722 when the German composer was 37, that marked a watershed in Western music. By publishing Book I of *The Well-Tempered Clavier*, with a prelude and fugue in each of the 12 major and 12 minor keys, Bach threw the weight of his genius behind what became known as equal temperament, the dividing up of the scale into 12 equal semitones.

Bach's system enabled musicians to explore the full harmonic range of the keyboard. Until then they had been restricted to a limited number of keys in order that important intervals, such as the third and the fifth, could stay perfectly in tune.

Although Bach was not the first to rework the keyboard's possibilities, he did it best: His music is gorgeous. And even though he never wrote for the piano, he opened the door to the rich tapestry of sound we associate with that instrument. By the middle of the 19th century the piano was a dominant force in Western music and an essential element of evening entertainment in living rooms across Europe and America. The stage was set for the pyrotechnics of Chopin and Liszt, for the crashing fortissimos and feather-soft pianissimos of Tchaikovsky—and for millions of humbler recitals. **PHOTOGRAPH BY GORDON PARKS**

THE PIANO

Bach preferred the clavichord, whose sound was produced by metal striking strings, to the harpsichord, whose plucked strings allowed little variation in dynamics. But the clavichord was too quiet for ensemble playing. Around 1700, Bartolomeo Cristofori created an ingenious hybrid: the pianoforte (Italian for "soft-loud"). By the 1860s it had evolved into the modern piano—a powerfully expressive instrument and one of the most complex, with 12,000 components.

42

1866 THE LAWS OF HEREDITY

Gregor Mendel, an Austrian monk who spent a decade crossbreeding pea plants in his monastery garden, aired his discovery of the basic laws of heredity in 1866. He gave up his research two years later when he became abbot, and his work, though published, was largely ignored. Rediscovered in 1900, it helped propel America's interest in agricultural reform. Mendel's thesis—that traits handed down from parent plants to offspring were mathematically predictable—led to the "hybrid vigor" theory, which transformed commercial agriculture. By crossing two inbred seeds, farmers could produce progeny that outperformed either parent, resulting in healthier and fuller crops. Corn, now bred entirely this way, has been called the greatest success story of modern genetics. In the 1960s, agronomist Norman Borlaug saved millions of lives in famine-stricken India and Pakistan by introducing a shortened, high-yielding dwarf wheat—a green revolution that had its roots in Mendel's garden. **PHOTOGRAPH BY DAVID NEWMAN**

MENDEL'S CHILDREN

His peas have spawned a plant-genetics industry, mostly seeking tougher varieties of existing produce (bruise-resistant tomatoes, for example). But we also have Mendel to thank for some exotic hybrids: tangelos, limequats, broccoflower and sugar snap peas among them. A recent experiment with a firefly gene and a familiar weed went further (though not for public consumption). The result? Glow-in-the-dark tobacco.

41

1844 THE TELEGRAPH GOES ON LINE

No other invention has shrunk the world so dramatically as the electric telegraph, capable of moving messages across land and sea at 16,000 miles per second. No wonder that when Samuel F.B. Morse inaugurated his first telegraph line (between Washington, D.C., and Baltimore), on May 24, 1844, he tapped out an exclamation from the Bible: "What hath God wrought!"

Morse's telegraph, unveiled in 1838, was not the first such device—Englishmen William Cooke and Charles Wheatstone beat him by a year with a model that used needles to spell out words—but it was by far the most practical. The sender simply pressed a key in a pattern of dots and dashes that was automatically marked on paper at the other end. Morse's machine and code became the international standard.

The telegraph spurred the growth of multinational corporations and transcontinental railways. It helped change the pace and scope of warfare. And it gave a boost to the news media. In 1848, six newspapers formed what would become the Associated Press to collect and distribute reports by telegraph. Soon news from anywhere could reach people everywhere the very day it happened. **PHOTOGRAPH FROM THE SMITHSONIAN INSTITUTION**

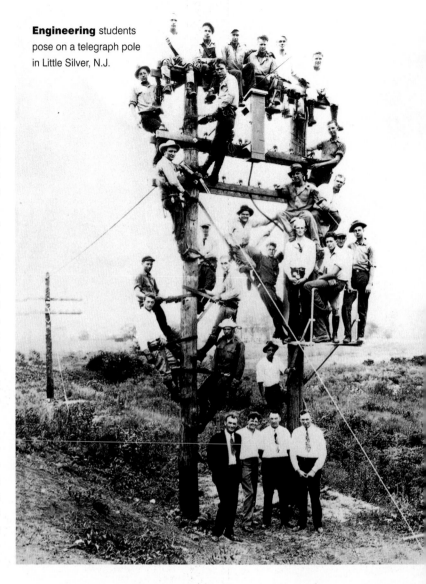

Engineering students pose on a telegraph pole in Little Silver, N.J.

1848 WOMEN'S RIGHTS

Many women still lead lives of dependence and submission, but if one considers that women didn't publicly demand suffrage until 1848, the advances made in the recent blink of history's eye seem remarkable. The Declaration of Sentiments, written by Elizabeth Cady Stanton and signed at the Women's Rights Convention in Seneca Falls, N.Y., was not the first expression of feminism. But the 12 resolutions adopted there provided an agenda broad enough to terrify many. Its defenders were pelted with rotten fruit, insulted by the press, ignored. By 1900 suffragists had taken to the streets, expressing a different kind of anger: "Men, their rights and nothing more; women, their rights and nothing less!" Still, it took until 1920 for American women to win the right to vote. In the 1960s women marched again, to argue for equal pay for equal work and freedom of reproductive choice. Those arguments continue, but women can now speak with their ballots, not just their voices. **PHOTOGRAPH FROM THE UPI/CORBIS-BETTMANN COLLECTION**

FEMINISM'S SECOND WAVE

The women's movement of the 1960s and '70s picked up where the suffragists left off. Led by such firebrands as Gloria Steinem and Betty Friedan, thousands marched for legal and social emancipation. Although the Equal Rights Amendment didn't pass, there were victories aplenty. The resurgence of feminism gave women new access to professional schools, the military, politics, sports. A wife no longer needed her husband's signature to get a bank loan. But all is not yet equal: Women still make only 74 cents for every male-earned dollar.

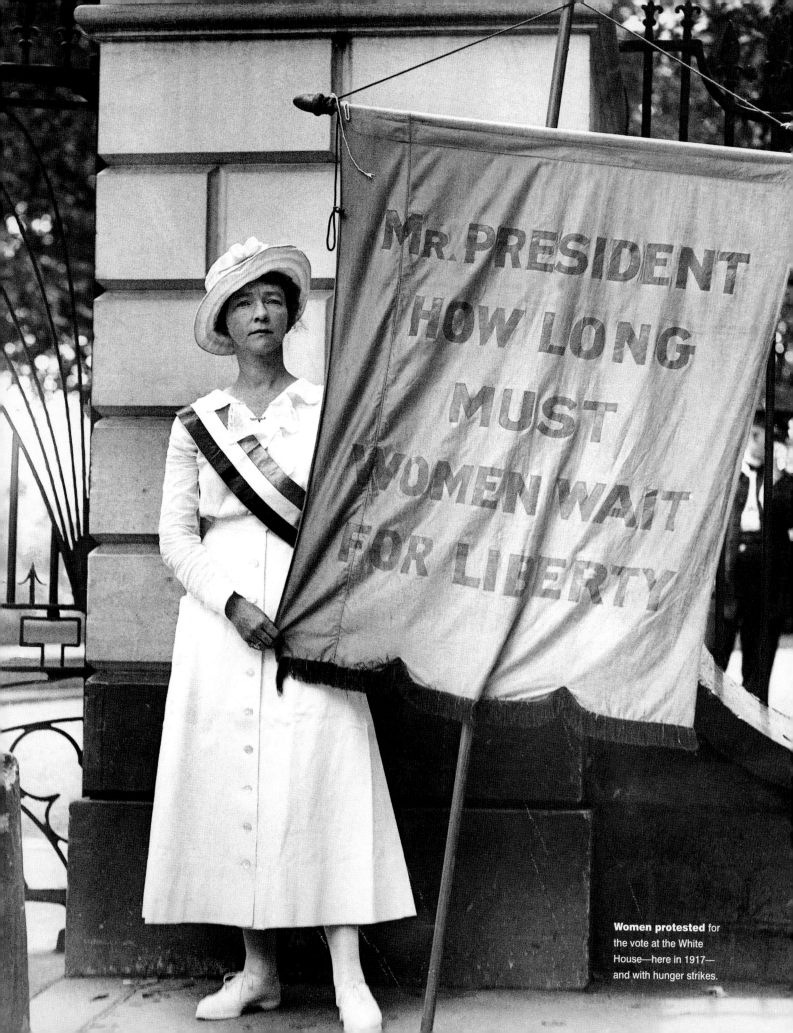

MR. PRESIDENT HOW LONG MUST WOMEN WAIT FOR LIBERTY

Women protested for the vote at the White House—here in 1917— and with hunger strikes.

39

1537 THIS SPUD'S FOR EUROPE Culti-
vated by Peruvians since 8000 B.C., potatoes were
encountered by Spanish explorer Gonzalo
Jiménez de Quesada in 1537. Easy to grow (no
tools required), they became, in one historian's
estimation, "the difference between having one
child and having five." And a lower infant mortali-
ty rate meant some children could leave the farm
to work in factories. First, however, grain-fed
Europe had to develop a taste for the potato. Con-
fusing it with deadly nightshade, some thought it
poisonous, the cause of leprosy—or at least flatu-
lence. But at the urging of scientists, leaders pro-
moted the tuber; Marie Antoinette wore potato
flowers in her hair in 1785. The Irish welcomed the
addition to their diet, consuming eight pounds per
person per day by the 19th century. The country's
population doubled but then was ravaged by a
potato blight beginning in 1845. As many as one
million died; another 1.25 million emigrated to the
U.S., giving rise, among other things, to the
Kennedy dynasty and all that came with it. The
potato's uses are legion: Potato-based alcohol pow-
ered German planes in WWII, potato acids are
found in detergents, and potato starch is used as
an adhesive in stamps and as an absorbing agent
in disposable diapers. **PHOTOGRAPH BY WOLFGANG KUNZ**

POTATO FACTS

651,077,028,000: Pounds of potatoes
grown worldwide in 1997
145.2: Pounds of potatoes eaten in 1996,
on average, by each person in the U.S.

McDonald's alone
uses 3.2 billion pounds
of potatoes a year.

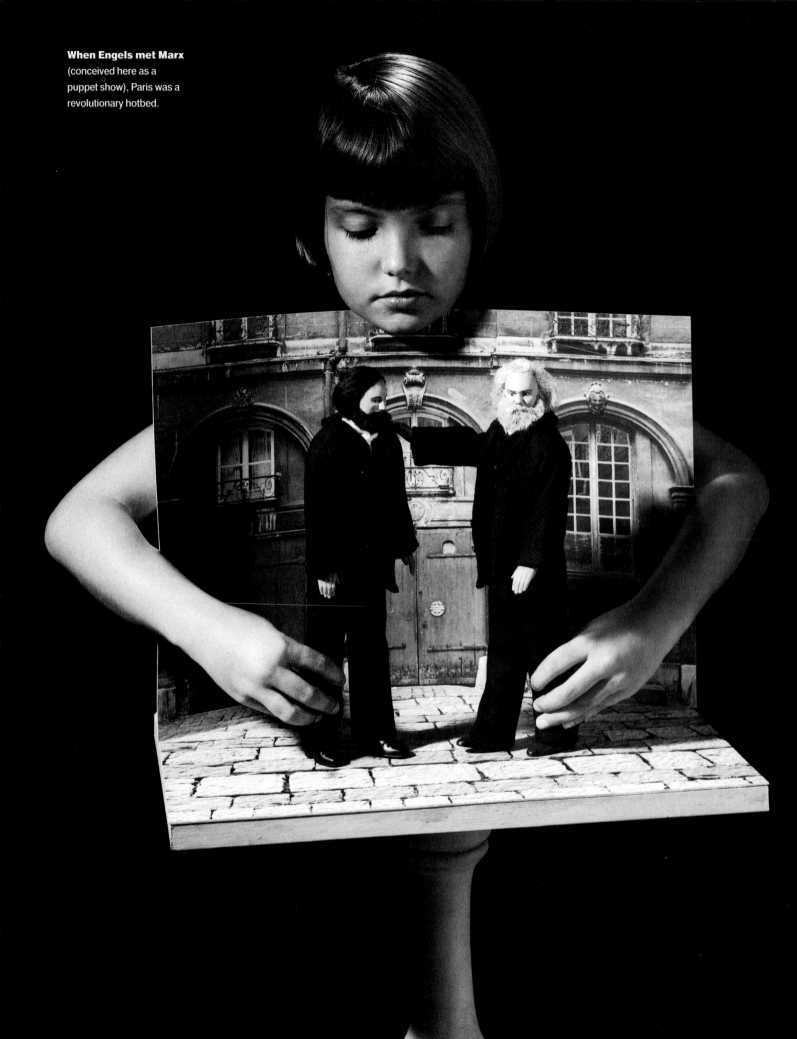

When Engels met Marx (conceived here as a puppet show), Paris was a revolutionary hotbed.

38

44 MARX MEETS ENGELS Industrial capitalism unleashed unprece-
dented productivity but plunged millions into misery. The socialist
movement offered visions of a workers' paradise, but no one could
explain how to get there. Then, in 1844, Karl Marx, 26, a philoso-
pher working in Paris, teamed up with political theorist Friedrich
Engels, 24, who ran the British branch of his family's textile firm.
When Engels passed through town on a business trip, the two Ger-
mans spent 10 days talking, and a 39-year partnership was born.
Their first collaboration, the *Communist Manifesto* (1848), opened
with the words, "A specter is haunting Europe." The specter was
communism—and the authors made its victory seem inevitable. All
history, they declared, was driven by class struggle. The bour-
geoisie had superseded the nobility and called the proletariat into
existence. Since capitalists exploited workers with ever-increasing
ferocity, proletarians would one day realize they had "nothing to
lose but their chains" and overthrow the bourgeoisie. The revolu-
tion would communalize property and production, eliminating
classes. The state—along with oppression and want—would disap-
pear. A century later a third of humanity was living under commu-
nist governments. But oppression and want persisted; within a few
decades most of those regimes were ousted from power and Marx-
ism was relegated mainly to academic debate. **PHOTOGRAPH BY GEOF KERN**

37

1826 FIXING AN IMAGE

Surely there have been windows more legendary. Rapunzel's. Juliet's. Hitchcock's rear one. But in 1826 a window swung open wider than any before, revealing a new way of seeing. The window was an attic perch on an estate in Burgundy. And it was from this pastoral vantage point that Joseph-Nicéphore Niépce took the world's first photograph—a ghostly picture of a courtyard and a granary framed by a pigeon house and a bread oven's chimney. Niépce, who would soon join forces with brilliant promoter Louis Jacques Mandé Daguerre, was the first man to fix an image, subtly rendering its essential light and shadow in permanent form. Using a primitive camera, a pewter plate and light-sensitive chemicals, he took a daylong exposure of the view, creating what he called a heliograph. From these humble beginnings, photography changed our perspective on the world: It helped elect Lincoln (Mathew Brady's campaign portrait), offered tangible proof of the horrors of war (journalists began carrying cameras into battle) and brought us to the nuclear brink (spy planes). Most important, Niépce's invention has allowed us to fix our own images of faraway places and familiar faces—and share them with friends, strangers and future generations. **PHOTOGRAPH BY RENÉ BURRI**

THE DIGITAL DARKROOM

Until the 1980s, no matter how the materials changed—metal plates, glass plates, celluloid film—photography always involved light-sensitive chemicals. Then came the digital camera, which converts light into electronic signals. No processing. No waiting. And no messy photo albums. Instead, images are stored on chips and disks, ready at a mouse-click and infinitely manipulable. The pictures are sometimes fuzzy now, but proponents predict digital will overtake chemical in the next few years.

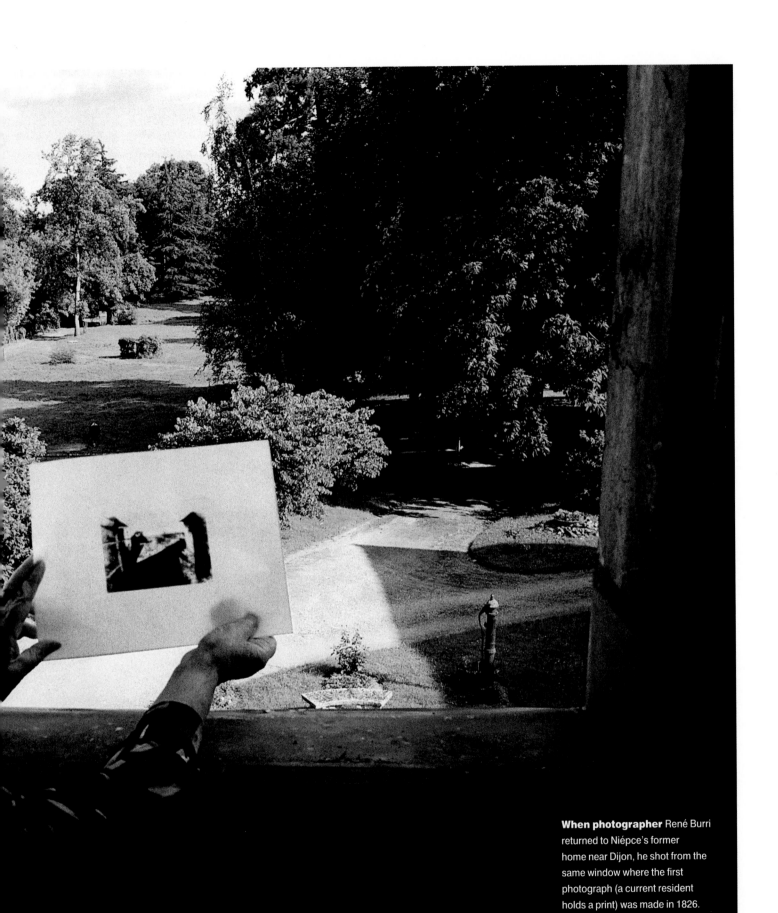

When photographer René Burri returned to Niépce's former home near Dijon, he shot from the same window where the first photograph (a current resident holds a print) was made in 1826.

36

1905 $E = mc^2$ It might have been easy to dismiss Albert Einstein's September 1905 paper as an afterthought, a coda to an extraordinary year. After all, in 12 months, Einstein had produced five revolutionary physics tracts, covering the special theory of relativity, the quantum theory of light and more. Any one of the young patent clerk's after-hours efforts would have been enough to promote him to the highest levels of achievement in physics. But the September paper, a three-page examination of one consequence of special relativity, had the power to change the world. Einstein's "thought experiment" delved into the underlying connection between matter and energy, the two basic components of the universe.

Within the principles of special relativity—nothing in the universe can travel faster than light in a vacuum, and the speed of light remains constant to all observers regardless of their own motion—Einstein found that he had imagined a strange universe where objects changed size and mass depending on how fast they traveled. Th[ese] effects, unimaginably small at ordinary spee[ds], would become evident only as velocities nea[r] that of light. However, if the energy of mot[ion] could change mass, Einstein concluded, m[ass] itself could become energy. He published [the] famous equation $E = mc^2$ (Energy = mass × spee[d of] light squared) and noted, almost in passing, "I[t is] not impossible that . . . the theory may be succe[ss]fully put to the test."

Within 40 years, research in radioactivity a[nd] physics, propelled by the desperation of a ghas[tly] world conflict, led to the development of nucl[ear] energy and the atomic bomb—dramatic reali[za]tions of Einstein's straightforward asserti[on.] Einstein, a lifelong pacifist, deplored the destr[uc]tive use of his ideas and regretted encouragi[ng] President Franklin D. Roosevelt to push devel[op]ment of nuclear weapons. The physicist was dis[ap]pointed, and the world was changed irreversib[ly.]

PHOTOGRAPH FROM THE UPI/CORBIS-BETTMANN COLLECTION

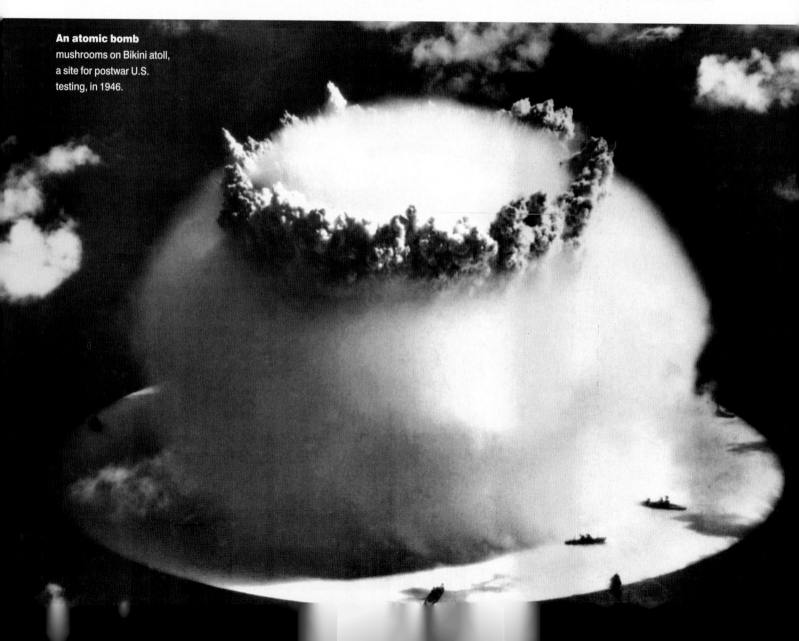

An atomic bomb mushrooms on Bikini atoll, a site for postwar U.S. testing, in 1946.

35

TO BE, OR NOT Alexandre Dumas said Shakespeare was the poet who, after God, created the most. By the time Shakespeare was 37 he had already written 21 plays and created a sonnet form. He was a prosperous landowner and part owner of the Globe Theatre. His works were regularly performed for Queen Elizabeth I. But in *The Tragedy of Hamlet, Prince of Denmark,* first published in 1603, Shakespeare surpassed himself, taking an ancient Scandinavian story of fratricide and revenge and turning it into a dark tale about the human condition that has been translated nearly a thousand times and rarely been out of production. Sarah Bernhardt, John Barrymore, John Gielgud, Laurence Olivier and Kenneth Branagh have all sought to interpret the melancholy Dane.

In the conflicted prince, Shakespeare created a hero whose impulse for revenge is paralyzed by indecision, a bitterly disillusioned observer of political and moral corruption, a consummate wordsmith. The play is full of questions, but it is through the poetry of its language that *Hamlet* captured the conscience of the world. PHOTOGRAPHS FROM THE KOBAL AND PHOTOFEST (2) COLLECTIONS AND BY TERENCE SPENCER, KEITH HAMSHERE AND DONALD COOPER

GREAT DANES

1864 Edwin Booth	**1948** Laurence Olivier
1899 Sarah Bernhardt	**1964** Richard Burton
1922 John Barrymore	**1986** Kevin Kline
1936 John Gielgud	**1995** Ralph Fiennes
1938 Alec Guinness	**1996** Kenneth Branagh

...mlets, clockwise from top left: Bernhardt, ...nael Redgrave, Richard Chamberlain, Branagh, ...Gibson and Olivier

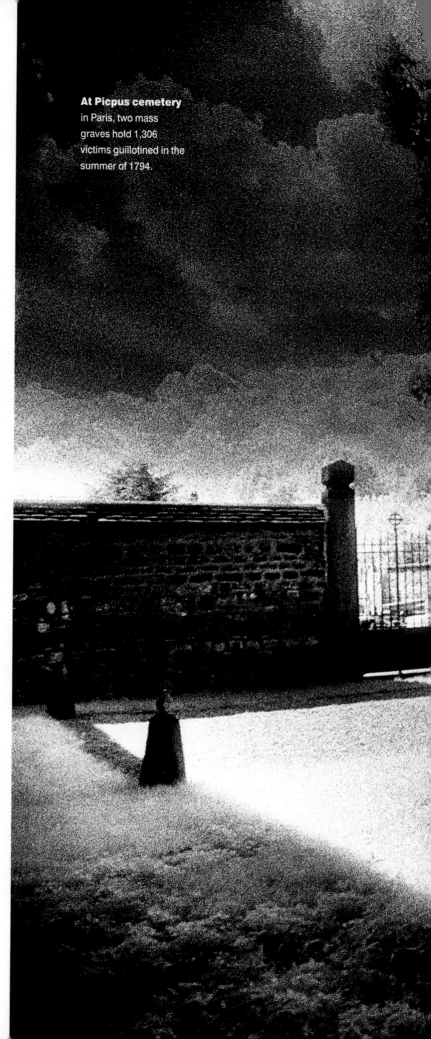

34

1789 THE FRENCH REVOLUTION

It was the world's first social revolution, forging not only a new government but a new society. Ordinary French citizens had long chafed under high-living, heavy-handed kings. The *philosophes*—Voltaire, Rousseau, Montesquieu—called for a social order based on law and reason rather than royal privilege. The revolt began in 1789 when middle-class delegates broke from a legislature rigged to favor the nobility and the clergy, forming their own National Assembly. Then thousands stormed Paris's Bastille prison. In the ensuing civil war, the guillotine claimed 17,000 heads—including those of Louis XVI; his queen, Marie Antoinette; and countless revolutionaries whose factions lost out in power struggles.

The monarchy was temporarily restored in 1814, but the revolution's legacy endured. Peasants and women gained equality before the law. The nobility lost power. The ideas of socialism and nationalism were among the insurrection's exports, as were its egalitarian legal system and its Declaration of the Rights of Man and Citizen. Even its tricolor flag became a model—hoisted, in various hues and configurations, by new republics throughout the world. **PHOTOGRAPH BY SIMON MARSDEN**

NAPOLÉON

Napoléon Bonaparte seized power in 1799, vowing to bring order to France and to export its revolutionary ideals. By 1812 he had conquered most of Europe; three years later he was defeated and exiled. The Corsican soldier laid the groundwork for modern France: its bureaucracy, its universities, its banking system, the body of laws (adapted by dozens of other countries) known as the Napoleonic Code. He was the first modern dictator, too—a self-styled liberator with tyrannical tendencies.

33

1969 ONE SMALL STEP FOR MAN Are we alone? Earthlings have asked this question ever since we fir weighed the riddle of the stars, and a giant leap wa taken toward realizing an answer when Neil Arm strong hopped from a flimsy lunar module onto the su face of the moon. It was July 20, 1969, only a centur after Jules Verne had written a novel about going ther *From the Earth to the Moon*. The Space Age began i earnest on October 4, 1957, with the Soviet launch c Sputnik I, the world's first artificial satellite to achiev orbit. The U.S. followed a few months later with Explo er I, and the race was on. An ardent commitment t

ploration by President John F. Kennedy and an equally zealous oviet program led to high-wire one-upmanship in the 1960s that aawned stunning technological advances, culminating in the *pollo 11* moonwalk. Televisions carried the fuzzy images of histo- / in the making, and a global community basked in this wondrous uman conquest. Fittingly, it was satellites themselves that made ie broadcast possible, and the world a little smaller. Since that rst trip to the moon, there have been deeper probes—*Discovery, ndeavour, Galileo*—into our solar system. But as space engineer 'ernher von Braun observed, the journeys to the moon were like eps in human evolution, akin to the moment life emerged from ie sea to establish itself on land. **PHOTOGRAPH BY EUGENE A. CERNAN**

Lunar landscape:
Harrison Schmitt, one of
the last astronauts to
mine for moon rocks, on
1972's *Apollo 17* mission

First reusable space shuttle/*Columbia* **1986** First permanently manned space station/*Mir* **1990** First orbiting space observatory/Hubble

32

1895 THE FIRST PICTURE SHOW

In the beginning there was nonfiction ("I was chased by a pterodactyl...") and fiction ("...and killed it in one blow"). People told stories, wrote them in words or pictures or acted them out. From cavemen until 1895, that was about it. Then 33 people met in a café for the only new storytelling form of this millennium: They watched a movie.

George Eastman introduced roll film in 1889, which Thomas Edison used to show movies to one person at a time with his Kinetoscope. In France two brothers, Auguste and Louis Lumière, worked on projecting moving pictures to a group. On December 28, 1895, they premiered 10 films. At a later showing of *The Arrival of a Train at La Ciotat Station,* startled viewers ducked at the sight of the locomotive.

With the technology in place, the grammar of movies rapidly developed. Audiences kept up, though many found closeups of intimate acts like kissing to be unnerving. Edison replaced an actor with a dummy to simulate the beheading of Mary, Queen of Scots, and sci-fi pioneer Georges Méliès made film magic in *A Trip to the Moon* (1902). Not so many years later, German expressionists would use weather to convey a character's mood and Orson Welles would sum up Charles Foster Kane's disintegrating marriage by elongating a breakfast table before the viewer's eyes. In the United States, movies became a giant industry; never before had so few people influenced the culture of so many. The nature of film, as opposed to, say, theater, means that the same images are banked in the consciousness of generations past, future and worldwide—people who would otherwise have little culture in common. After seeing *Jurassic Park,* kids from Beverly Hills to Bombay could suffer the same nightmare that they, too, were being chased by a pterodactyl. **PHOTOGRAPHS BY HIROSHI SUGIMOTO**

MEGA-MOVIES

All-time highest-grossing films in the U.S., as of June 1998, in millions
1. **Titanic**/$580.2
2. **Star Wars**/$461.0
3. **E.T.**/$399.8
4. **Jurassic Park**/$357.1
5. **Forrest Gump**/$329.7
6. **The Lion King**/$312.8
7. **Return of the Jedi**/$309.2
8. **Independence Day**/$306.2
9. **The Empire Strikes Back**/$290.3
10. **Home Alone**/$285.8

The Los Angeles Theater, built in 1931 (top), no longer shows movies. But the Cinerama Dome, a 1963 Hollywood haven, still draws a crowd.

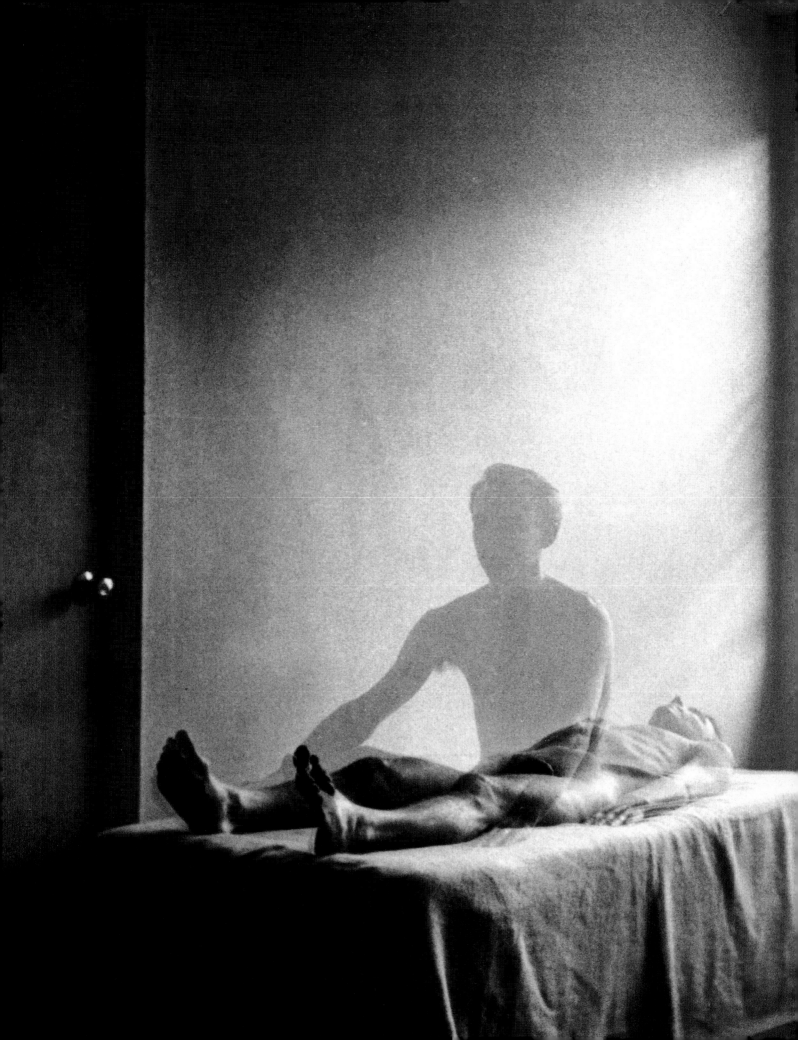

Inspired by one of his own dreams, Freud began his journey down what he called the "royal road" to the unconscious.

31

1900 INTERPRETATION OF DREAMS

Five years after the discovery of X rays let us see inside our bodies, Viennese neurologist Sigmund Freud opened up our minds. *The Interpretation of Dreams*, published in 1900, changed the psychological and cultural landscape of the modern world. In it and later works, Freud claimed that dreams were ordered clues to our unconscious self—the part of our mind containing repressed wishes, traumas and desires too frightening to acknowledge.

Though Nietzsche and others had hypothesized about the unconscious, Freud pioneered a systematic way to gain access to it. He saw the human psyche as a battleground for the primitive, aggressive, sexually driven beast and the socialized adult self within us. Children were complicated beings with urges, including sexual ones, at predictable stages. Through a "talking cure," a patient could be analyzed, gaining insight into and control over his unconscious impulses.

Today practitioners of quicker therapies and psychopharmacology outnumber psychoanalysts. But Dr. Freud is indisputably with us, informing the very way we think about being human. **PHOTOGRAPH BY DUANE MICHALS**

FIGHTING FREUD

Recent years have brought a backlash against Freud, spurred only partly by penny-pinching, Prozac-pushing HMOs. Feminists lambaste him for dreaming up penis envy, while conservatives revile him for his theory of infantile sexuality. The "recovered memory" movement assails him for claiming patients' tales of molestation are often fantasies; the movement's opponents berate him for blaming neuroses on patients' parents. Biographers say he fudged clinical evidence. Still, an estimated 10 million Americans are undergoing some form of the therapy he pioneered.

30

THE TRANSISTOR AGE BEGINS No cable television. No spa[ce] travel. No CD players or faxes. Computers as big as refrigerator[s]. Without the transistor, the past 50 years take on a decidedly ret[ro] look. The triode vacuum tube—the original electronic amplifier—powered the development of radio, TV and early digital computer[s]. But tubes were bulky and power-hungry, a drag on the develo[p]ment of complicated electronic machines; engineers needed a re[li]able, small, cheap device. The likely building blocks? Semicondu[c]tors, crystals of nearly pure germanium or silicon that cou[ld] selectively allow or deny the transmission of electricity. A team [of] scientists at Bell Labs in New Jersey demonstrated the first sem[i]conductor amplifier, a primitive transistor, on December 23, 194[7]. First used in telephone equipment and hearing aids, the devic[es] found their way into everything with a plug or battery. Integrate[d] circuits—silicon chips etched with microscopic transistors—we[re] developed in the late 1950s; chip-based computers invaded th[e] kitchen, the car, the office, the den. Today most Americans are us[u]ally within a few feet of one. **PHOTOGRAPH BY TED MORRISON**

CHIPS AHOY

The first integrated circuits (ICs), developed by American engineers Jack Kilby, Jean Hoerni and Robert Noyce, crammed about 10 components onto a silicon chip three millimeters square. By 1971, when Intel introduced a large-scale IC called a microprocessor, the number had grown to 2,300. And by the mid-1990s, a microprocessor the size of a postage stamp could hold more than seven million transistors. As computers grew exponentially smarter, smaller and cheaper, California's Silicon Valley—the world capital of the chip industry—swelled into a giant mightier than whole nations.

first transistor: Its
ce was two square
meters, about the size
humbnail—room
gh for 200 million
ern ones.

In modern Mongolia,
where the land is still
worked by herders on
horseback, the legacy of
Genghis Khan lives on.

29

1211 GENGHIS KHAN'S EMPIRE

"The greatest joy is to conquer one's enemies," proclaimed Genghis Khan, "to pursue them, to seize their property, to see their families in tears, to ride their horses and to possess their daughters and wives." Unfortunately for most of Asia and much of eastern Europe, Genghis Khan had a thoroughly enjoyable life.

In 1175, at the age of 13, he became chief of a small tribe of Mongol herdsmen. He used his position to unite a constellation of tribes under his rule, then converted those tribesmen into an army so formidable none could stand against it. The Mongols rode in hordes, sweeping away everything in their path. In 1211 they began their conquest of China. Later, they overran Persia and the Arab civilization of present-day Iraq to the west, and parts of Korea, Burma and Vietnam to the east and south. Nearly all of Russia fell before them too. Everywhere they rode, the Mongols left devastation, sometimes slaughtering entire cities. After Genghis's death in 1227, his successor, Ogadai, stormed through Poland and Hungary, reaching the banks of the Danube River.

The Mongols amassed more territory than anyone in history. Their influence on human development was overwhelmingly destructive, though as a result of their depredations, East met West. Mongols—in particular, Genghis's grandson Kublai Khan, who completed the conquest of China in 1279—brought foreigners into their realm to serve as administrators over vanquished masses. An Italian named Marco Polo later astounded Europe with news of such Asian innovations as money made of paper and a stone called "coal" that could be used for fuel.

The size of the Mongolian empire was ultimately its undoing, and within a few decades it began to fragment. The finishing blow came in 1368, delivered by Zhu Yuanzhang, a Chinese peasant whose talent for military and political organization rivaled that of Genghis Khan himself. **PHOTOGRAPH BY JAMES L. STANFIELD**

28

1610 THE DRINK THAT STARTED WARS Ever since 1610, when the Dutch East India Company first brought tea to Europe from the island of Hirado, off the coast of Japan, tea has had few rivals as a catalyst for world events.

By the middle of the 18th century, tea had become Great Britain's signature quaff. Tea drinking stimulated workers, leading to increased productivity and accelerating the Industrial Revolution. By the end of the century, the English were importing so much tea that they decided to sell opium grown in India to China to correct the trade imbalance. In 1839 the Qing government, concerned about China's social and economic disintegration, destroyed opium stored in Canton, provoking the first of two Opium Wars. Chinese junks proved no match for British Congreve rockets; at the war's end, China ceded control of Hong Kong.

On the other side of the world, American colonists refused to pay a threepence-a-pound tax on tea imports "without representation." They seized control of three British tea-bearing vessels docked at Boston Harbor on December 16, 1773, and hurled the contents of 342 chests overboard. Similar protests in Charleston, S.C., Philadelphia and other cities fomented the American Revolution. **PHOTOGRAPH BY GEORGE F. MOBLEY**

TEATIME

If tea made Britons clearer-headed it was not only because of the br caffeine content: Before its adven the populace had been drinking soup for breakfast. More than a r refreshment, the "cuppa" genera daily rituals—elevenses, afternoc tea, high tea—without which Eng would hardly be English. Today, constitutes 42 percent of everyth (besides tap water) drunk in Brita That's 3.4 cups per day for every person over the age of 10.

Two commune workers in Hangzhou, China, pick tea leaves from a sea of shrubs.

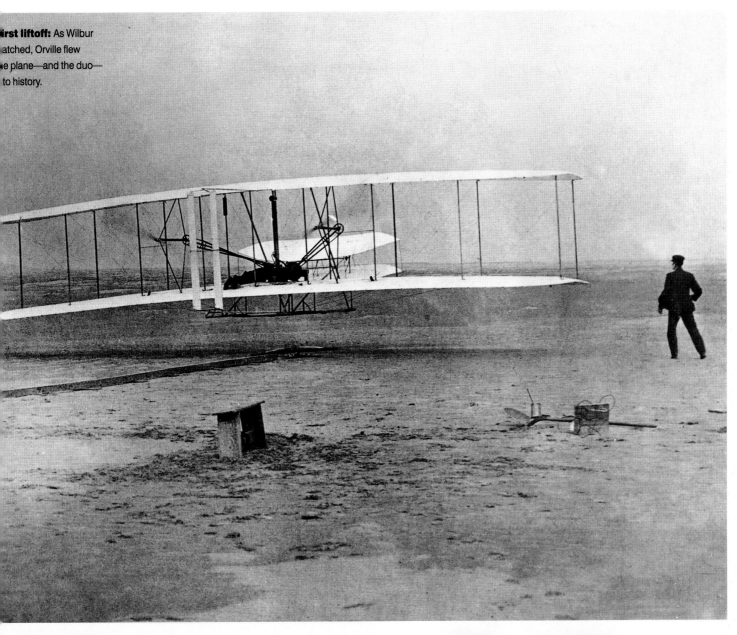

First liftoff: As Wilbur watched, Orville flew the plane—and the duo—into history.

THE WRIGHT STUFF On December 17, 1903, on a stretch of sand near Kitty Hawk, N.C., two bicycle mechanics achieved one of humanity's maddest dreams: For 12 seconds they were possessed of true flight. Before the sun set, Orville and Wilbur Wright would keep their wood-wire-and-cloth *Flyer* aloft for 59 seconds. Few newspapers deigned to comment on the event because the notion that human beings could take to the air, like some contemporary Daedalus and Icarus, was deemed absurd by most sober citizens. Now, of course, some of our greatest heroes—Lindbergh, Earhart, Yeager—have been fashioned out of the wild blue yonder. While it had taken us almost forever to get airborne, once we were there the advances came fast and furious. Indeed, there 15 years later nearly all the elements of the modern airplane had been imagined, if not realized. **PHOTOGRAPH BY JOHN T. DANIELS**

27

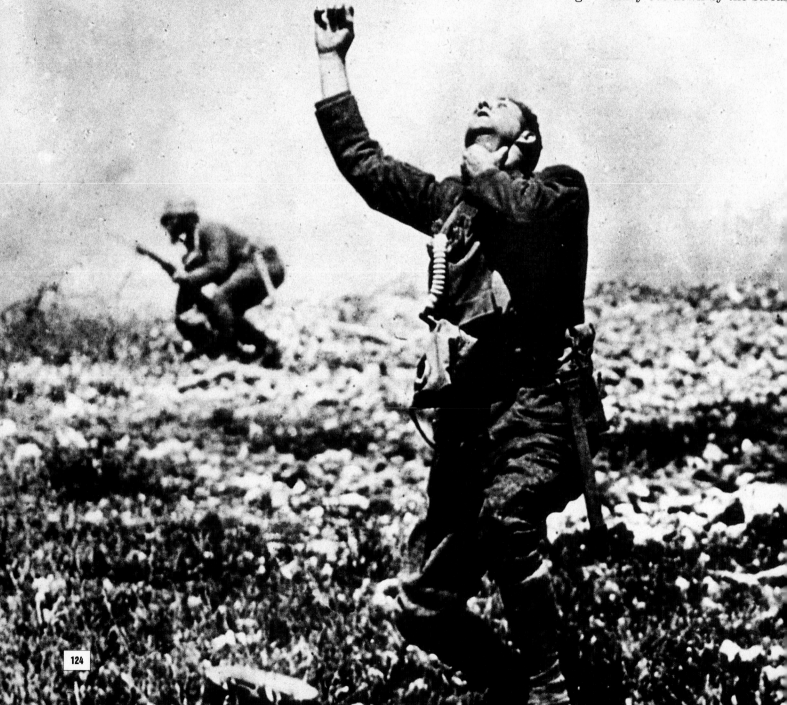

26

1914 THE WAR TO END ALL WARS

It is eas[y to] record how the Great War began: The assassination of A[rch]duke Ferdinand, heir to the throne of Austria-Hungary[, set] off a disastrous chain reaction of demands and coun[ter]demands among the great powers of Europe. But it is al[most] impossible to comprehend why, for the scale of the slaug[hter] was out of all proportion to the grievances of either side.

Nearly nine million soldiers were killed from 191[4 to] 1918—an average of 5,600 each day. And it wasn't just [the] number killed that made the war a historical watershe[d; it] was also the way they died. World War I was the first mo[dern] war, the first to make wide use of some of the gha[stly] weapons of destruction we know today. "I saw trees as la[rge] round as a man's thigh literally cut down by the strea[m

l," gasped one witness, describing the effects of a machine
n, which could fire 500 bullets per minute. The H.M.S.
hfinder became the first warship ever torpedoed by a sub-
rine. The world's first tanks rumbled across a French bat-
ield. And, it was discovered, havoc and death could be
aked from the air. But for millions the war was defined by
aches—wide enough for two men to walk abreast, filled
h mud, rats, lice and misery. Clouds of mustard and chlo-
e gas drifted into them, bringing excruciating deaths.
The war's effects resonated for decades: Russia's suffer-
led to the rise of communism, Germany's helped produce
zism. In two decades the embers of conflict would ignite
econd world war that would prove more horrible still.
GRAPH FROM THE ARCHIVE PHOTO COLLECTION

CHEMICAL WARFARE

The Germans introduced a fearsome new weapon in 1915: chlorine gas. The Allies responded in kind. Later both sides turned to mustard gas, which burns skin as well as lungs. World War I saw the first massive use of chemical agents—about 113,000 tons. But gas had little strategic effect: It caused 28 percent of U.S. casualties, yet only 2 percent of them died. Most nations subsequently outlawed the use of chemical weapons, but that didn't banish them from the battlefield—as Iraq showed in its war with Iran in the 1980s.

Battle of Verdun:
600,000 soldiers died at the bloody western front during the spring and summer of 1916.

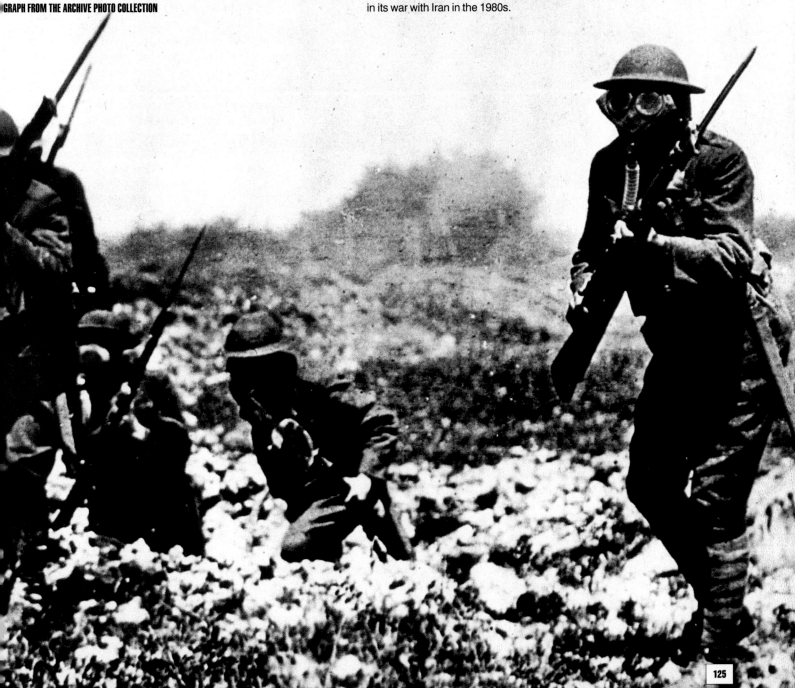

25

The Newfoundland site where Marconi got the message—some 80 years before the first cell phone

1901 WIRELESS At the start of the 20th c[en]tury, few people imagined that an electromag[net]ic wave could travel without wires or cables [of] any significant distance. How could a radio sig[nal] possibly bend along the curvature of the ear[th?] Surely it would shoot right off the horizon i[n a] straight line. But Guglielmo Marconi belie[ved] that radio waves, if given the chance, would fol[low] the earth's contours. In 1895, in his native It[aly,] he transmitted a radio signal about a mile an[d a] half; six years later, on December 12, 1901, M[ar]coni raised the stakes. Affixing antennae to hi[s] flying kites, Marconi, only 27 at the time, [ar]ranged for one signal—the Morse code le[tter] S—to cross the Atlantic, some 2,000 miles. [The] signal was sent from the town of Poldhu in Co[rn]wall, England; a fraction of a second later, [at a] receiving station in St. John's, Newfoundla[nd,] Marconi heard three faint clicks. It was the so[und] of the communications industry being hatch[ed,] the first wave of an electronic age that wo[uld] include radio broadcasts, television and cell[ular] telephones—a discovery that would open up [our] imaginations. **PHOTOGRAPH BY BILL HARRIS**

1830 THE IRON RACEHORSE For most of human history, all land transport depended on a single mode of propulsion—feet. Whether the traveler relied on his own extremities or those of another creature, the drawbacks were the same: low cruising speed, vulnerability to weather, the need to stop for food and rest. But on September 15, 1830, foot power began its long slide toward obsolescence. As brass bands played, a million Britons gathered between Liverpool and Manchester to witness the inauguration of the world's first fully steam-driven railway.

Other rail lines existed at the time, but all used horse-drawn cars along parts of their routes. And none could sustain the 30-mph clip of the Liverpool & Manchester's engines. Those machines, and the roadway they ran on, were designed by George Stephenson—a former coal-mine mechanic who hadn't learned to read until he was 18—and his university-educated son, Robert. The older man was already known for innovations that had transformed the locomotive (introduced by Englishman Richard Trevithick in 1804) from a balky contraption into a long-distance workhorse. Now, with Robert's help, he had created an iron racehorse.

Despite the death of a member of Parliament who was run down by the train at the opening ceremony, the Liverpool & Manchester inspired a rash of track-laying around the world. The railroads sent the Industrial Revolution into overdrive, stimulated trade, built cities from Chicago to Nairobi. In the U.S. they ferried settlers westward, uprooted Native Americans and attracted thousands of Chinese and Irish laborers, who stayed on after the spikes were driven. Wherever the engines ran, they brought their lonesome whistle, the distillation in sound of that most modern of blessings and curses—mobility. **PHOTOGRAPH BY O. WINSTON LINK**

24

Train No. 17 crosses the New River Bridge in Radford, Va., December 1957.

TIME LINE RAILROADS **1804** First steam locomotive/England **1859** First Pullman sleeping cars/U.S. **1869** First transcontinental rail

irst fail-safe compressed-air brakes/U.S. **1925** First mainline diesel locomotive/U.S.S.R. **1964** First high-speed passenger trains/Japan

127

Gravity helped explain the heavens—and how humans stay down to earth.

23

1666 HEAVY THINKING

Isaac Newton, one of the brainiest men who ever lived, was also one of the quirkiest. He used his power as president of London's Royal Society to harass rival scientists. He labored over equations up to 22 hours a day. And, most curious in a man exalted as the father of modern science, he had a mania for alchemy.

But his eccentricities pale next to the grandeur of his greatest discovery, the law of gravitation. For decades, Europe's best minds had been trying to explain the force that holds celestial bodies in orbit. In 1666 inspiration struck the 23-year-old Newton when he saw an apple fall from a tree in his mother's yard. The same force pulling the apple earthward, he realized, was also tugging steadily at the moon.

Newton figured out the mathematical formula defining the gravitational pull between two objects. But there were other discoveries that alone would have secured his undying fame. His three basic laws of motion created a foundation for modern physics. He was the first to prove that white light is a mixture of all colors. And calculus, an advanced form of mathematics Newton invented to make calculations of change, is now an essential tool in fields as diverse as economics and space exploration. PHOTOGRAPH BY TEUN HOCKS

THE LANGUAGE OF CHANGE

Newton's calculus set modern science in motion by creating a mathematical language to describe a universe in flux. Expressing change in infinitesimal increments, calculus can be used to compute the trajectories of rockets, dosages of medicine, the movement of hurricanes. It can help predict behavior, from economic cycles to the growth of cities to the extinction of species. Calculus may even provide a model for how the mind works.

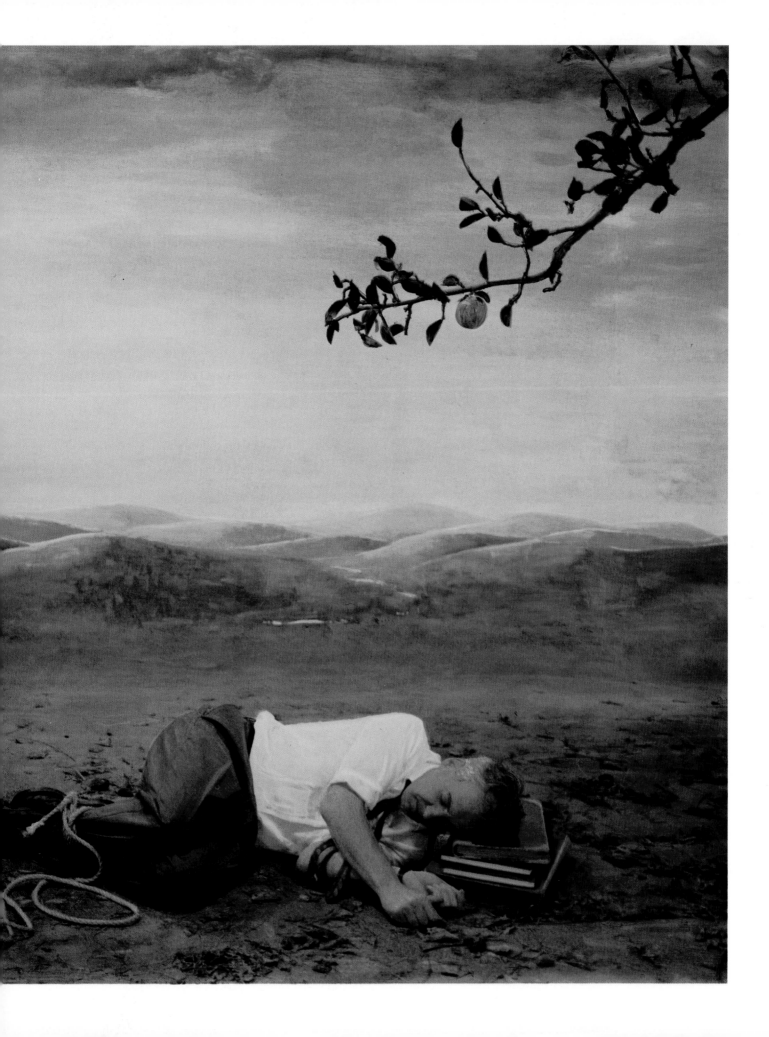

A cloud of penici
gangs up on a grou
staphylococcus bac

22

1928 PENICILLIN

From Ordinary Mold! proclaimed the ad in the August 14, 1944, issue of LIFE. *The Greatest Healing Agent of This War!* As infection fighters, molds had been used for 2,500 years, although their effects were unpredictable, puzzling and sometimes toxic. Until 1928, that is, when Scottish physician Alexander Fleming noticed that a small amount of mold growing on a staphylococcus culture in his laboratory had destroyed the bacteria. He later named an extract of the mold penicillin. Only after other scientists had refined the potent antibiotic in the early 1940s did drug companies begin mass-producing it. Fleming's chance discovery revolutionized the treatment of diseases previously considered incurable—pneumonia, rheumatic and scarlet fevers, syphilis, tetanus, gangrene. But penicillin's "miracle" status led to overuse. Recently, classes of "superbugs" resistant to antibiotics have sprung up—a phenomenon Fleming warned of in 1945. **PHOTOGRAPH BY LENNART NILSSON**

1348 THE BLACK PLAGUE

Perhaps it's preposterous to suggest that man would not have stepped on the moon had it not been for the black plague. But the disease, which killed a third of Europe's inhabitants from 1348 to 1350, took the world down many intricate pathways. Also called the bubonic plague—for the buboes, or boils, that form on the neck, underarm and groin areas—the disease was transmitted by fleas carried by rodents on ships from Asia. Europe's labor force was crippled, half the clergy in England and Germany perished, and scholars were left wondering how anyone survived. Those who did not come in contact with the plague or who developed an immunity began to see the world differently. Men who had lived in virtual slavery left their lords to work the land of the highest bidder, and many even came to rent their own plots. Because people had no idea where the disease came from, it was seen as God's punishment for sinners. So when priests took sick, the Catholic Church's grip was weakened and the door to Protestantism opened. Doctors discarded dogma and began dissecting human bodies, leading to the rise of the scientific method. The clothes of plague victims were turned to pulp, creating a supply of paper that made it possible to increase the production of manuscripts. The new spirit of adventure emboldened Gutenberg to develop the printing press. It pushed Columbus across the Atlantic. And it would touch all that came after. **PHOTOGRAPH BY ANTONIN KRATOCHVIL**

21

A NEW PLAGUE

When doctors first described it in 1981, acquired immunodeficiency syndrome was thought to strike only gay men. But in Africa—which has suffered four times as many cases as all other continents combined—AIDS is mainly a heterosexual plague. The epidemic has killed an estimated 11.7 million worldwide, and some 30 million are currently infected with HIV, the virus that causes AIDS. Thanks to new medications, death rates are dropping in the U.S. and Europe, and vaccine trials are now under way.

MAJOR EPIDEMICS

Syphilis: Estimated 10 million dead, Europe, 1493–1543
Smallpox: 2 million dead, Mex
1519–1522
Cholera: 3 million dead, India,
1876–1877
Influenza: 20 million dead,
worldwide, 1918–1919

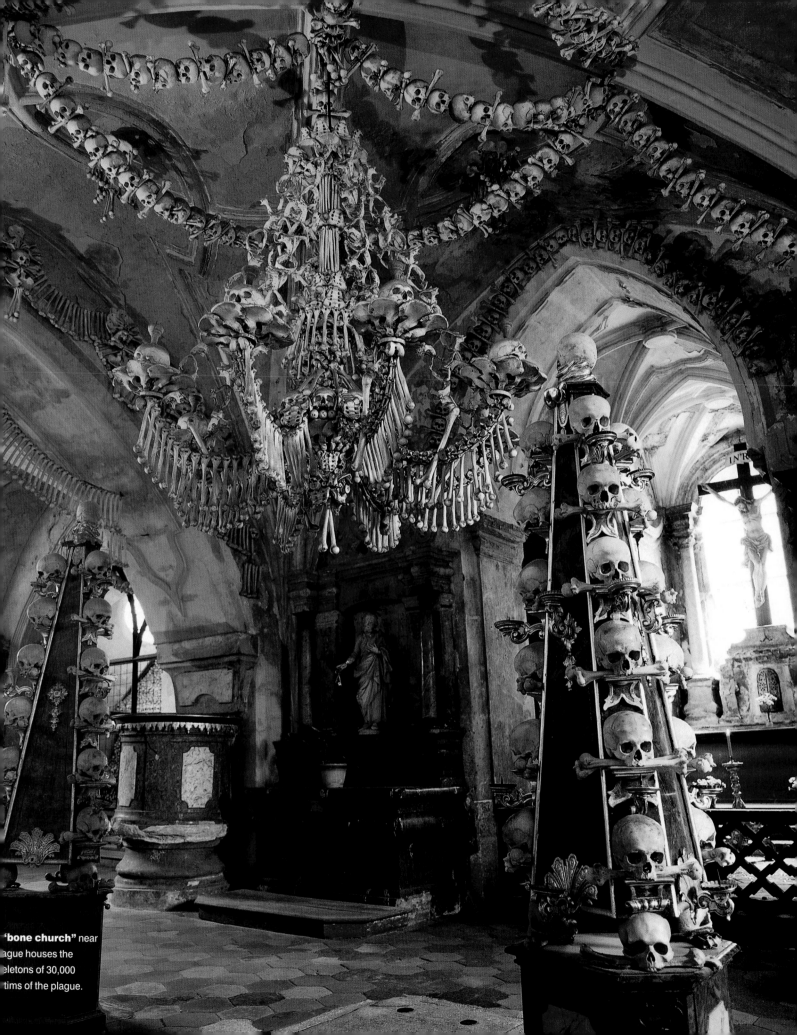

This **"bone church"** near Prague houses the skeletons of 30,000 victims of the plague.

God, it talks!" said a
an emperor in 1876. By
when this photo was shot,
begun to rule teen life.

20

1876 THE TELEPHONE

The first telephone transmission, on March 10, 1876, was a one-way message—"Mr. Watson! Come here! I want you!" But Alexander Graham Bell's invention would change *two*-way communication forever. A professor of vocal physiology at Boston University, the Scottish-born Bell, 29, had dreamed for a decade of sending speech through wires. He was trying to improve the telegraph when he discovered the phenomenon that would make the telephone possible: Sound vibrations caught in a drumlike membrane could be translated into electromagnetic waves. Aided by technical assistant Thomas Watson, Bell figured out how to transmit those waves to a receiver and turn them back into sound. The company he cofounded, Bell Telephone, morphed into AT&T and became one of the largest corporations in the world.

For businesses, governments and ordinary people, the telephone represented a quantum leap in efficiency. Instead of composing a letter or telegram and waiting for a reply, one had only to get on the horn. But the phone altered human relations on a deeper level, too. Millions isolated by circumstance could reach out and touch someone, if only figuratively. No longer requiring physical proximity, intimacy became both easier and less intimate.

Today, there are some 750 million telephone subscribers around the globe. Computers, including 29.7 million that are connected to the Internet, share the circuits. And letter writing is staging a surprise comeback—this time over the phone lines, via E-mail. **PHOTOGRAPH BY IRVING PENN**

DIAL-A-FACT

643,000,000,000: Phone calls made by people in the U.S., 1997
60,268,000: Cell phone subscribers in the U.S., 1998
93.9: Percent of U.S. households with telephone service, 1995
$75: Cost of first three-minute phone call between New York and London, 1927

19

1215 SEEDS OF DEMOCRACY

King John of England was a knave. He waged costly wars, sold legal judgments, imposed crushing taxes, seized hostages from his barons' households. In 1215 the barons rose against him, forcing John to sign the Magna Carta—and securing the unsavory king a place in the annals of human freedom.

Most of the document simply held the monarch to his feudal obligations. But it also contained seeds of democracy. No free man was to be imprisoned without "the lawful judgment of his peers." Justice was not to be sold or impeded. No property was to be seized without compensation. Should the king renege on the charter, the barons had the right to revolt. John did renege, and died fighting in 1216. The Magna Carta lived on. Its promise of due process came to cover all social classes. Its requirement that the king consult the barons on decisions was used to justify parliamentary limits on the monarchy. It influenced Locke and Rousseau, who preached that governments must protect citizens' rights or perish—a notion central to the American and French revolutions. Its echoes persist in many constitutions. And when the U.N. adopted the Universal Declaration of Human Rights in 1948, coauthor Eleanor Roosevelt called it the "Magna Carta of all mankind." **PHOTOGRAPH BY DENIS WAUGH**

EVERYBODY'S MAGNA CARTA

In the aftermath of the Holocaust, a United Nations commission set out to establish a "common standard" of behavior for civilized nations. The result was the 1948 Universal Declaration of Human Rights, which began with the items found in most constitutions and added new ones—the rights to work, education and social security, to join trade unions, to participate in cultural life and enjoy the fruits of science. Although the U.N. ratified it (with only the Soviet bloc, South Africa and Saudi Arabia abstaining), few nations today—including the U.S.—fully live up to the code.

Runnymede Meadow:
The Magna Carta, signed here, planted ideas that blossomed into democracy.

18

1095 THE CRUSADERS WERE HERE The 200-year Christian campaign to reclaim Jerusalem from Muslim rule brought Europe's greatest military and commercial expansion since the fall of Rome. It inspired a wealth of art, literature and song. It was also a bloody episode, a portent of ethnic strife to come.

Purported relics from the era of Jesus, unearthed in Jerusalem (the Holy Lance, John the Baptist's remains), proved to Western Christians that the city belonged to them. Almost from the moment Pope Urban II launched the First Crusade in 1095, zealots plundered their way toward Palestine, slaughtering unbelievers—including thousands of European Jews.

In 1099 the Christians took Jerusalem. But battles continued there and throughout the Middle East, and in 1244 the Muslims regained the city. Still, Europe won much from the Crusades. Mining and manufacturing were revived. New trade routes opened, conduits for Eastern imports that enriched the West: silk, spices, gunpowder, algebra. A less popular novelty was the income tax—instituted to help pay for the holy wars. **PHOTOGRAPH BY ZEV RADOVAN**

BRINGING IT BACK HOME

Some things Europeans got from the Crusades: apricots, artichokes, brocades, cinnamon, cloves, cotton, ginger, glass mirrors, henna, ivory, muslin, opium, pepper, Persian carpets, pistachio nuts, rhubarb, silk, slippers, steam baths, sugar, watermelon, windmills

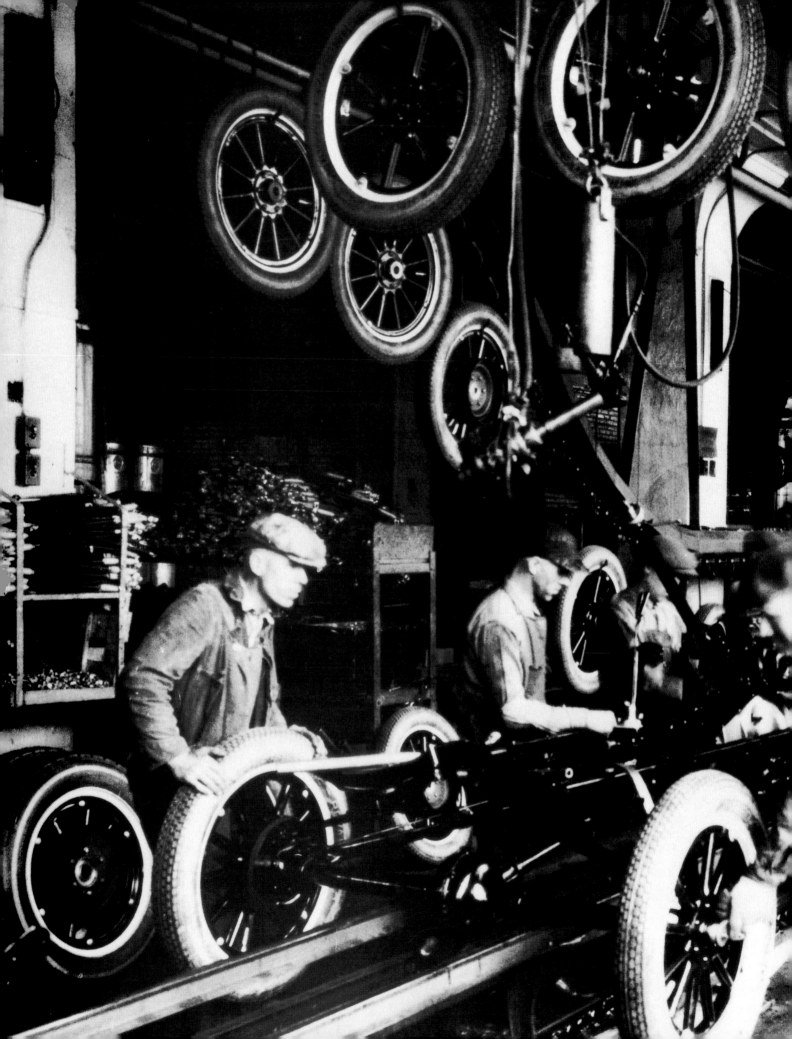

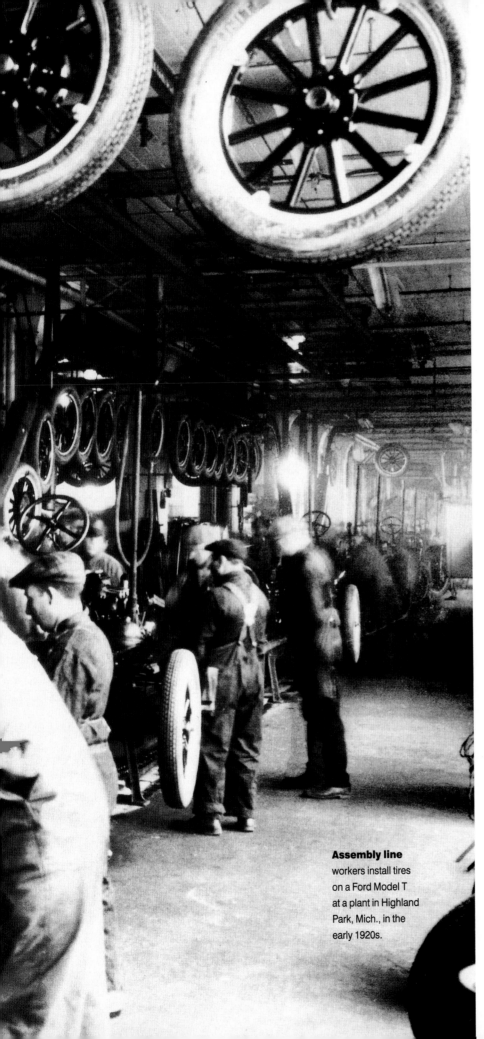

17

1908 FORD'S MODEL T

The automotive age began in 1908 when Henry Ford unveiled his "car for the great multitude." At $850, the tough and homely Model T was the first car that could fit a farmer's budget. Prices fell still further after Ford introduced a revolutionary system—the moving assembly line—that eventually spewed out a Tin Lizzie every 24 seconds. As other manufacturers adopted Ford's methods, cars altered the face of the planet. Industries arose to serve a flood of travelers. The economics of petroleum decided the fate of nations. Traffic deaths mounted (43,200 fatalities in 1997 in the U.S. alone). Smog spread inexorably. And so did another by-product of the assembly line: the culture of mass consumption. **PHOTOGRAPH FROM THE FORD ARCHIVES**

CAR FACTS

Motor vehicles manufactured worldwide, 1996: 51,513,163

Best-selling model in U.S., 1996: Ford Taurus, 401,049

Country with highest per capita motor vehicle registration, 1995: San Marino, 1 car per person

Country with lowest per capita motor vehicle registration, 1995: Ethiopia, 1 car per 1,358 people

Assembly line workers install tires on a Ford Model T at a plant in Highland Park, Mich., in the early 1920s.

16

1945 THE DAY TIME STOOD STILL

It took a blitzkrieg to start Wor[ld] War II, but only two bombs to end it. The first, on August 6, 194[5] leveled most of Hiroshima, annihilating some 80,000 Japanese [in] a blinding flash. The second hit Nagasaki three days later, killir[g] 40,000. After three years of top-secret work, the Manhattan Pro[j]ect had translated Einstein's theory of relativity into devastatir[g] reality: a weapon that harnessed the energy released by the spli[t]ting of the atom. The effects of the A-bombs were as eerie as the[y] were deadly. Those closest to the blasts were vaporized, leavir[g] bright silhouettes on blackened ground. Others perished slowl[y], radiation flaying them and devouring their organs. Cancer adde[d] to the toll, which eventually approached 200,000 in Hiroshim[a]. Whether or not the atomic attacks were militarily necessary [a] question that continues to stir debate today), one thing was clea[r] from the moment the *Enola Gay* released its payload: Huma[n] beings now had the means to exterminate humanity. The mus[h]room cloud would shadow politics and culture—and the dreams [of] millions—forever after. **PHOTOGRAPH BY SEIJI FUKASAWA**

THE NUCLEAR CLOUD

The fear of future Hiroshimas triggered a nuclear arms race. The Soviets tested their own A-bomb in 1949 and the far more powerful hydrogen bomb in 1953. The U.S. and the U.S.S.R. kept upping the firepower, each aiming to amass enough nuclear weapons to frighten its rival out of using them. When the cold war ended in 1989, it was partly because the arms race had bankrupted the Soviet Union. By then there were at least 60,000 warheads stockpiled in the two countries, enough to kill everyone on earth many times over.

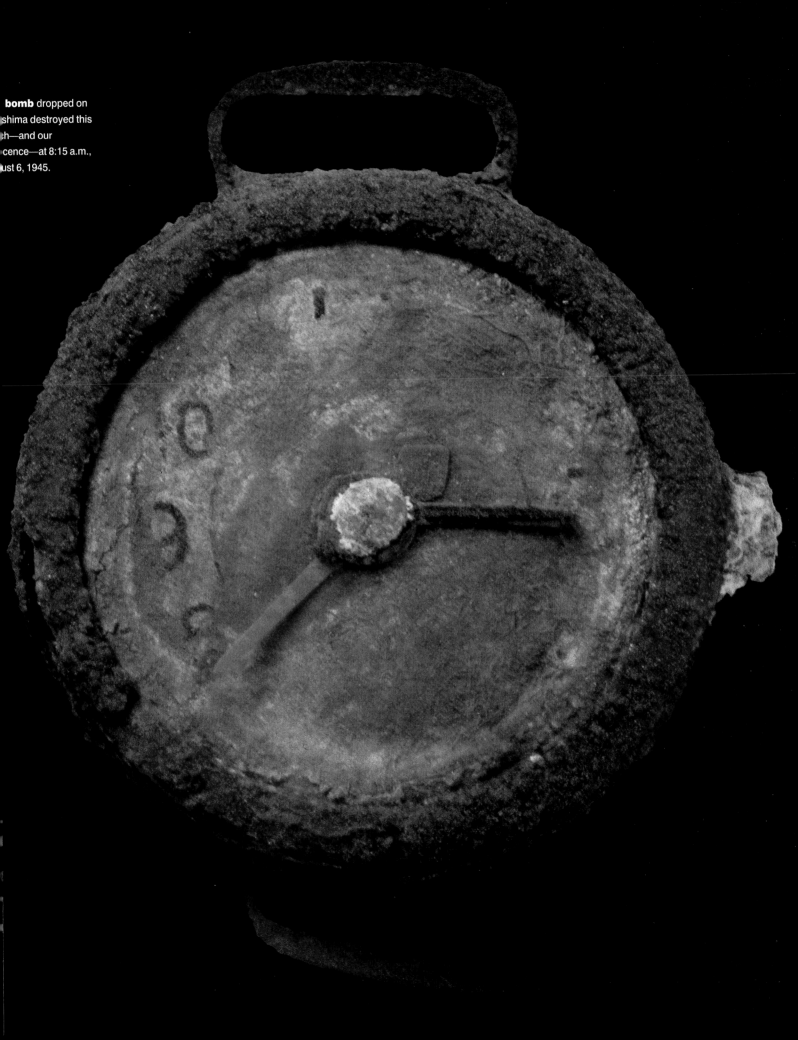

bomb dropped on
shima destroyed this
h—and our
cence—at 8:15 a.m.,
ust 6, 1945.

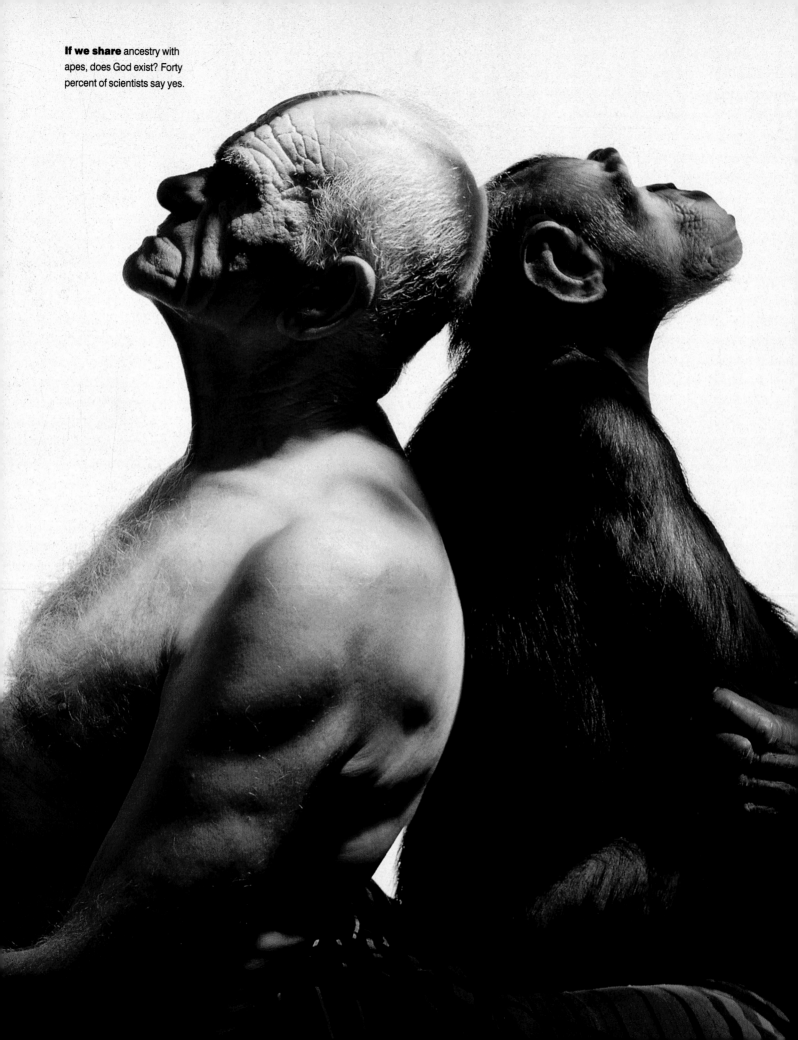

If we share ancestry with apes, does God exist? Forty percent of scientists say yes.

15

59 HOW DID WE GET HERE? He was the first scientist to come with a compelling alternative to the biblical account of creation. Observing plants and animals during a five-year voyage around the world on the H.M.S. *Beagle,* Charles Darwin concluded that evolution explains the diversity of living things. In *Origin of Species* (1859), the English naturalist posited that random mutations may help an organism—a Galápagos finch, say—adapt to its environment. Better equipped for survival, it would also be more likely to pass advantages on to its offspring. Over generations, this process of "natural selection" might give rise to whole new species. Indeed, all life might be descended from a few primitive organisms. Darwin was denounced as a heretic, especially for hinting at an ancestral link between humans and apes. But his theory's elegance—its ability to explain so many phenomena that had seemed whims of nature—prevailed. Today evolution is as basic to the scientific worldview as the idea that the earth circles the sun. **PHOTOGRAPH BY JAMES BALOG**

RWIN'S DOUBTERS

g after most scientists accepted Darwin's theory, fundamentalist Christians cted it as contrary to a literal interpretation of the Bible. In 1925, when cher John Scopes fell afoul of Tennessee's law banning evolution from classroom, his trial—pitting creationist crusader William Jennings Bryan inst attorney Clarence Darrow—transfixed America. Scopes lost. And ugh the Supreme Court later ruled that public schools may not teach ationism to promote religious belief, evolution's doubters battle on today.

14

1928 LIVE FROM SCHENECTADY...

As a television show, it had a somewhat limited appeal. *Live from General Electric's radio laboratories in Schenectady, New York, it's* . . . a guy removing his glasses. And then putting them on again. Then blowing a smoke ring. So went the world's first television broadcast—into three homes. Yet on that January afternoon in 1928, GE's brilliant Swedish-born engineer, Ernst F.W. Alexanderson, laid the crude foundation for one of the most powerful media in history.

Ever since the launch of radio broadcasting in the early 1920s, the race had been on to combine and transmit sound with moving images. Two years before Alexanderson's demonstration, Scotsman John Logie Baird used a mechanical scanner to transmit a flickering image of a human head. But GE surpassed Baird's efforts. Four months after Alexanderson's transmission, the company was broadcasting images three times a week, and the basic elements of television were in place. Then in 1937 an electronic system employing the more sophisticated cathode-ray tube was adopted by the BBC in England. The broadcast of the 1947 World Series clinched television's growing importance. By the end of the 1950s, nearly 90 percent of U.S. homes could boast at least one TV set. The world no longer needed to be imagined—now it could be seen and heard. America had a new communal fireplace. **PHOTOGRAPH BY PASCAL MAITRE AND YVES GELLIE**

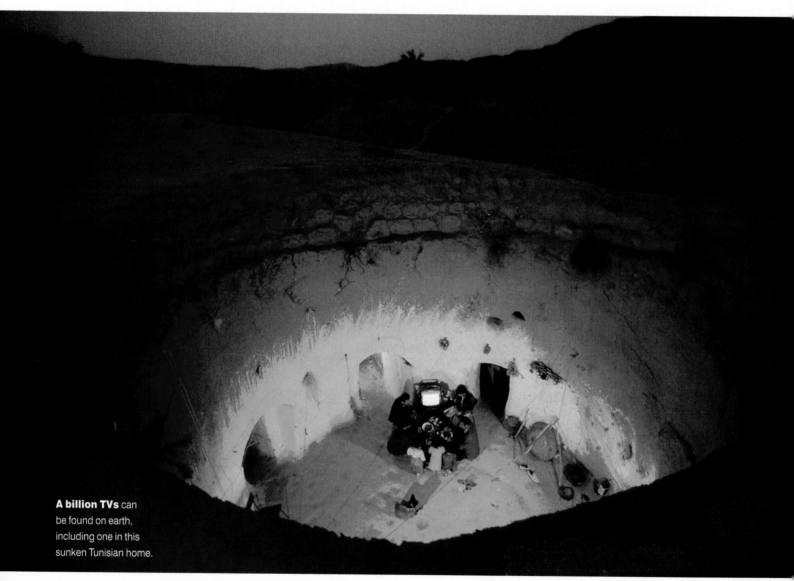

A billion TVs can be found on earth, including one in this sunken Tunisian home.

Iran, 1956: When the
U.S. gave shots felt
around the world, moms
smiled, kids cried.

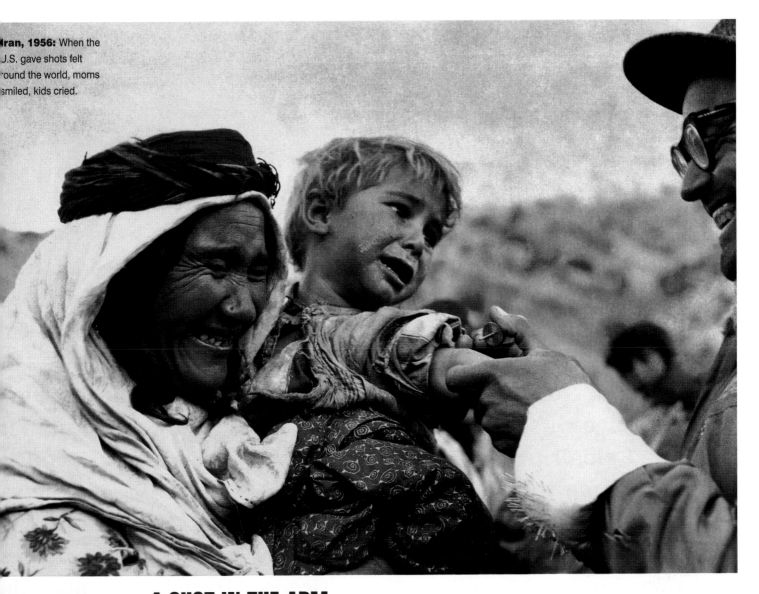

13

1796 A SHOT IN THE ARM The eradication of one of the worst plagues ever can be traced to a cow. Smallpox caused scarring and blindness and, at its peak in the 18th century, killed 60 million Europeans, most of them children. Variolation, a 2,000-year-old practice of inoculating patients with strains of a disease, was often so bizarre—and deadly—as to be worse than the disease itself. In China doctors crumpled smallpox scabs and blew them up the nostrils of healthy patients, sometimes infecting them with other illnesses.

Enter Edward Jenner, a general practitioner from rural England. Trusting in the popular belief that cowpox built one's immunity to smallpox, Jenner extracted cowpox-infected lymph from pustules on a Gloucestershire milkmaid in 1796 and inserted a small amount into the arm of an eight-year-old boy. Seven weeks later, Jenner injected the boy with smallpox. His immune system held its ground; the science of immunology had become a possibility. Vaccinations for diphtheria, polio and measles revolutionized public health—and created one of the first battle wounds of childhood. The word is derived from the Latin *vaccinus,* meaning "of the cow," a nod to an anonymous English animal to whose stature Mrs. O'Leary's can only aspire. **PHOTOGRAPH FROM THE U.S.I.S.**

A POX ON THE FUTURE?

The last known case of smallpox (aside from a woman infected in a lab accident) occurred in Somalia in 1977. Three years later, the disease became the first on earth to be officially declared eradicated. But the virus lives on—in more than 500 frozen specimens—at two maximum-security facilities in Atlanta and Koltsovo, Russia. The World Health Organization, citing the dangers of a leak, has called for the destruction of both stocks. Some scientists, however, urge that the samples be preserved because further study may help combat other deadly viruses such as Ebola and HIV.

...tion **1948** First news show **1951** First color set **1956** First videotape recorder **1962** First communications satellite **1998** HDTV

145

12

1509 OF HUMAN BONDAGE

Slavery was with us long before this millennium began. Ancient, medieval, Asian, European, African—almost every society practiced it in some form. But from the 16th through the 19th centuries, the transatlantic slave trade transformed four continents as Europeans shipped 10 million to 15 million Africans across an ocean and into the horrors of servitude. The largest forced migration in history started slowly and followed the expansion of European trade and conquest. The earliest African slaves arrived in the New World in 1509, but their numbers remained small until 1530 when Portugal, the first European nation to trade with the kingdoms of West Africa, began sending slaves to work on sugar plantations in Brazil, then in the West Indies. The suffering during the Middle Passage was enormous, and an estimated 1.5 million died. Uprooted from family, shackled and marched to Africa's coast to be placed in pens before shipping, the slaves knew no end of degradation. For weeks or months they stayed chained together in the hulls of ships, packed in rows, shoulder to shoulder with the sick and dying, not knowing their destination or their fate. **PHOTOGRAPH BY J.T. ZEALY**

SLAVERY'S TOLL

The traffic in human beings played a critical role in the rise of the West, creating private and national fortunes. The expansion of trade and technological advances—indeed, all of Europe's political and economic gains—are difficult to imagine without the exploited labor of millions of Africans. Slavery brought with it upheaval and conflict: a dramatically changed political and social landscape in Africa, including widespread colonization, and a civil war in the United States. It also brought a culture of music, dance and art that has continued to influence the world. But the most lasting impact may be the lesson in human decency that slaves, in their struggle and longing for freedom, taught their masters.

A South Carolina sla...
photographed in 1850

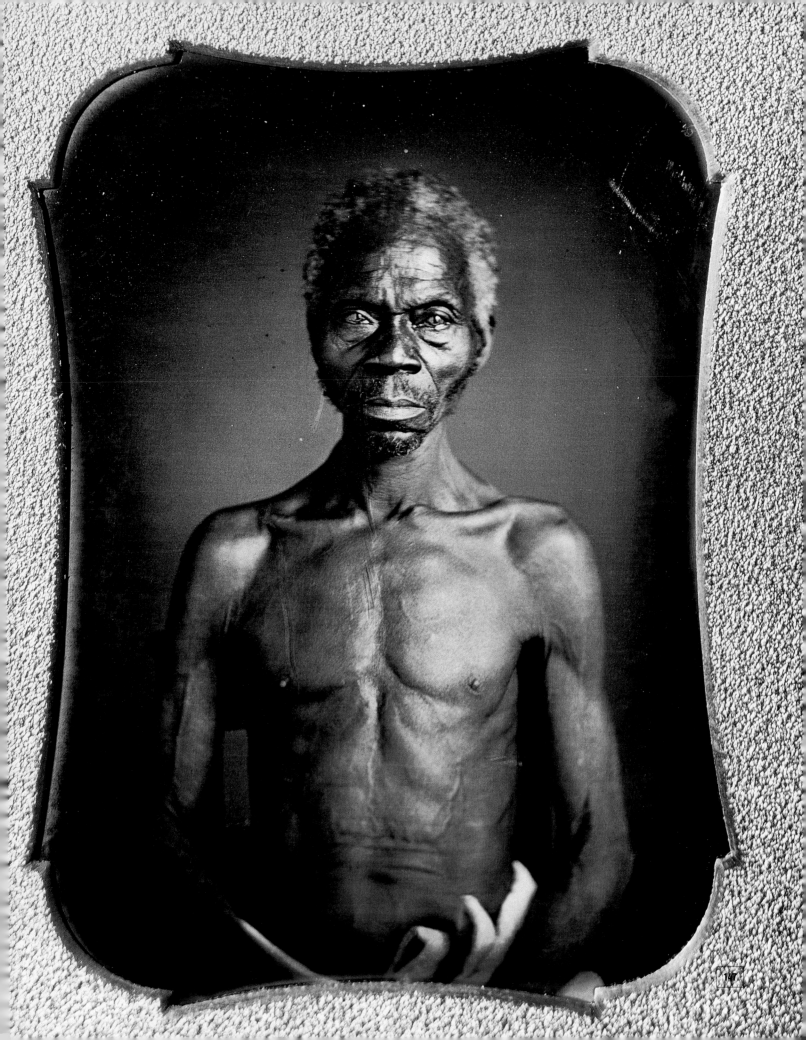

Even a forest of lightbulbs wouldn't begin to represent all of Edison's ideas.

11

1876 THE WIZARD OF MENLO PARK

He tamed both lightning and thunder in a tiny lab in New Jersey. Born in small-town Ohio in 1847, Thomas Alva Edison parlayed an early fascination with chemistry and telegraphy into a string of business successes that in 1876 enabled him to build a boxy two-story building in Menlo Park. It was the first factory in the world designed to produce nothing but inventions. The next year he and a colleague created a machine that translated recorded vibrations into a representation of sound—the phonograph. Then, in November 1879, the Menlo Park team tested a carbonized cardboard filament that could glow for days on end. After more than 1,000 trials, Edison had done it: He had given birth to a useful incandescent lamp. His goal had not been to invent electric light—that had been done decades earlier—but to create a lightbulb that would be long-lasting and inexpensive, along with a system, from power station to screw-in socket, that would render it viable on a large scale. Before Edison, the artificial light that people had to live in was harsh, flickering, ephemeral and dangerous.

In 1903 Edison produced an important early motion picture, *The Great Train Robbery*, which accompanied his many other advances, such as the telephone transmitter, the stock ticker, the fluoroscope, the storage battery and the "Edison effect" lamp (it would lead to the tubes used in radio and television). In all, he held more than 2,000 patents, many of them products of his Menlo Park think tank. It is difficult to overestimate their significance: The can-do intelligence in that little lab let us see and hear. **PHOTOGRAPH BY TIM SIMMONS**

10

1117 THE COMPASS GOES TO SEA It was little more than a magne floating in a bowl of water, but without the nautical compass th millennium's great voyages of discovery could never hav occurred. Invented in China in the 4th century B.C., compasse were first used in *feng shui* (the Taoist system of environment: design). Lodestone pointers were replaced by flat slivers of iro and then by needles, which appeared around the 6th century A.1 But the first account of seagoing compasses doesn't come unt 1117, from Zhu Yu's *P'ingchow Table Talk:* "In dark weathe sailors look at the south-pointing needle." The compass reache Europe around 1190, almost certainly from China. (Its power were so little understood that captains forbade their crews to e onions, which were thought to destroy magnetism.) For Medite ranean sailors, used to long periods when overcast skies made na igation difficult, the device meant liberation. By the 15th centur; they were ready to venture beyond familiar seas. **PHOTOGRAPH BY NEIL WINOI**

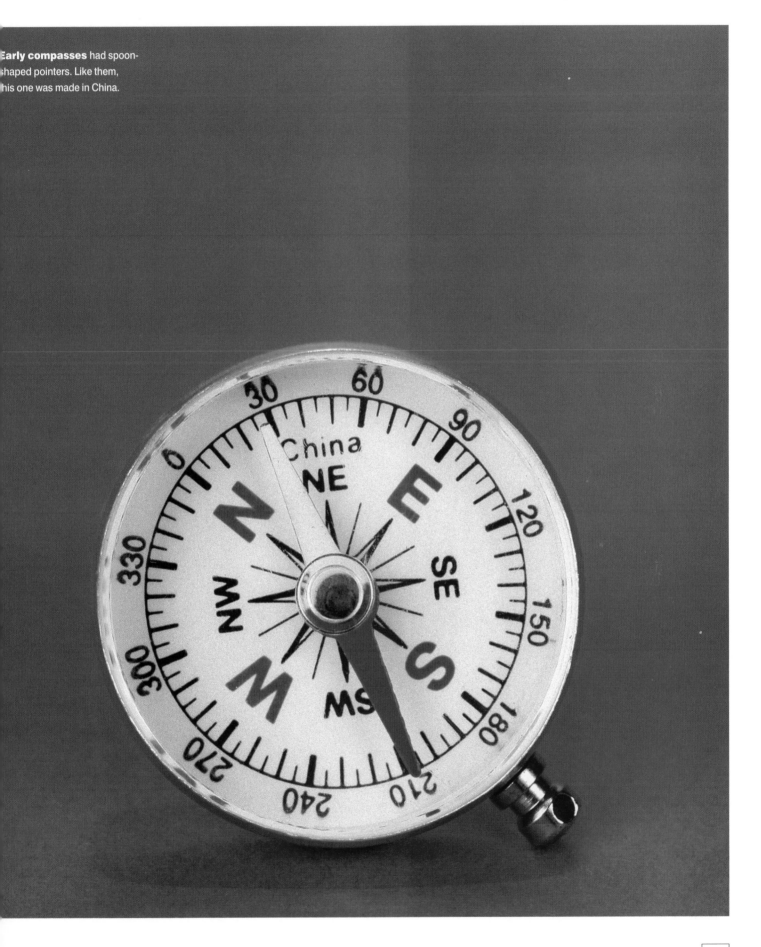

Magellan's crew circumnavigates globe **1770** Cook maps coast of Australia **1906** Amundsen navigates Northwest Passage

151

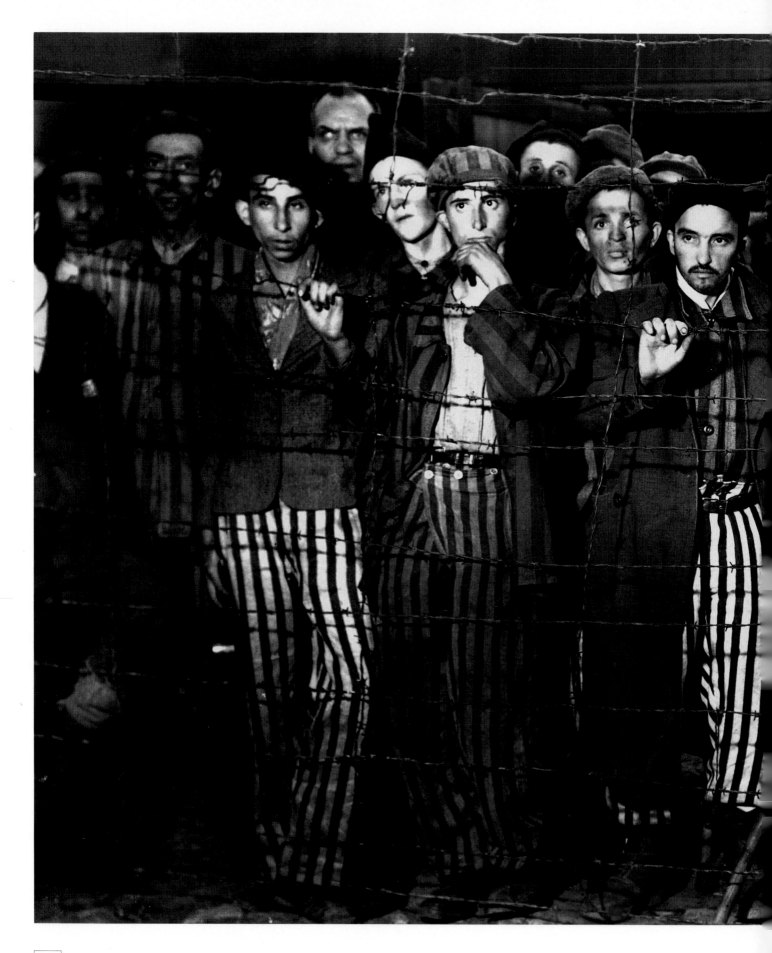

TIME LINE 20TH CENTURY GENOCIDE **1915–16** 1 million Armenians massacred by Turks **1932–33** 5 million Ukrainians starved

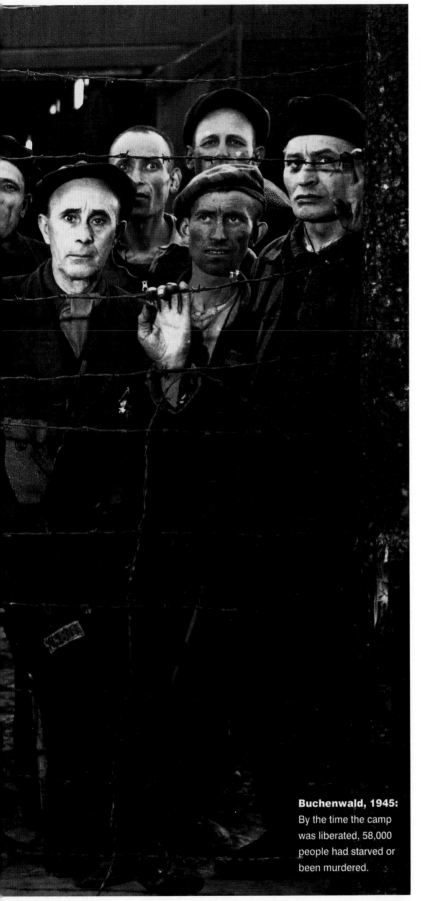

Buchenwald, 1945: By the time the camp was liberated, 58,000 people had starved or been murdered.

9

1933 HITLER COMES TO POWER

In any accounting of the millennium's monsters, first place must go to the ruler who made genocide a multinational industry—Adolf Hitler. The scale of the enterprise boggles the mind: freight trains carrying Jews to human stockyards from across Nazi-occupied Europe; victims worked to death, shot or gassed; corpses incinerated or processed into soap; gold teeth harvested for the coffers of the Reich. Hitler's megalomania sparked the Holocaust and history's most destructive war. The preparation for both began the moment he became Germany's chancellor in January 1933.

Promising salvation from the chaos of the Depression, Hitler swept aside German democracy. A hypnotic orator, he preached a sort of crank Darwinism: At evolution's pinnacle were the so-called Aryans (Germans and other Nordic peoples), destined to subdue or destroy all "inferior" races—particularly the Jews, whom Hitler blamed for most of humanity's ills. Linking ancient prejudice to wild dreams of glory, this mad ideology galvanized the nation. Herded into lockstep by the propaganda and police forces of a totalitarian state, Germans prepared to conquer the earth.

World War II began in 1939 with Hitler's invasion of Poland. Six years later, the Axis countries were vanquished; some 17 million combatants and 60 million civilians were dead. And within that horror lay a new benchmark of evil: six million Jews and nearly as many other "undesirables" (Gypsies, homosexuals, leftists, Slavs) systematically slaughtered. **PHOTOGRAPH BY MARGARET BOURKE-WHITE**

THE NAZI LEGACY

Hitler's war for Aryan supremacy backfired spectacularly. It made superpowers of the U.S. and the Soviet Union (whose populations he reviled as genetically unfit). It led to the founding of the multiracial United Nations and the Jewish state of Israel. Half of Germany fell to communism. The other half gained more wealth through commerce than it had ever won by force.

forced collectivization **1975–78** 1.5 million Cambodians killed by Khmer Rouge **1994** 1 million Tutsi murdered by Hutu in Rwanda

8

1776 A DECLARATION TO THE WORLD

"We hold these Truths to be self-evident, that all Men are created equal, that they are endowed by their Creator with certain unalienable Rights. . . ." Today most governments at least pay lip service to those truths. But before July 4, 1776, when the Continental Congress adopted "The unanimous Declaration of the thirteen united States of America," no nation had been founded on such enlightened principles.

Penned by 33-year-old Virginia delegate Thomas Jefferson, the Declaration was meant to explain, after a year of war, the American colonies' break with Britain. The document listed the offenses of King George III, ranging from restriction of trade to the use of foreign mercenaries. (A passage denouncing the king's promotion of slavery was cut to placate some delegates.) More important, it laid out the concept of natural rights—borrowed largely from British philosopher John Locke—that would form, in the words of Congress president John Hancock (one of the document's 56 signatories), "the Ground & Foundation" of the U.S. government.

The Declaration became more than just one country's manifesto. It spurred Latin Americans to sever ties with Spain and the French to overthrow their king. Vietnam's Ho Chi Minh paraphrased it when he defied France. And its avowal that all men are born equal moved more than males: When the U.S. women's suffrage movement was launched in 1848, its founders modeled their declaration on Jefferson's. PHOTOGRAPH BY ROBERT LEWIS

FIGHTING WORDS

"That to secure these Rights, Governments are instituted among Men, deriving their just Powers from the Consent of the Governed, that whenever any Form of Government becomes destructive of these Ends, it is the Right of the People to alter or to abolish it . . ."

Jefferson's "appeal to the tribunal of the world" was taken up by revolutionaries everywhere.

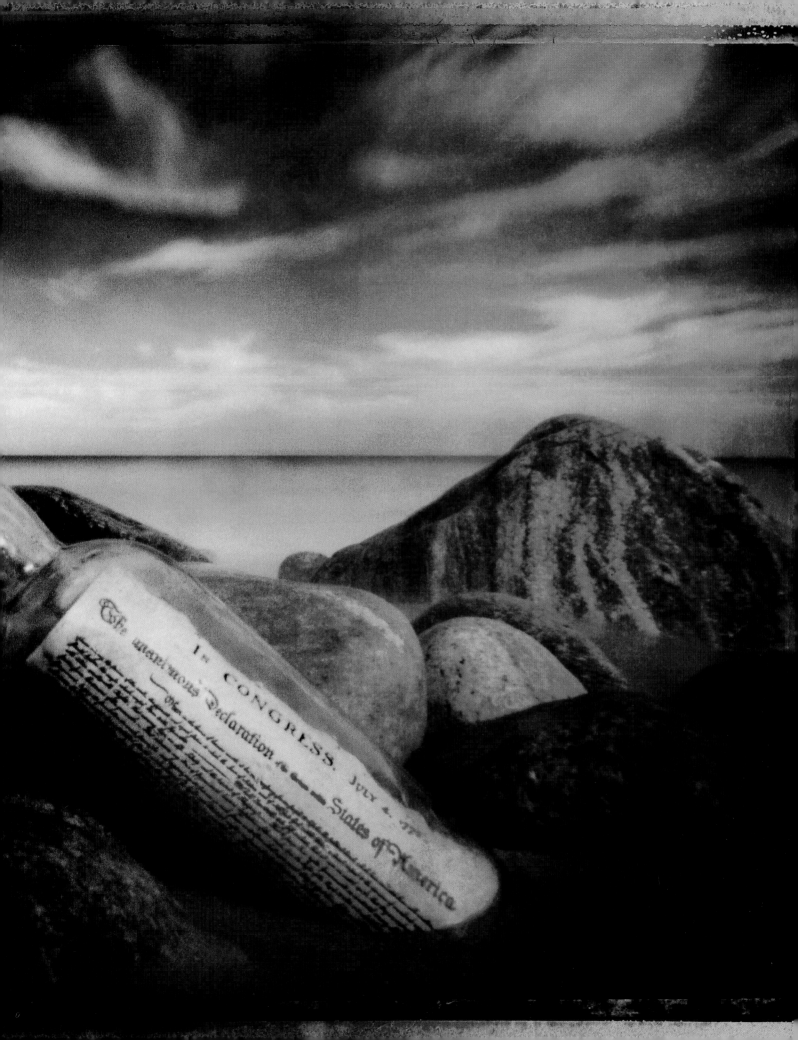

Seventy-five million
handguns in the U.S. rely
on gunpowder, first used
in weapons in China.

TIME LINE **GUNS** **c. 1350** First hand cannon **c. 1425** First musket **c. 1540** First pistol **1836** First Colt revolver **1866** First Winc

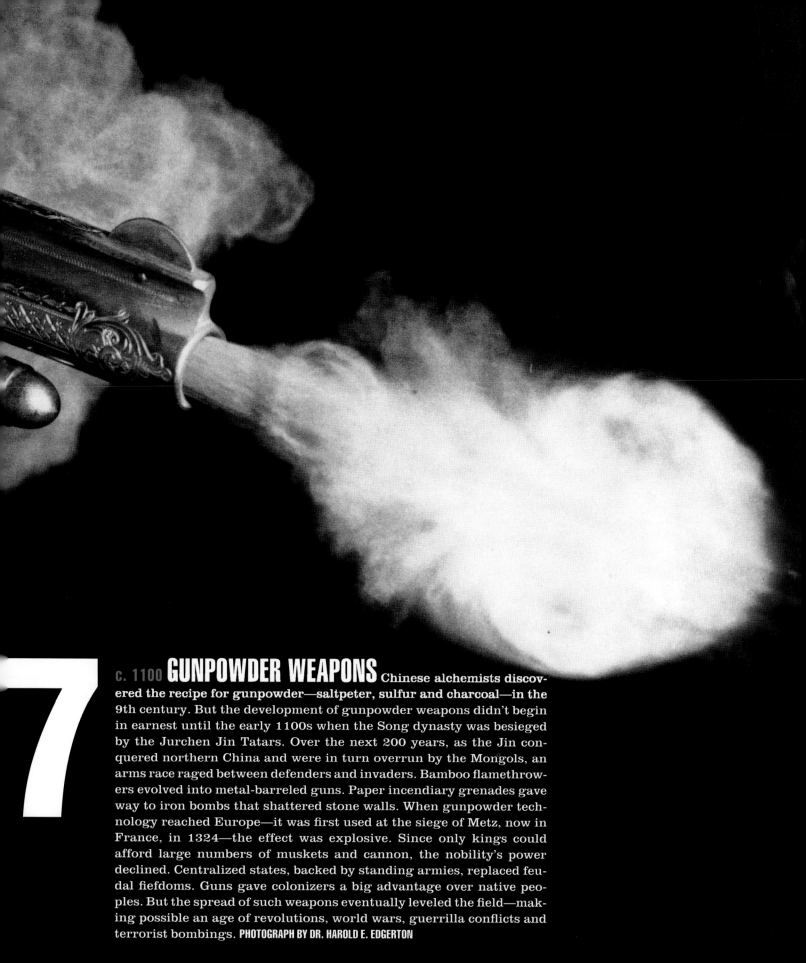

7

C. 1100 GUNPOWDER WEAPONS Chinese alchemists discovered the recipe for gunpowder—saltpeter, sulfur and charcoal—in the 9th century. But the development of gunpowder weapons didn't begin in earnest until the early 1100s when the Song dynasty was besieged by the Jurchen Jin Tatars. Over the next 200 years, as the Jin conquered northern China and were in turn overrun by the Mongols, an arms race raged between defenders and invaders. Bamboo flamethrowers evolved into metal-barreled guns. Paper incendiary grenades gave way to iron bombs that shattered stone walls. When gunpowder technology reached Europe—it was first used at the siege of Metz, now in France, in 1324—the effect was explosive. Since only kings could afford large numbers of muskets and cannon, the nobility's power declined. Centralized states, backed by standing armies, replaced feudal fiefdoms. Guns gave colonizers a big advantage over native peoples. But the spread of such weapons eventually leveled the field—making possible an age of revolutions, world wars, guerrilla conflicts and terrorist bombings. **PHOTOGRAPH BY DR. HAROLD E. EDGERTON**

884 First Maxim machine gun **1890** First semiautomatic rifle **1892** First semiautomatic pistol **1947** AK-47

6

1882 GERM THEORY

Disease was once thought to be caused by evil spirits. The connection between sickness and germs remained a mystery until the mid-19th century, when experiments revealed that infectious agents can multiply within the human body. By 1864, French scientist Louis Pasteur had concluded that microorganisms were also present in the air. He isolated microbes responsible for fermentation and silkworm diseases, but it took 12 more years for Robert Koch, a German scientist, to show that a specific bacillus caused a specific disease. Koch's work with anthrax and tuberculosis established the germ theory of disease and had immediate implications for diagnosis and treatment. His 1882 report of the discovery of the microbe that causes TB proved the disease's infectiousness and outlined his famous postulates, still used today, that link a given organism to a specific illness. The work of Pasteur and Koch ushered in the science of bacteriology and led to developments in immunology, sanitation and hygiene that have done more to increase the life span of humans than any other scientific advance of the past 1,000 years. PHOTOGRAPHS FROM THE CUSTOM MEDICAL STOCK COLLECTION

WASHING UP

When Hungarian physician Ignaz Semmelweis asked medical students at his hospital in 1848 to wash their hands before seeing patients, mortality rates plummeted—yet his hygienic preachings were widely attacked. In 1865 (the year Semmelweis died of an infected cut on his hand), English surgeon Joseph Lister, inspired by Pasteur, began using carbolic acid as an antiseptic; despite his successes, it took more than a decade for "Listerism" to catch on. After Koch, progress came faster: steam sterilization in 1886; surgical gloves in 1890; gauze masks in 1896.

Tiny killers: *E. coli* (top left) and bubonic plague bacteria (top right); a TB bacterium (bottom left) magnified 105,600 times and a group of them (bottom right).

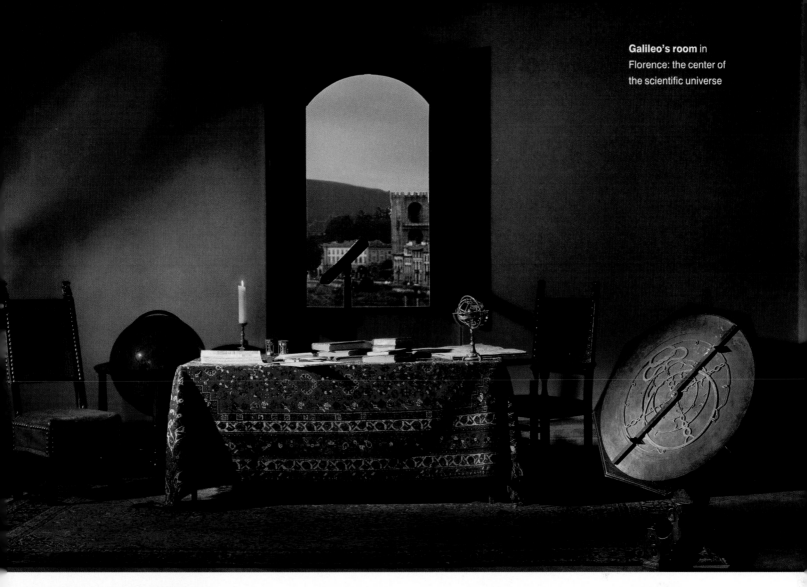

10 GALILEO'S TELESCOPE

The tension ween religion and science can be symbolized by man: Galileo Galilei. He did not originate the ory that the earth revolved around the sun. Nor he invent the telescope. But Galileo's skill as a :hanic enabled him to improve the telescope ugh that in 1610 he was able to see the moons upiter. He used the sightings to support the that Jupiter and Earth both revolve around sun. And, at least at the time he published his uments, he possessed a spine stiff enough to d up to the Catholic Church, which believed earth was the center of the universe.

The textbook version of Galileo's life calls him father of modern mechanics because of his k on the laws of motion. Born in Pisa in 1564, ecame a math professor and developed the law lling bodies—that falling objects accelerate at same rate regardless of their mass.

he breathing, pulsing Galileo was a compli-:d character whose sense of self-importance knew few bounds. He abandoned his mistress and stashed his two daughters in convents. He used political connections to impede competing inventors. His arrogance ultimately helped cause a quake within the Church that a more diplomatic scientist might have avoided.

With its armies facing Protestant forces to the north, the Catholic Church was in no mood to accept any questioning of its authority. Pope Urban VIII, convinced that Galileo had mocked him, felt compelled to call the astronomer before the Inquisition. Under threat of torture, at the age of 69, Galileo recanted and was placed under house arrest until his death nine years later. To this day, the world remembers him for an exchange that may in fact be fiction. After recanting, Galileo is said to have muttered, "And yet it [the earth] does move." Whether or not those words were spoken, it took more than 300 years for the Church, under Pope John Paul II, to do its own recanting. **PHOTOGRAPH BY ERICH LESSING**

5

EYE IN THE SKY

Through his spyglass, Galileo could see objects 100 times fainter than those visible to the naked eye. The Hubble Space Telescope, launched in 1990, can detect objects a billion times fainter—and witness almost the entire history of the universe.

159

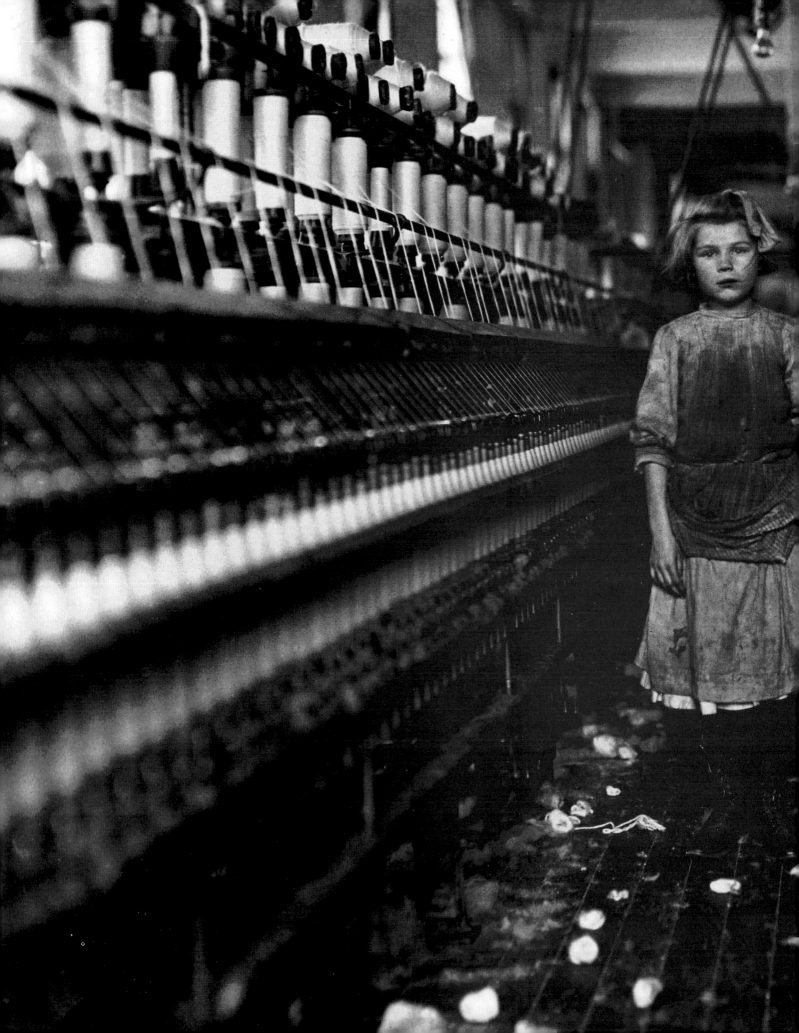

4

THE INDUSTRIAL REVOLUTION

A column of black smoke splits the millennium: People who lived before the Industrial Revolution could not have imagined what the world would someday look like, just as those living in its wake can scarcely envision a time without its conveniences and ills.

James Watt, a mathematical-instrument maker at Glasgow University, triggered the change by tinkering with a model of the Newcomen steam engine, built in 1712 to pump water out of mines. He patented a version in 1769 that saved 75 percent in fuel costs. Soon his superior engines powered coal mines and textile mills, as well as the railroads and ships that carried the new technologies to the Continent and the New World. Before, Britons had been agrarian; by 1870, more than two thirds of them had moved to cities, living mostly in slums, where overcrowding, poor sanitation and outbreaks of typhus, cholera and dysentery were common. Factories belched smoke. Mines and quarries scarred the earth.

The landscape of the postrevolution family also changed. Women and children as young as six were exploited by factory bosses. For the upper classes, the result was an elevated quality of life. Rapidly expanding prosperity, combined with the new cost-efficiency of machines, gave bankers, entrepreneurs and merchants wealth on an unprecedented scale. A middle class of managers grew more educated, enjoying better health, more leisure time and greater mobility. Even the lower class could afford better, cheaper products. Despite Luddite attacks on machinery, the revolution kept gathering steam. **PHOTOGRAPH BY LEWIS HINE**

MARY—FALL RIVER, MASS., 1905

"I got a job 'spooler-tender' when I was twelve—there wasn't the law then. I must of been about fourteen when I went to weaving. . . . At first the noise is fierce, and you have to breathe the cotton all the time, but you get used to it. . . . Only it's bad one way: when the bobbins flies out and a girl gets hurt, you can't hear her shout. . . . You can't never tell when you will get hit—in the eye some time, most likely!"

Children, like this young girl at a textile mill in the U.S., were sought after for factory work.

3

1517 LUTHER KNOCKS Martin Luther was tortured by anxiety abo[ut] his own sinfulness. How, he wondered, could the Vatican promi[se] forgiveness of sins in exchange for donations? Didn't the powers [of] mercy and redemption belong to God? Unable to contain his ske[p]ticism, Luther nailed his "Ninety-Five Theses" to the door of t[he] All Saints Church in Wittenberg, Germany, on October 31, 1517[. A] criticism of papal policy, particularly the selling of "indulgence[s,]" the document stressed the inward, spiritual character of the Chr[is]tian faith. It denounced those who would pay fees to avoid havi[ng] to share privately in the suffering of Christ, and it rejected t[he] notion that Church doctrine had authority approaching that [of] Scripture. The Vatican quickly moved against Luther, fina[lly] excommunicating him in 1521. "Here I stand," Luther said. "I c[an] do no other." When the Edict of Worms declared him a political o[ut]law, his message was taken up by others. The laity took over mo[n]asteries and their landholdings; priests married; princes alli[ed] against the Holy Roman Empire; and bishops were appointed [by] secular authorities. The Reformation had begun: Political autho[ri]ty would never again be fully subject to the dictates of a dista[nt] clergy, and the map of Europe would be determined by the natio[n]alism that still dominates world politics today. **PHOTOGRAPH BY WILFRIED KIRS[CH]**

PROTESTANT DENOMINATIONS

Estimated worldwide figures for some major denominations	**61,000,000:** Lutheran	**33,000,000:** Methodist
	56,000,000: Baptist	**2,500,000:** Episcopalian
70,000,000: Anglican	**46,000,000:** Presbyterian	**1,400,000:** United Church of Christ

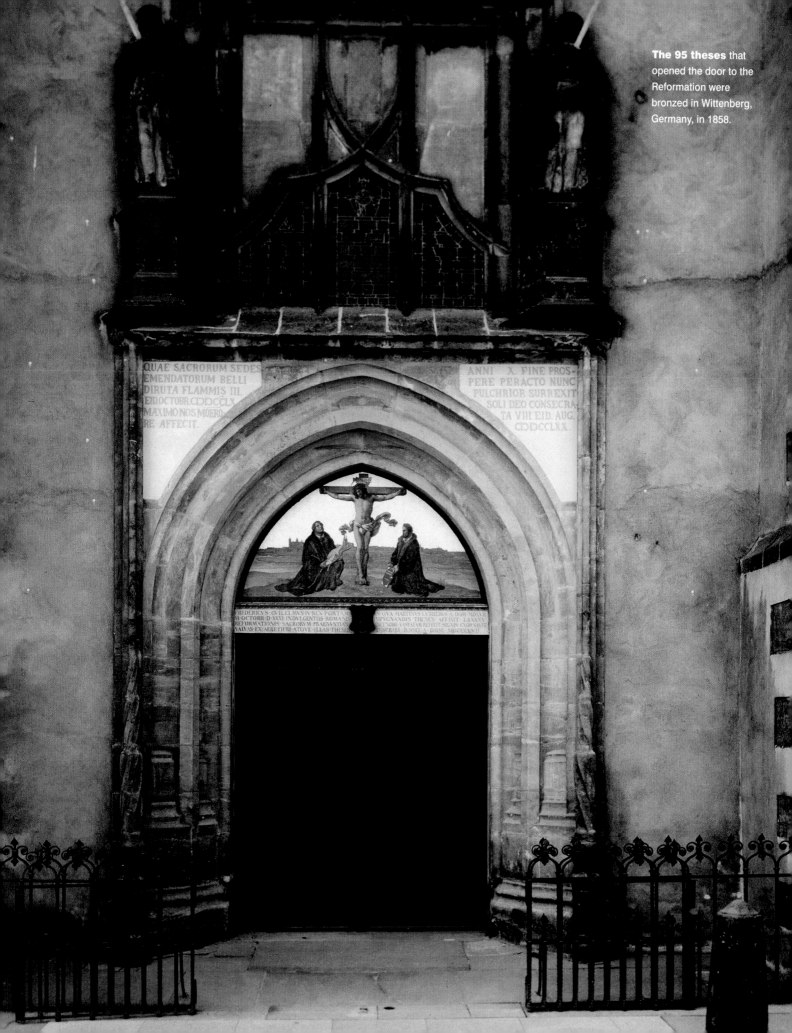

2

1492 COLUMBUS'S VOYAGE

Christopher Columbus died a magnificent failure. Four times he tried to find a route to Asia by sailing west across the Atlantic. When his quest ran aground against another continent, he simply insisted Cuba was part of China.

Columbus set sail in August 1492—and got lost. Only shouts of *"Tierra, tierra!"* on October 12 ended threats of mutiny. The island the natives called Guanahani, renamed San Salvador by Columbus and now part of the Bahamas, is believed to have been his first landfall. He thought the native people simple, naturally good and "easy to conquer"—until they resisted. Then things got ugly. His governorship of Hispaniola (Haiti) was the low point, an outburst of gold fever accompanied by the enslavement and slaughter of the native people. In December 1500, Columbus was arrested for mismanagement and sent home in chains. Ideas, goods, deadly microbes, colonizers and African slaves followed him to America. His discovery of a "new world" may have been accidental, but his adventurous spirit played no small role in creating a new, global civilization. **PHOTOGRAPH BY PIERRE BOULAT**

TRADING PLACES

Some things Europe got from the New World: avocados, cacao beans, cod, corn, peanuts, pineapples, potatoes, tobacco
Some things the New World got from Europe: apples, Christianity, guns, hogs, horses, oranges, rice, roses, smallpox, wheat

For the 500th anniversary of Columbus's voyage, a replica *Santa María* retraced his transatlantic path.

1

1455 GUTENBERG PRINTS THE BIBLE

Of all the millennium's technological revolutions, the most far-reaching started just before the era's midpoint. Throughout history, the ability to read and write had been confined mostly to tiny elites of nobles, priests and scribes. But in the 15th century a literate middle class arose in Europe. Its hunger for knowledge led inventors to seek a way to mass-produce the written word. And when German goldsmith Johann Gutenberg succeeded—creating his masterpiece, a run of 200 gorgeously typeset Bibles, in 1455—he unleashed an information epidemic that rages to this day.

To appreciate Gutenberg's achievement, it is necessary to understand what he did not do. He didn't invent printing: The craft emerged in 8th century China, using multiple characters carved on a single woodblock. He didn't invent movable type (letters rearranged for each new page): Chinese printer Pi Sheng did, around 1040. Gutenberg didn't even invent movable metal type: The Koreans did, in the 14th century. But wood-block printing of text reached Europe only in the early 1400s, and it appears that no one on the Continent knew of Asia's more advanced techniques. Movable type had not, in fact, caught on widely in China or Korea, where writing involved 10,000 characters. In Europe, however, such technology seemed full of promise. What Gutenberg devised was the first Western movable-type system that worked—so well that it remained largely unchanged for 350 years.

Gutenberg designed a new kind of press, based on those used to squeeze olives. He came up with a tough, cheap alloy of lead, tin and antimony, and a precisely calibrated type mold to pour it into. He concocted a smudge-resistant ink of lampblack, turpentine and linseed oil. Each page of his Bible probably took a worker a day to set, but once the type was in place, the rest was relatively easy.

Gutenberg's methods spread with stunning rapidity. By 1500 an estimated half million printed books were in circulation: religious works, Greek and Roman classics, scientific texts, Columbus's report from the New World. An acceleration of the Renaissance was only the first by-product of the Gutenberg press. Without it, the Protestant movement might have been stillborn, as well as the subsequent political and industrial revolutions. Gutenberg, however, got none of the glory. His brainchild bankrupted him; the year his Bible was published, a creditor took over his business. Little more is known of the inventor—in part because he never put his own name into print. **PHOTOGRAPH BY CRAIG CUTLER**

THE BEST-SELLING BOOK OF ALL TIME

2,500,000,000: Estimated number of Bibles sold or distributed worldwide since 1815

2,197: Languages into which excerpts from the Bible have been translated

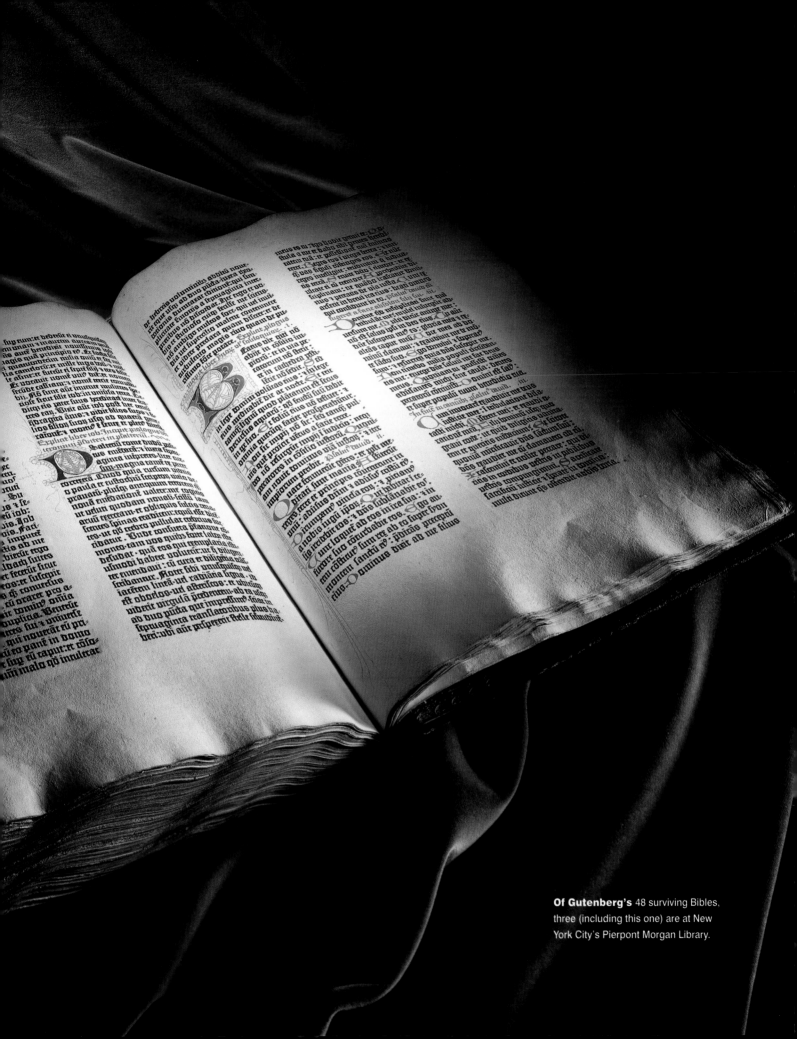

THE 100 PEOPLE WHO MADE THE MILLENNIU

What, no Babe Ruth? How, you ask, could a list of the millennium's most important people not include the Sultan of Swat? Plenty of other monarchs failed to make the lineup as well. To get on this team, a person had to change more than just a corner of the world—he or she had to divert the great stream of human history, alter our perceptions perceptibly. A runner edged out Ruth (and Jackie Robinson) by setting a

new standard for any owner of two legs. You'll find his na at No. 92 on the following list, which ranks the honoree importance. Many names will be familiar from the events tion, but not all. A few—Watt, Koch, Gutenberg—app there but not here. Some of history's paramount figures remembered more for a single accomplishment (such as t ering in the age of print) than for the force of their perso

1847–1931

1
THOMAS EDISON

Because of him, the millennium will end in a wash of brilliant light rather than in torchlit darkness as it began. In 1879, Thomas Edison gave humans the power to create light without fire by inventing a long-lasting, affordable incandescent lamp. Among life's many conveniences we can take for granted, thanks in part to him: radio, movies, TV, telephones (he improved on Bell's). The night after his funeral, Americans dimmed their lights for the man who lit up the world.

1451–1506

2
CHRISTOPHER COLUMBUS

He failed four times to find a route westward from Europe to the Orient, but the Italian explorer stumbled upon two giant continents rich in raw materials and agricultural products that would change the economy and politics of the world. Christopher Columbus is often criticized—principally for cruelty toward and enslavement of Caribbean natives—but his delivery on a promise to "discover islands and mainland in the Ocean Sea," however inadvertent, has never been surpassed.

1483–1546

3
MARTIN LUTHER

When Martin Luther nailed his 95 Theses to the door of a Wittenberg, Germany, church in 1517 "for the purpose of eliciting truth," he began the Reformation that changed political and religious alliances for centuries. While some later writings were marked by anti-Semitism, his early works stressed salvation by God's grace and Christian spirituality. He argued against papal authority in affairs of state and, when he refused to recant, was excommunicated by the Catholic Church—an act that gave rise to all Protestant churches.

1564–1642

4
GALILEO GALILEI

By challenging views of the natural world that had prevailed for 1,500 years, Italian astronomer, physicist and mathematician Galileo Galilei changed the way we think. By inventing a mathematical approach to everyday experience, he discovered the laws of inertia, falling bodies and the pendulum. With a telescope he built, he also made astronomical discoveries that convinced him of the heliocentric view of the universe, which Copernicus had formulated earlier but been hesitant to publish. Galileo took the chance but was forced to retract his findings before a Catholic Church tribunal in 1633. Nonetheless, his beliefs and discoveries lived on, opening the door for modern physics and a new approach to scientific thought.

1452–1519

5
LEONARDO DA VINCI

Renaissance man—one knows much, whose interests are broad and deep, whose zest for inq is indefatigable—was bo Vinci, Italy, in 1452 and named Leonardo. As an apprentice he quickly showed talent for paintin and sculpture. Soon after came projects in engineering, anatomy, architecture, scientific illustration, mapmaking, mathematics, optics. Wh his finished artworks— notably *Mona Lisa* and *The Last Supper*—are fe his copious and disorder notebooks continue to enthrall us. Regarded as the greatest of amate this enduring icon of the Renaissance set a mark unequaled by any who came after.

. Though the actions of the individuals who made the list
cted all kinds of people, they are an overwhelmingly male,
bunch. All but 17 are of European extraction; only 10 are
men. This reflects not the biases of LIFE's editors and
ert advisers but the sociopolitical realities of the past
usand years. For most of that time, as Virginia Woolf not-
women have served largely as "looking-glasses . . . reflect-
ing the figure of man at twice its natural size." Likewise, the
millennium's most conspicuous historical movement has
been the rise of the West—which means that Westerners,
often borrowing ideas and technology from other peoples,
have done a disproportionate amount of global moving and
shaking. The next millennium's list of planet-rattlers promis-
es to look strikingly different.

2–1727

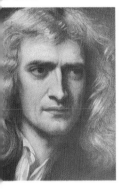

c. 1480–1521

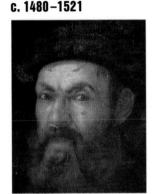

1822–1895

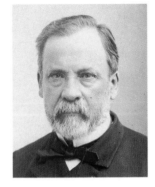

1809–1882

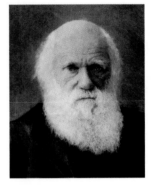

1743–1826

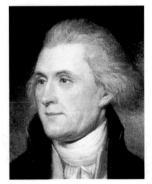

AC NEWTON

ssionately religious man
ime of great scientific
overy, Isaac Newton
ted to know how God's
erse worked. His quest
nswers gave us the law
niversal gravitation,
ulus, a new theory of
r and light, and the three
s of motion that form the
s of modern mechanics.
ant and creative, the
ish physicist and
hematician synthesized
iscoveries of Galileo,
er and others,
alizing and transforming
sical science. Yet,
ing back, Newton said,
em to have been only
a boy, playing on the
shore, and diverting
elf, in now and then
ng a smoother pebble or
tier shell than ordinary,
st the great ocean of
lay all undiscovered
re me."

7
FERDINAND MAGELLAN

When Ferdinand Magellan
headed west across the
Atlantic in 1519, people
already understood the
world to be round. But this
expedition, under his brave
command, provided proof.
The Portuguese captain,
sailing under the Spanish
flag, survived mutiny,
desertion, shipwreck and
the treacherous strait off
South America's tip. Still,
Magellan and his crew faced
starvation as they headed
into the Pacific. Magellan
died in the Philippines, but
a small band of his men
eventually reached home,
the first to have sailed
around the world.

8
LOUIS PASTEUR

Eulogized as "the most
perfect man who has ever
entered the kingdom of
Science," Louis Pasteur
was both practical problem
solver and theoretical
genius. The French chemist
discovered that heat killed
the microorganisms that
turned wine sour. Soon the
process of "pasteurization"
was applied to many foods
and beverages. Pasteur
is credited with saving the
French silk industry by
finding and eliminating the
microbe attacking silkworm
eggs. But his greatest
contribution was his work
on the germ theory of
disease. Using weakened
microbes to develop
vaccines against anthrax
and other diseases, Pasteur
saved countless lives and
founded the modern
science of immunology.

9
CHARLES DARWIN

A child of wealth and an
undistinguished student,
Charles Darwin leaped at the
chance to serve as an
unpaid naturalist on the
H.M.S. *Beagle.* In the course
of his five-year adventure, he
developed one of the most
important scientific theories
of the millennium. Though
he returned a semi-invalid,
he proceeded to father
10 children—and to work
out the implications of
what he had seen in the
Galápagos Islands and
the atolls of the Pacific.
Published in 1859, his
theories of evolution and
natural selection, although
widely accepted today, still
provoke controversy.

10
THOMAS JEFFERSON

Were it not for his mind and
his pen, the world might
have witnessed one more
bloody revolution signifying
nothing. A lawyer by trade,
a pioneer of American
architecture, a President
who spurred westward
expansion, a slave owner
who opposed slavery,
Thomas Jefferson embodied
many of the aspirations—
and some of the
contradictions—of a
newborn nation. It was a
self-evident truth, wrote the
33-year-old Virginian, "that
all Men are created equal."
Natural law, the right to "Life,
Liberty, and the Pursuit
of Happiness," became the
New World blueprint.
It remains an alluring goal
for democracies around
the world.

1564–1616

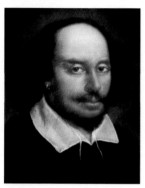

11
WILLIAM SHAKESPEARE

His masterly use of language has captivated audiences for 400 years. He penned 38 plays and 154 sonnets that explored the complexities of the human soul with unprecedented emotional range. His subject matter, from romantic comedies to moving tragedies, was equally diverse. But what all of his work demonstrates is a facility for wordplay unrivaled by any writer before or since. William Shakespeare's ubiquity on world stages, on film, in textbooks and in our vernacular is a testament to his achievement.

1769–1821

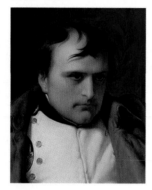

12
NAPOLÉON BONAPARTE

Already a war hero, Napoléon Bonaparte seized power in France in 1799 and quickly set out to conquer the world. He treated soldiers well and promoted for reasons of talent, not class. He said he hoped to build a federation of free governments throughout Europe. But to some, Napoléon looked like a tyrant. He met his Waterloo at Waterloo, Belgium, in 1815 and spent his last six years in exile on the British isle of St. Helena.

1889–1945

13
ADOLF HITLER

A failed artist who was gassed and wounded during World War I, Adolf Hitler would soon embark on a vicious campaign of global domination. He almost succeeded. Along with his mastery of propaganda, his ideology of racial purity and his ruthless political skills, Hitler possessed a diabolical personal magnetism. He secured the chancellorship of Germany in 1933, declared war on the world in 1939 and set about systematically exterminating Jews and other "undesirables." By the time Hitler was defeated in 1945, as many as 77 million people had died, leaving him responsible for more death than any other man in the history of the world. As the Allies were closing in on Berlin, Hitler committed suicide in his bunker.

1371–c. 1435

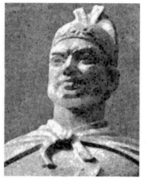

14
ZHENG HE

In the early decades of the 15th century, the seas off Asia were dominated by the huge Chinese treasure ships of Admiral Zheng He—each of them five times as large as a typical European caravel. Zheng, a court eunuch turned diplomat, led seven naval expeditions for Ming Emperor Yongle between 1405 and 1433. Zheng's assignment was to extend China's political sway overseas. His first entourage included 62 ships and 27,800 men; the others were of similar scale, making them the most fantastic naval ventures the world had yet seen. His journeys took him to the east coast of Africa, to Mecca and to India. Zheng brought back exotic souvenirs as proof of his exploits, including, once, an African giraffe.

1863–1947

15
HENRY FORD

When Henry Ford set up shop in Detroit in 1903, al wanted to do was make a sell cars. For 19 years he sold only one kind, the Model T, but he sold 15.5 million of them, half the au output in the world. His revolutionary assembly lir enabled him to sell cars a price the average America family could afford and to double his workers' wage while cutting hours. What had been a toy of the rich became a necessity of life spawning gas stations, superhighways and traffic jams around the world.

6–1939

1732–1792

1818–1883

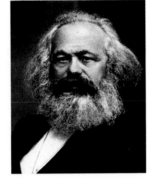

1473–1543

1871–1948 & 1867–1912

MUND FREUD

experimenting with the
of hypnosis to cure
erics, Sigmund Freud
eloped free association,
ouraging patients to
whatever came into
minds. He used this
nique, along with dream
ysis and other methods,
elp patients express
hidden wishes and
essed experiences.
ud's emphasis on the
er of the unconscious
fluence behavior
adened our view of
an nature and sexuality
gave rise to the age
elf-examination.

17
RICHARD ARKWRIGHT

His 1769 invention of a
water-powered spinning
frame meant that all-cotton
cloth could for the first time
be made in England. But
because his creation had to
be housed in a large room
with a water supply at the
ready, Richard Arkwright
inadvertently became the
founder of the modern
factory system, a system in
which specialized workers,
using specialized machinery,
work together in one place—
very quickly.

18
KARL MARX

Though not one of the
working-class proletarians
about whom he wrote, Karl
Marx followed his own
advice and renounced his
bourgeois roots. Hounded
from Germany to France to
England, often living hand-
to-mouth, he devoted his
life to political journalism,
supported by his patron and
writing partner, Friedrich
Engels. Marx's vision of a
postcapitalist world where
the working class owns the
means of production has
not come to pass, but his
critique of the class system
has inspired millions.

19
NICOLAUS COPERNICUS

The earth was the fixed
center of the universe until
Polish astronomer Nicolaus
Copernicus ventured the
idea that the sun is the
center of the solar system,
with the earth and the
planets revolving around
it. Copernicus, a student
of mathematics and
astronomy, began to amass
evidence disputing the
geocentric universe of
Aristotle and Ptolemy. But
he was also a cautious,
one might say a wise, man—
at a time when heretics were
put to death. Copernicus
didn't publish *On the
Revolutions of the Celestial
Spheres,* which would
revolutionize our concept of
the world, until 1543, when
he was on his deathbed.

20
ORVILLE & WILBUR WRIGHT

The Wright brothers, who
designed and made bicycles
for a living, were so
distressed after hearing of
the German scientist Otto
Lilienthal's death in a gliding
experiment that they
determined to pursue his
dream of flight. For eight
years the brothers studied
flying buzzards, tested wing
models in a homemade wind
tunnel, built engines and
launched gliders, most of
them doomed, on the windy
bluffs of Kitty Hawk, N.C.
Finally, in 1903, Orville and
Wilbur succeeded in flying
the first powered airplane.
Flight time: 12 seconds.
By 1908 the Wrights were
making warplanes. Man-
kind's view of the world—
and of its own power—had
changed forever.

1879–1955

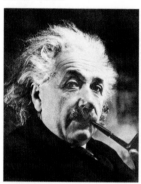

21
ALBERT EINSTEIN

One dreamy, academically lax German youth would follow his curiosity until he had bumped Newton from the pinnacle of physics and painted a fantastic new picture of our universe. In the process, Albert Einstein changed the scientific and political balance of power in our century and for the foreseeable future.

1869–1948

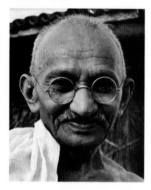

22
MOHANDAS GANDHI

"The candle of non-violence should be able to burn even when the cyclone of violence surrounds it." So said Mohandas Gandhi, explaining the philosophy that lifted India to independence in 1947 after nearly two centuries of British domination. Gandhi's powerful strategy, called *satyagraha,* involved nonviolent noncooperation, boycotts of all things British, civil disobedience, marches and fasts. His methods have been adopted by protest movements throughout the world.

1215–1294

23
KUBLAI KHAN

Ruler of the Mongols from 1260, Kublai Khan completed the conquest of China that had been started by his grandfather Genghis. In 1271 he became the first emperor of the Yüan dynasty. Establishing Beijing as his capital, Kublai boosted agriculture and business, fostered scholarship, encouraged the arts, retained many Chinese institutions, promoted religious tolerance and oversaw generally prosperous times for nearly one quarter of the world's population. The splendor of his court stirred the imagination of Western travelers, including Italian adventurer Marco Polo.

1751–1836

24
JAMES MADISON

Before he served as the fourth President of the U.S., James Madison was already called the Father of the Constitution. He supported checks and balances among the government's branches and clear divisions between federal and state authority. The Virginian who had once considered becoming a minister also drafted the Bill of Rights, which, among other things, prohibited the establishment of a national religion.

1783–1830

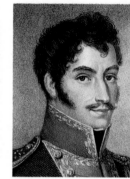

25
SIMÓN BOLÍVAR

El Libertador devoted his life to fighting for the independence of northern South America. In 1819, Bolívar, a Venezuelan, chased the Spanish out of what is now Colombia by staging one of the most daring attacks in military history. He led 2,500 men over terrain so rough the Spanish thought it impassable, then surprised the imperial forces in the Battle of Boyacá. Military leader, statesman, dictator, Simón Bolívar was also the emancipator of Venezuela and a key figure in the liberation of Ecuador and Peru.

–1797

1874–1937

1893–1976

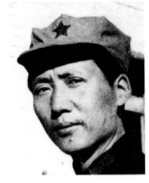

1870–1924

1929–1968

6
Y WOLLSTONECRAFT

dication of the Rights of
an, British author Mary
stonecraft's landmark
for women's equality,
published in 1792, a
when French citizens
demanding reforms
overthrowing their
archy. Inspired by those
ocratic principles,
stonecraft challenged
sseau and others,
ing for equal education
employment for women
urging national
lation to guarantee
en's rights.
stonecraft, who gave
to her first child while
arried (her second,
Wollstonecraft Shelley,
e Frankenstein), was
ized for a lifestyle that
ed convention, but her
influenced generations
minists.

27
GUGLIELMO MARCONI

In the early days of
telephones and telegraphs,
the thought of sending
messages through thin air
(sans wires) was all but
inconceivable. Then, in a
leap of faith, a young Italian
proved it could be done.
Guglielmo Marconi's
transmission of a signal—the
Morse code letter S—across
the Atlantic in 1901 was a
worldwide sensation. It
opened the airwaves for
today's complex network of
global communications—
from radio to radar to
orbiting satellites—and
interglobal, too, as NASA
now pulls in daily messages
from the far reaches of the
solar system.

28
MAO ZEDONG

In 1921, when Mao Zedong
was one of a dozen men
forming the outlaw Chinese
Communist Party, few
foresaw his being the leader
of modern China. It was a
Long March indeed for
Mao's Red Army, from
resistance to the Japanese
to defeat of the Nationalists
and the rise, in 1949, of the
People's Republic. A brilliant
warrior, Mao was a despotic
dictator. His economic Great
Leap Forward failed at a cost
of 20 million peasant lives.
His Cultural Revolution led to
more injustice and death.
Mao cast a giant shadow on
the world, and a darker one
on his own people.

29
VLADIMIR LENIN

Marx was theory, Lenin (nom
de guerre of Vladimir Ilyich
Ulyanov) was action. With
Leon Trotsky, he led the
October 1917 revolution that
delivered Russia to the
Bolsheviks and started the
worldwide spread of Soviet-
style communism—which,
though it deviated from
Marx's, was attractive to
many Marxists. Lenin called
his regime a "dictatorship of
the proletariat," but in reality
it was a dictatorship of Lenin
and his party. This is his life's
central irony: A fighter
against czarist injustice
laid the foundation for
decades of murderous
totalitarianism. Nevertheless,
Lenin built an economic
engine that would make the
Soviet Union a superpower.
The state he founded helped
stop Hitler in World War II,
forced the cold war and
initiated the space race—
shaping the 20th century.

30
MARTIN LUTHER KING JR.

Born into the segregated
society of America's South,
the Baptist preacher from
Atlanta walked a Gandhian
path of nonviolence, and
the civil rights movement
followed. Martin Luther King
Jr.'s crusade for equality
started with a protest of the
bus system in Montgomery,
Ala., in 1955 and peaked in
the nation's capital. "One
day this nation will rise up
and live out the true meaning
of its creed," he dreamed
aloud during the 1963 March
on Washington, "that all
men are created equal." Five
years later, at 39, he was
felled by a sniper's bullet.
King won the Nobel Peace
Prize in 1964, and in 1986
became only the third
American to have a birthday
observed as a national
holiday. His call to "let
freedom ring" still resonates.

1847–1922

31
ALEXANDER GRAHAM BELL

When Alexander Graham Bell patented the telephone in 1876, he knew he could transmit sounds between two distant places, but he hadn't yet been able to relay human speech. Three days after the patent was issued, or so the legend goes, he spilled battery acid on his clothes while working near a transmitter in his lab. His shout to his assistant for help became the first phone transmission of a voice. The Scottish-born Bell left the development of his invention to others and refocused his energies on another passion: creating communication devices for the deaf, including his wife, Mabel.

1596–1650

32
RENÉ DESCARTES

A mathematician, scientist and philosopher, René Descartes introduced groundbreaking concepts in each of these disciplines. Called the inventor of analytic geometry and a founder of modern philosophy, the Frenchman also made advances in optics and physiology. He introduced what came to be called the Cartesian method: beginning an inquiry with universal doubt, as opposed to medieval philosophy, in which faith played a leading role. He also identified a split between mind and body, a dualism that remains an issue in philosophy today. But he is best remembered for one simple statement: "I think, therefore I am."

1770–1827

33
LUDWIG VAN BEETHOVEN

Arguably Western music's greatest composer, Ludwig van Beethoven was also one of its prime disrupters. Achieving early success in the classical forms perfected by Haydn and Mozart, inspired by the French Revolution's ideals and afflicted with romantic sorrows and encroaching deafness, the German-born Beethoven expanded the traditional sonata, quartet, concerto and symphony into personal expressions both sublime and profound. To a doubting contemporary, he replied, "They are not for you, but for a later age."

c. 1225–1274

34
THOMAS AQUINAS

Scholars at Europe's universities in the 13th century were arguing about the Greek texts being translated back into Latin from Arabic. Was Christian dogma correct or was the world explainable by the rationalism of Aristotelian science? Both were right, said Thomas Aquinas, a Dominican priest from Italy. Synthesizing the two traditions, he asserted that faith and reason did not conflict, that man is rational but that his highest happiness can be found in contemplation of God. Aquinas taught in Naples and Paris, advised popes and wrote the unfinished *Summa theologiae*, a dominant influence on Roman Catholic theology.

1809–1865

35
ABRAHAM LINCOLN

When Abraham Lincoln his first presidential oath 1861, he faced the great crisis in his nation's histo The fabric of the America experiment, "a more perf Union," was being torn apart. But before an assassin's bullet brought him down in 1865, this so of a poor Kentucky farme led his countrymen—Sou as well as North—back to union. The fabric was ma whole again, this time without slavery.

5–1564

c. 1460–1524

c. 1494–1566

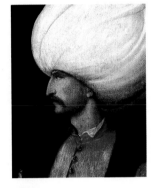

1791–1872

1509–1564

6
HELANGELO

ved to the age of 88,
though he was never a
er, the world is full of
ielangelo's "children."
s considered the
itest sculptor of all time
vid, the *Pietà*); his
tings take one's breath
y (the ceiling of the
ne Chapel); his designs
it. Peter's Basilica
the Campidoglio
ishadowed the
oques. A man of
ligious gifts and
ievements, Michelangelo
much unfinished
k—the half-carved
ie; the unfulfilled plans;
sculpture he broke,
nayed by its
erfection—a reminder
though his ambitions
e divine, he was
y human.

37
VASCO DA GAMA

His mission for the king of
Portugal was to break up
the Muslim, Venetian and
Genoese monopolies that
controlled the lucrative trade
route between Europe and
Asia. In time he would
achieve this goal, but his
most memorable success
came on his first voyage, in
1497, when Vasco da Gama
rounded Africa's Cape of
Good Hope and sailed to
India, opening an all-water
route from Europe to Asia.

38
SÜLEYMAN
THE MAGNIFICENT

Greatest sultan of the
Ottoman Empire, Süleyman I
undertook bold military
campaigns that expanded
his realm and generated
tremendous riches. Also
known as the Lawgiver,
Süleyman imposed
cohesion on a government
that linked three continents.
He built fortresses, bridges,
aqueducts and mosques,
including Istanbul's grand
Süleymaniye Mosque. The
art and literature that
flowered during his reign
are still renowned.

39
SAMUEL F.B. MORSE

While returning from a
European sojourn to study
art, Samuel F.B. Morse
fell into a shipboard
conversation about the
electromagnet. Voilà, the
idea for his first telegraph
machine. Five years later,
in 1837, he staged a
demonstration, transmitting
signals over 1,700 feet of
wire. By 1844, when he
wired (in his Morse code)
the biblical phrase "What
hath God wrought!" from
Washington, D.C., to
Baltimore, there was no
question that Morse—an
influential American painter
and publisher as well as an
inventor—had wrought a
new way to communicate.

40
JOHN CALVIN

French-born theologian
John Calvin wrote one of the
most significant works of
the Reformation and trained
ministers who spread
Protestant faith through
Europe and Puritan New
England. His teachings
shaped 16th century political
and social customs and
influence theology to this
day. Calvin became a
Reformation leader in
Geneva, but theological
conflicts and the severe
penalties he espoused for
gambling, drinking and
dancing prompted riots that
drove him from the city. He
returned in 1541, eventually
creating a refuge for
persecuted Protestants.
Thus was born the Calvinist
movement, which included
the concept of an elected,
representative church
government.

1820–1910

41
FLORENCE NIGHTINGALE

She became a nurse in spite of her wealthy family's opposition. A true angel of mercy, Florence Nightingale served with the British army during the Crimean War, turning filthy, vermin-infested camps where the wounded were brought to die into clean wards where they could heal. She returned a hero but refused to participate in any public celebration. Rather, she used her stature to gain Queen Victoria's support for health care reform in the military. Nightingale then worked for improved conditions in hospitals and workhouses and established the first school for nurses. She accomplished all this despite spending the last 40 years of her life as an invalid.

1485–1547

42
HERNÁN CORTÉS

Eager for fame and riches, Hernán Cortés set out in 1519 for Mexico, where gold was said to be abundant. There was no turning back for the few hundred men who landed at Vera Cruz: Cortés ordered them to burn their ships. Exploiting local resentment against the Aztecs, who used prisoners of war for human sacrifice, Cortés negotiated alliances as he headed toward Tenochtitlán, seat of Aztec emperor Montezuma. The Spanish conquistadores gained the capital and seized vast amounts of gold before being driven out. Returning in 1521, Cortés laid siege to Tenochtitlán, destroying the Aztecs' most splendid jewel and planting seeds of domination that would grow for the next three centuries.

1827–1912

43
JOSEPH LISTER

Seeking to cut the postoperative mortality rate in his Glasgow hospital, Joseph Lister revolutionized surgery. Inspired by Pasteur, he reasoned that if microbes could cause infection, they could be killed before reaching an open wound. His method, employing carbolic acid as an antiseptic on dressings and instruments as well as on surgeons and patients, resulted in stunning statistics: The mortality rate among his amputee cases fell from 45 to 15 percent. Lister's discovery enabled millions to undergo surgery with far less risk.

1304– c. 1377

44
IBN BATTUTA

In 1325, Ibn Battuta left Morocco for a pilgrimage to Mecca. Three decades and 75,000 miles later, medieval Islam's most extraordinary traveler had covered nearly the entire Muslim world. For the sheer adventure of it, Battuta traipsed from Spain to the east coast of China. An invaluable picture of the 14th century, his book, *Travels,* is one of the greatest peripatetic tales of all time.

1130–1200

45
ZHU XI

One of China's most influential philosophers, Zhu Xi recast Confucius's teachings in more than 100 works, including commentaries on most of the Confucian classics. His teachings—emphasizing morality and logic, condemning popular religion and denying the existence of a personal deity—were a challenge to the spread of Buddhism in China. Zhu's neo-Confucian writings became required reading for China's civil service exams for the next 600 years.

–1884

1632–1704

1542–1605

c. 1254–1324

1265–1321

;OR MENDEL

ould not pass the test to ertified as a biology er, but Gregor Mendel, h century Austrian ‹, discovered a basic iple of biology. Cross- ding peas in the garden s monastery, he learned to predict the features e hybrids. He presented ork to the Natural ice Society in Brünn ublished his results, ving he had achieved a itific breakthrough, but esearch was ignored. until 16 years after his n was he recognized for ig discovered the amentals of genetics.

47
JOHN LOCKE

Enlightenment philosopher John Locke was noted for his writing on education, science and religious freedom. But the Englishman's ideas about politics—that people by nature have certain rights, including life, liberty and property, and that their consent is the only legitimate basis of government—had a more profound effect. His proposals for legislative representation and free speech influenced the U.S. Constitution and democratic movements throughout the world.

48
AKBAR

Tolerant and wise, Akbar was the greatest of India's Mughal emperors. This Muslim leader realized that India's Hindus were too powerful to subjugate, and during his 50 years of rule he allowed the princes to keep their lands in return for allegiance. He offered their subjects jobs and religious freedom. At his glittering court in Agra, Akbar savored learned discussions. He fostered architecture that melded Mughal and Hindu traditions, culminating in 1650 in the Taj Mahal, which was the vision of Akbar's grandson Shah Jahan.

49
MARCO POLO

History tells of his leaving Venice at age 17 to join his father and uncle on a journey deep into Kublai Khan's China. Marco Polo himself tells in his writings how they were welcomed and spent 20 years in Asia. Polo's tales have been called products of the imagination, but whether fact or fiction, they inspired Europeans to seek out the Orient and Columbus to sail the Atlantic.

50
DANTE

The Divine Comedy, Dante Alighieri's epic masterpiece, is an allegorical and literary triumph, a walk through the cultural, political and religious landscape of 13th century Italy. Dante's writing influenced poets from Chaucer to Byron. But his vivid depiction of the nine circles of hell terrified centuries of ordinary readers with its descriptions of horrendous punishments after death. "Dante and Shakespeare divide the modern world between them," T.S. Eliot said. "There is no third."

1839–1937

51
JOHN D. ROCKEFELLER

He was worth more than a billion dollars when a billion dollars meant something. In fact, John Davison Rockefeller was the very first U.S. billionaire, building his pile on the monolithic Standard Oil Co. A fierce conniver, he slashed costs and dodged antitrust rulings. Then, at age 58, after three decades as an oilman, the religious robber baron turned to charity. In his lifetime he spent $540 million—the equivalent of $5.6 billion today—on projects primarily in medical research and education. He died at 97, having never smoked a cigar or drunk a glass of champagne, leaving behind a vast fortune and a family active in many spheres—politics, philanthropy and, of course, business.

1712–1778

52
JEAN-JACQUES ROUSSEAU

An educational theorist who ranked emotional development and experience above book learning, Jean-Jacques Rousseau abandoned his own five children at a Paris foundling hospital. A believer in living in "a state of nature" where compassion and honesty could flourish, he also wrote that a good society could improve people if they would submit their own desires to the General Will. Both totalitarians and democrats look to the Geneva-born polemicist as their prophet.

1885–1962

53
NIELS BOHR

The world of Niels Bohr is a strange one: Particles act like waves; looking at something is like giving it a shove; electrons are only probably where they ought to be. Stranger yet, his world is ours. The Danish physicist's elucidation of quantum theory changed the way we understand the smallest components of matter and energy, replacing the concrete predictability of classical mechanics with the mathematical complexity and seeming randomness of the quantum. Physics and philosophy collided in Bohr, who mentored generations of physicists; the echoes of that collision are with us still.

1412–1431

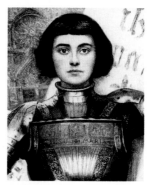

54
JOAN OF ARC

A young peasant who believed she was guided by the voices of saints, Joan of Arc led the French to crucial victories in the Hundred Years War and became a surpassing hero for her countrymen and her fellow Catholics. The teenager who dressed in men's clothing defeated the English at Orléans in 1429; her triumph at Reims not only earned her the nation's adulation but also paved the way for the coronation of King Charles VII. On a campaign to free Paris, she was captured, tried for heresy and burned at the stake. Named a saint in 1920, she has been the subject of hundreds of movies, books and plays, including Shaw's *Saint Joan*.

1818–1895

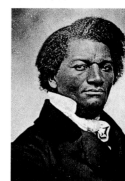

55
FREDERICK DOUGLASS

The fate of African people America rested not on his shoulders but on his mind. The son of a slave woman and an unknown father, Frederick Douglass escaped the master's whip in 1838 when, disguised as a sailor, he fled north. A self-made intellectual, he decried the ignorance and bigotry of slave society. Crisscrossing the Union, he testified about the bonds that held his people's bodies and souls. He was attacked after some speeches but won adherents as well. His first autobiography was an overnight success; his *North Star* newspaper was, like Douglass himself, a never-to-be-ignored beacon of morality.

8–1715

1856–1943

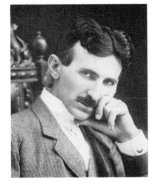

1724–1804

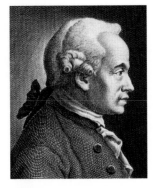

c. 990–c. 1030

1815–1898

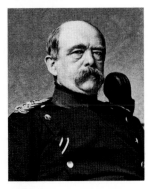

6
IS XIV

egocentrism was
owed upon him: As an
nt he was given the title
st Attractive. In 1643, a
months shy of his fifth
iday, he was crowned
of France. He survived a
olt by the nobility and
rged to declare himself
vine monarch—the Sun
j. Louis XIV was an
olutist: A passport could
be issued without his
mission. He raised a
hty army, fought wars
inst England, Holland
the Holy Roman
pire—and France's own
testants—and
structed the sprawling
ace of Versailles, to which
noved the royal court
n Paris. There he lived
ruled, surrounded by
ilgence, spectacle and
ophancy. Louis is
dited with making France
ading power—and
ned for precipitating
ecline.

57
NIKOLA TESLA

He may be second only
to his onetime boss
Thomas Edison as the most
farsighted inventor of the
electric age. His work on the
rotating magnetic field and
alternating current (AC, as
in AC/DC, the patents
for which he sold to George
Westinghouse in 1885)
helped electrify the world by
enabling power to travel over
wires to customers great
distances away. A tireless
and eccentric inventor,
Croatian-born Nikola Tesla
came up with some things—
a "death ray" to shoot down
attacking aircraft, for
instance—that don't seem
nearly as far-fetched now as
they must have in his day.

58
IMMANUEL KANT

His entire life was spent in
Königsberg, East Prussia,
and it is said he was never
out of earshot of the town's
church bells. But Immanuel
Kant made up for his lack of
adventure by traveling great
distances in his mind. In
Critique of Pure Reason he
examined the nature and
limits of human knowledge.
He wrote about aesthetics
and ethics, too, and
established the direction of
modern philosophy.

59
FAN KUAN

A Taoist recluse, Fan Kuan is
best known as the painter of
*Travelers Amid Streams and
Mountains* (detail above), the
greatest single example of
the monumental-landscape
style of painting and a model
for all Chinese artists. The
painting, nearly seven feet
tall, is based on the Taoist
principle of becoming one
with nature. Fan's style—
reducing human figures to
minute proportions and
dramatizing the awesome
power of their
surroundings—has led
critics to compare his
creative powers to those
of nature itself.

60
OTTO VON BISMARCK

It took Prussian statesman
Otto von Bismarck nine
years, three wars and a
legendary cunning to unify
his homeland and other
German states and create
a single powerful nation.
As Iron Chancellor, he
instituted a social welfare
system intended to crush
the social democracy
movement. Remembered
by some as a moderate,
he's seen by others as a
ruthless conservative who
set the stage for fascism.

c. 1027–1087

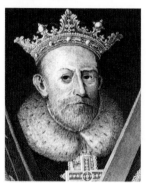

61
WILLIAM THE CONQUEROR

England as we know it began when William, Duke of Normandy, crossed the Channel and went on to win the Battle of Hastings in 1066. Eager to increase his power as king, he dispossessed Anglo-Saxon nobles and divided their lands among his followers. The Norman influence was felt in every sphere, from language to architecture to warfare. William spent his 21-year reign successfully fending off enemies. No one has invaded England since.

c. 991–c. 1033

62
GUIDO OF AREZZO

Musical theorist and teacher Guido of Arezzo solved two practical problems. Choirboys were learning chants by listening and imitating, not always accurately. Guido devised a system of musical notation—it has evolved into today's five-line staff—that enabled certainty of pitch. He also used the syllables that began six lines of a popular hymn *(ut, re, mi, fa, sol, la)*, along with the notes on which they were sung, to perfect a method of teaching sight-singing still in use today.

1693–1776

63
JOHN HARRISON

Scientists scoffed when British clockmaker John Harrison presented his marine chronometer, a device that allowed seamen to calculate longitude. But in the 1760s the chronometer's reliability was established, and in 1775, Capt. James Cook used one to chart the South Sea Islands, a feat achieved with the aid, he wrote, of "our never failing guide, the Watch."

1160–1216

64
POPE INNOCENT III

Lotario di Segni was only 38 when he was elected Pope Innocent III in 1198; his 18-year reign dominated the Middle Ages. Claiming the right to guide the Holy Roman Empire, he launched two crusades to assert the Church's power. Meanwhile, he embraced the poor and saw the Church's rolls swell. His Fourth Lateran Council shaped the Catholic Church that we recognize today.

1840–1916

65
HIRAM MAXIM

He changed the way we wage war. In 1884, Hiram Maxim, an American-born British inventor, developed recoil mechanism that made it possible to load cartridges into a machine gun and eject them without using a hand crank. The fully automatic magazine discharged up to 600 rounds of ammunition per minute. Recognizing its advantages, the British army and the royal navy were among the first to adopt the new weaponry—in 1889 and 1892, respectively. Other nations soon followed, to such an extent that World War I came to be called the machine gun war.

-1935

c. 1715–1763

1552–1610

c. 1901–1971

1791–1867

ADDAMS

o wealth, Jane
ns founded Chicago's
louse, one of the first
ment houses in North
ca, in 1889. Two
and immigrants a week
to eat, to attend
s, to see plays or hear
rts. They used the
ry, gym, dispensary
layground. Regarded
mother of social
Addams was also a
st and a suffragette.
elped found the
can Civil Liberties
and the Women's
ational League for
e and Freedom, and
warded the Nobel
e Prize in 1931.

67
CAO XUEQIN

When *Story of the Stone* was
published anonymously
around 1765, it caught the
attention of the best writers
in Beijing. Later the author
was identified as Cao
Xueqin, the grandson of
a wealthy government
minister. The book,
eventually expanded and
republished as *Dream of the
Red Chamber,* tells the story
of the rise and fall of a
powerful Chinese family.
Its depiction of personal
relationships and daily life
has earned the novel a
reputation as the greatest
ever written in vernacular
Chinese, and its influence
on later art forms, including
Chinese opera, has been
enormous.

68
MATTEO RICCI

When he moved to China
from Italy in 1582, little did
Jesuit missionary Matteo
Ricci realize that conversion
worked both ways. The
Chinese were fascinated by
Ricci's possessions: clocks,
maps, Western works on
science. After Ricci's death,
Europeans were fascinated
by his manuscript on China.
Enlightenment thinkers,
inspired by the concept of
a state based on Confucian
values, used those ideas
to challenge their own
leaders and religions.

69
LOUIS ARMSTRONG

His improvisational verve
and technical virtuosity
defined jazz. An orphan who
learned the trumpet on the
streets of New Orleans,
Louis "Satchmo" Armstrong
popularized the idea of
the featured soloist. His
trademark "scatting"—
singing nonsense syllables
to mimic a horn riff—was
widely imitated. And his
engaging personality and
ever-present grin made him
a natural as the international
ambassador of jazz,
America's greatest musical
contribution to the world.

70
MICHAEL FARADAY

Although Michael Faraday
specialized in chemistry, he
laid the groundwork for
the electrical age. The
Englishman's discoveries
and inventions dealing
with magnetic fields and
electric currents showed
there was promise in power;
his original model of a
generator and his design of
an electric motor are the
prototypes of those that
light the planet and drive
everything from subways to
vacuum cleaners. Faraday
was a humble man who
declined many honors in life,
including a knighthood.

980–1037

71
IBN SINA

Islam's most renowned philosopher-scientist, Ibn Sina outgrew his teachers while a teenager and educated himself in law, medicine and metaphysics. His intellect served him well: As a court physician in Persia, he survived intrigue and imprisonment to write two of history's greatest works, *The Book of Healing,* a compendium of science and philosophy, and *The Canon of Medicine,* an encyclopedia based on the teachings of Greek physicians. The latter was widely used in the West, where Ibn Sina, known as Avicenna, was called the Prince of Physicians.

1908–1986

72
SIMONE DE BEAUVOIR

She developed existentialist philosophy in novels and nonfiction, protested for countless causes and wrote the most influential feminist book of the 20th century. In *The Second Sex* (1949), French writer Simone de Beauvoir argued that women have been forced into an inferior position not by biology or psychology but by male-dominated society. Although her own 50-year relationship with philosopher Jean-Paul Sartre often put her in an inferior position, she inspired women around the globe.

c. 1207–1273

73
JALAL AD-DIN AR-RUMI

A 13th century Sufi mystic, Jalal ad-Din ar-Rumi composed passionate love poems while turning in a circle to the beat of drums or the music of rushing water. The poems found Allah outside the Koran—in people, nature and the commonalities of everyday life. Recorded in Persian by a disciple, they helped spread Islam to a wider audience. Rumi is still read today, and his followers, whirling dervishes (holy men), still perform their elegant, hypnotic dances to express the idea that God can be experienced in manifold ways.

1723–1790

74
ADAM SMITH

Scottish economist Adam Smith advocated open competition and freedom from government regulation, principles that would become the bedrock of modern capitalism. In his 1776 book, *An Inquiry into the Nature and Causes of the Wealth of Nations,* Smith argued that the free market is self-regulating and that by pursuing their own interests individuals would produce the types of goods most needed by society. He saw labor—not land or money—as a thing of primary value. His ideas are the foundation of the science of economics.

1867–1934

75
MARIE CURIE

The first woman to win a Nobel Prize, Marie Curie experimented with radioactivity (she coined word) and opened a new frontier in physics: the interior of the atom. Cur shared the 1903 Nobel in physics with her husb Pierre, and another scie for their work with radioactivity, and she w the 1911 award in chem for her isolation of radiu The Polish scientist, who suffered exhaustion, bu and cataracts from radia exposure, collected gas from radium for cancer treatments and establish the Radium Institute in France, which became a center for nuclear resea

–1580

1672–1725

1881–1973

1789–1851

1743–1794

EA PALLADIO

ian who is probably
y's most imitated
ect began work in a
of masons and stone-
rs. A Vicenza scholar
Andrea di Pietro della
ola under his wing,
him the name Palladio
humanist education.
lio's use of elements
Greco-Roman
es—most notably the
o, or roofed porch,
orted by columns and
d with a pediment—
one legacy. Another
is *Four Books of
ecture,* still a bible to
rs. His emulators
led Thomas Jefferson.

77
PETER THE GREAT

Peter the Great willed Russia
to be a modern world power.
He made Russian men
shave their beards and
replace ancient costumes
with Western clothing. He
built roads, canals, schools,
new industries, a navy.
(He used his fleet to extend
Russia's dominance over
Baltic ports.) But he
was as repressive as he
was forward-thinking—a
despot as well as a
reformer—forcing serfs to
work in his factories and
executing his own son,
Alexis, for opposing him.

78
PABLO PICASSO

He dominated 20th century
art, helping create Cubism,
pioneering innovations in
sculpture and lithography,
experimenting with new
media and captivating
imaginations around the
world with his powerful
personality and boundless
energy. Pablo Picasso, the
prolific Spaniard who
painted subjects ranging
from the women he loved
to the devastating effects
of war, had a career that
spanned 70 years—and an
influence that spans
generations and cultures.

79
LOUIS JACQUES
MANDÉ DAGUERRE

In 1826, Frenchman Joseph-
Nicéphore Niépce took a
picture (a heliograph, he
called it) of a barn. The
image, the result of an eight-
hour exposure, was the
world's first photograph. In
1839, his associate Louis
Daguerre devised a way to
permanently reproduce an
image on a metal plate that
required just 20 minutes'
exposure. (This would soon
shorten to less than a
minute.) A practical process
of photography—known as
the daguerreotype—was
born. Portrait studios and,
eventually, photo snapping
by the masses would follow.

80
ANTOINE-LAURENT
LAVOISIER

The founder of modern
chemistry, Antoine-Laurent
Lavoisier demonstrated
that combustion results
when a burning substance
combines with oxygen,
and stated the law of the
conservation of matter:
The weight of the products
of combustion equals
the weight of the original
materials. The French
chemist clarified the
distinction between
elements and compounds
and was instrumental in
devising the modern system
of chemical nomenclature.
He also had a career as
a tax collector, for which he
was guillotined during the
French Revolution.

1810–1891

81
PHINEAS T. BARNUM

The patron saint of promoters, he had a flair for the spectacular that was—and perhaps still is—unmatched. Through shameless hucksterism, his American Museum, a menagerie of freaks and curiosities, attracted millions of visitors a year. One outrage: He bought a slave and passed her off as 161 years old. A more legitimate P.T. Barnum enterprise, the circus he dubbed the Greatest Show on Earth, plus a stunt that involved moving an elephant named Jumbo from the London Zoo to the U.S., sealed his reputation as the consummate showman.

1889–1953

82
EDWIN HUBBLE

His 1924 discovery that the Andromeda nebula is located beyond the known boundaries of the Milky Way forced other astronomers to revise their thinking: The existence of multiple galaxies meant the universe was far larger than imagined. Next, Edwin Hubble determined that all galaxies are receding away from each other—hence, the universe is expanding. Today, as it orbits the earth, the Hubble Space Telescope, named in his honor, searches deep into the galaxies whose existence he proved.

1820–1906

83
SUSAN B. ANTHONY

Her tireless campaign for women's suffrage made her a leader in the first wave of American feminism. The daughter of Quaker abolitionists, Susan B. Anthony was incensed that women were barred from speaking at temperance meetings. She barnstormed for equality and was insulted, vilified, even pelted with rotten eggs for her trouble. After brazenly casting a vote in 1872, she was arrested and fined $100 (which she never paid). The ratification of the 19th Amendment in 1920, 14 years after her death, finally confirmed her credo: "Failure is impossible."

1483–1520

84
RAPHAEL

Italian art soared in the early 1500s for three major reasons. One of them was Raphael. And it is he—more than Leonardo or Michelangelo—who has influenced artists ever since. Raphael's portraits were at once serene and incisive, human and sublime. During his final 12 years, spent in Rome, he produced a series of masterpieces, including what many consider his greatest work, *The School of Athens*. This Vatican fresco, which shows Plato and Aristotle surrounded by philosophers past and present, perfectly embodies the Renaissance spirit.

1880–1968

85
HELEN KELLER

An illness when she was months old left her deaf, blind and mute. But ther was an exceptional mind and a strong will—trapp inside the tiny girl's bod With the help of a teach named Anne Sullivan— miracle worker"—Helen Keller learned to unders language (by having wo finger-spelled on her pa' read (by feeling raised letters), write (by followi the movements of a writ hand), hear (by placing fingers against a speake nose, lips and larynx) an speak (usually with sign language and occasion with her voice). Keller graduated with honors f Radcliffe and became a author, antiwar activist a advocate for the rights c workers and women, as as the deaf and blind. Sl remains proof that disab does not mean inability.

–1849

SAI

age of 74, Hokusai,
f the greatest artists of
illennium, bemoaned
:k of talent. "Of all I
prior to the age of
ity there is truly nothing
great note," he wrote,
:ting that "at 100
have become truly
lous." The master
r, illustrator and
naker of the Japanese
e school of art didn't
it to his century mark,
did create thousands
isured images—of
:apes, flora, fauna,
ical scenes—including
int series *Thirty-six
of Mount Fuji.* His
influenced the French
issionists, especially
Gauguin.

1860–1904

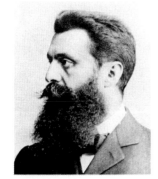

87
THEODOR HERZL

Although he did not invent
Zionism, Theodor Herzl is
considered the father of the
movement that eventually
led to the founding of a
Jewish state. No stranger to
anti-Semitism in his native
Austria-Hungary, he was
shocked to find it flourishing
in Paris when he moved
there as a journalist in 1891.
Herzl's belief that Jews must
organize and emigrate to
their homeland displeased
assimilationists. But it
resonated with nationalistic
Jews (in turn heightening
nationalist aspirations
among Arabs). Herzl
organized a world congress
in 1897 and later wrote in his
diary: "At Basel I founded the
Jewish state. If I said this
aloud today, I would be
greeted by universal
laughter. Perhaps in five
years, and certainly in fifty,
everyone will agree." A half
century later Israel was born.

1533–1603

88
ELIZABETH I

Daughter of Henry VIII,
Elizabeth ascended the
throne in 1558. A supremely
skilled diplomat, the Virgin
Queen—she never
married—fended off suitors
as cleverly as she
manipulated foreign
negotiators and domestic
factions. She was pragmatic:
Although she disliked
waging war, she built up
England's navy and in 1588
defeated Spain's Armada,
not only staving off invasion
but laying the basis for
empire. She was visionary:
She supported
Shakespeare, the poet
Edmund Spenser and Walter
Raleigh, who dispatched
settlers to Virginia, a colony
named in her honor. The
Elizabethan era: a 45-year
span of stability, growth and
dazzling achievement.

1567–1643

89
CLAUDIO MONTEVERDI

Claudio Monteverdi was
already known outside Italy
for his madrigals and church
works when he became
interested in opera, an
experimental form joining
storytelling and dialogue
with music. His *Orfeo* of
1607, employing theatrical
music effects, a climactic
aria and orchestral
interludes, was the first
composition to show opera's
potential. In *The Coronation
of Poppea,* a much more
complex work performed
35 years later, he conveyed,
far in advance of his time,
the expression of character
and emotion through music.

1901–1966

90
WALT DISNEY

Entertainment was more
than child's play to Walt
Disney. A gifted animator
and motion picture
producer, he created a
stable of unforgettable
cartoon characters,
beginning with Mickey
Mouse, that provided comic
relief to American men,
women and children during
the Depression and later
charmed audiences all over
the world. A multimedia
visionary, Disney produced
the first feature-length
animated film, *Snow White
and the Seven Dwarfs,*
opened a theme park,
adapted popular children's
books for the movies
and produced a weekly
television series, all with
the Disney moniker. Today
his name is synonymous
with family fun.

1918–

91
NELSON MANDELA

He roused South Africa's black majority—and sympathizers abroad—to rebel against the system of racial tyranny known as apartheid. Originally a proponent of nonviolence, he started a military wing of the African National Congress after watching police brutalize unarmed protesters in 1960. He languished in prison for a quarter century before his release in 1990. Nelson Mandela's courage and re-solve earned him a Nobel Peace Prize, the presidency of his country and the admiration of millions around the world.

1929–

92
ROGER BANNISTER

The elements were elemental: one mile, four minutes. For the longest time, man could not run a mile in under four minutes. It was one of those perplexing barriers. Then, on May 6, 1954, an Englishman who was just finishing his medical studies was paced by teammates at a track meet in Oxford, crossing the line in 3:59.4. Why did the world stand hypnotized for so long before a wall that didn't exist? Hard to say. But when Roger Gilbert Bannister showed us it could be done, human potential suddenly seemed limitless.

1828–1910

93
LEO TOLSTOY

The son of a Russian nobleman, Leo Tolstoy began wrestling with questions about the purpose of life while writing *Anna Karenina*. He rejected the divinity of Jesus, renounced violence, condemned private property and tried to live simply, working in the fields on the estate he shared with his wife and 13 children. Excommunicated by the Russian Orthodox Church, the author of *War and Peace* attracted admirers from around the world, including a fellow believer in nonviolence, Mohandas Gandhi.

1903–1957

94
JOHN VON NEUMANN

One obituary of John von Neumann referred to him as "the greatest mathematician of his time." He was a vital contributor to the development of both the hydrogen bomb and the digital computer. The Hungarian-born von Neumann's intellect was dizzying—he worked on problems ranging from the minutiae of quantum mechanical calculations to the real-world applicability of game theory—but he was always able to explain his most complicated explorations to the uninitiated.

1852–1934

95
SANTIAGO RAMÓN Y CAJAL

At the end of the 19th century most scientists thought brain fibers fuse form a continuous net. Spaniard Santiago Ram Cajal showed that the br was made up of distinct nerve cells. His work he point the way to the understanding that thes cells, or neurons, communicate with one another. Ramón y Cajal work is the foundation of modern neuroscience, study of everything from the biological basis of psychology to how a pe learns, remembers, sme sees, walks and talks— in essence, how the bra makes us what we are.

-1997

JES COUSTEAU

ever Jacques-Yves
eau donned his red
p and sailed off on
lypso, he brought
millions of television
s drawn by his motto:
ist go and see for
ves. An inventor of
-diving equipment,
ench author and
turer popularized
ation of the two
of the earth's surface
ed by water. Through
e got up close and
nal with long-lost
recks, giant
uses, killer sharks.
7, Cousteau won the
his three Academy
s, for *The Silent World.*
ly crusader against
pollution, he also
ed the Cousteau
y to promote marine
rvation.

1519–1589

97
CATHERINE DE MÉDICIS

The Italian-born queen of France and mother of three French kings, Catherine de Médicis engaged in such ruthless political maneuvering that she was called *Madame la serpente.* She also had a touch of elegance, introducing the fork to France and, in 1581, commissioning the first court ballet. The Paris performance of *Circe* included specially written music, elaborate costumes and scenery, choreography and a single dramatic theme. The five-hour extravaganza, costing more than three million francs, marked the birth of a new art form.

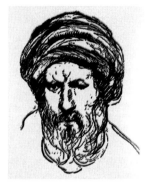

1332–1406

98
IBN KHALDUN

Shuttling between both Mediterranean coasts, Tunisian diplomat Ibn Khaldun may qualify as the 14th century's most frequent flee-er; he was surely one of its most brilliant minds. In and out of favor, and prison, he scrutinized human nature. When he wrote a history of the Muslim world, his stunning array of ideas included the importance of a group's social cohesion in attaining its goals, as well as history's cyclical nature. Five centuries later historian Arnold Toynbee described Khaldun's pioneering work as "undoubtedly the greatest of its kind that has ever yet been created by any mind in any time or place."

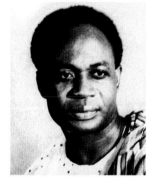

1909–1972

99
KWAME NKRUMAH

His radical push for Ghanaian self-governance in the 1950s triggered decolonization throughout the African continent, which led to the end of European domination. Inspired by Marx and Marcus Garvey, Kwame Nkrumah launched a "positive action" campaign of nonviolent protest that won Ghana its independence from Britain by 1960. Nkrumah was a better revolutionary than a president, and civil unrest led to a coup in 1966. African nations continue to grapple with the upheaval he began.

1707–1778

100
CAROLUS LINNAEUS

His 18th century contemporaries called Carl von Linné bold, even salacious, when he used sexuality as the starting point for his botanical classification system. He described calyxes as "nuptial beds," corollas as their "curtains," but by using the number and length of stamens to sort plants into classes, and pistils to subdivide these into orders, he enabled students in the field to identify a specimen quickly and simply, by counting. The Swedish physician, writing in Latin as Linnaeus, also devised a system of naming the genus and species of plants—and, later, animals. His nomenclature was adopted by naturalists in his time and is evident everywhere in ours.

2001–3000
THE WORLD
AS IT WILL BE

We are about to enter a millennium of miracles. If a person cuts off his hand while fixing a lawn mower, doctors will be able to grow him a new one. Houses and cars will be made of materials that can fix themselves when damaged. There will be a white powdered food that is 90 percent protein and can be made to taste like almost anything.

These predictions may sound bold, but in truth they're pretty conservative. Replaceable limbs? Scientists began regenerating human skin in the 1970s, and doctors who have successfully regenerated heart valves from just a few cells say the era of replaceable body parts is inevitable. As for self-repairing building materials, there's already a metal, Nitinol, that can fix its own dents with a simple application of heat. The miracle food? It's called soy isolate, and Archer Daniels Midland has been shipping it around the world since the 1980s.

Little can be said about the future with any certainty. We do not know if our descendants will ever live on Mars. The planet would first have to be "terraformed," its atmosphere cleaned and warmed so that life as we know it could take root there and thrive—a process that, if possible, would take generations. Nor do we know if we will ever be able to reanimate our dead. About 70 human heads (some with bodies attached, others not) are awaiting the future in tanks of liquid nitrogen, chilled to a temperature of -196°C. It is hoped that through the magic of cloning—the same technology that generated an entire sheep from just a few cells—these corpses may one day dance the 23rd century's version of the hustle. We do not know when, if ever, we will have robot slaves, orgasmatrons or time machines. But we do know that whatever miracles the next millennium holds, all will be wrought by the same genie: the computer.

Computers, the electronic brains behind intelligent metals, miraculous foods and replaceable organs, are growing smarter by the minute. According to Moore's Law (pro-

pounded by Gordon Moore, cofounder of Intel), they get t as smart every 18 to 24 months. They are already 3,300 t smarter than when microprocessors were introduce 1971. Paul Horn, senior vice president of research at says Moore's Law will apply for at least another 15 ye This means that when country singer LeAnn Rimes is computers will be nearly 200 times more powerful than t we use today—or roughly 660,000 times more powerful the first microprocessor.

If that doesn't boggle your imagination, consider We're fast approaching a time when computers will de themselves, with no help from us lowly, jabbering prim As computer scientist Carl Feynman puts it, "We've di ered that the gray mush in our heads is probably no best material for thinking." Computers will soon be u their superior "thinking material" to make themselves smarter. Humans and computers are already collabora on the design of new generations of computers, but, says, sometime down the road, people will be phased o the process.

At that moment, our relationship to our world will ch more profoundly than it has at any time since Homo sap made friends with fire. For eons, human beings have bee and away the most intelligent entities on earth. But thi is coming to an end. If you are a human and not a comp you may be wondering: Is this good? No one has any idea are crossing a Rubicon—perhaps into paradise, perhaps hell, definitely into a life our pitiful brains are incapab anticipating.

Should we put the brakes on while we still have chance? Forget about it, unless you're willing to use a writer while everyone else uses Microsoft Word, or i your kids amuse themselves with tic-tac-toe while friends play Nintendo. "The competitive advantage-nomic, military, even artistic—of every advance in aut

10,806,000,000: Projected world population in the year 2150
86: Projected worldwide life expectancy in 2150
2063: Year the world's crude-oil reserves will run out, based on current production rates

is so compelling that passing laws, or having customs, forbid such things merely assures that someone else will them first," writes Vernor Vinge, a computer science pro- or at San Diego State University. Every day, computers duce some new improvement in our lives that we find ossible to resist. And every day we fail to resist, they come er to cutting themselves loose from us.

\n IBM computer called RS/6000 SP is a compelling sym- of what's to come. Better known as Deep Blue, it beat the ld's greatest human chess player, Garry Kasparov, in 7. And that's only a fraction of what it can do. Its talents e also been used in such pursuits as engineering, air traf- ontrol and financial analysis. Deep Blue doesn't approach of its tasks the way people do, but make no mistake: It's a hine that thinks. To deny this, writes Yale computer sci- e professor Drew McDermott, "is like saying an airplane n't really fly because it doesn't flap its wings."

'erhaps there's nothing to worry about. The potential de of living with *Über*computers is fantastic to contem- e. Computers will warn us about threats to our health before doctors can, enable us to exchange business doc- nts by simply shaking hands, help us understand foreign uages without learning them.

\nd how they will entertain us! Forget about movies on and; we'll have experiences on demand. Want to talk phi- phy with Plato, match wits with W.C. Fields, play a game attleship against Lord Nelson? Entirely possible. Horn, z enthusiast, relishes the thought of someday jamming Charlie Parker. "The computer will react to my playing e way Charlie Parker would have done," he says. Sounds t, until some spoilsport asks if it's not possible that Bird-Computer might be so revolted by his playing, it will sim- cover its cyber-ears and order him to get lost. Horn hs. "That's exactly the point," he says. "Something just that might happen."

That's the downside: These new computers might not like us very much. In fact, they may well regard us as we regard poorly trained dogs. Scientists like Feynman are searching for ways to increase the chances that computers of the future "don't have malevolence, like their creators." But, he cautions, it may not be possible.

Here's another caution: Predicting the future is a fool's game. Countless thinkers of the past have tried, only to miss the mark by a billion gigabytes. Consider this effort by H.G. Wells in 1939: "After the second world war [there will remain only] a patchwork of staggering governments ruling over a welter of steadily increasing social disorganization. It will be the Dark Ages over again. . . . There will be a return to primitive homemade weapons, nonmechanical transport, a new age, if not of innocence, yet of illiteracy, and slow, feeble and less lethal mischiefs will return to the world."

On the other hand, it's also possible that all these predictions underestimate the changes that lie ahead. Lew Platt, chairman and CEO of Hewlett-Packard, tells a story about ENIAC, the first general-purpose computer, built in 1946. After it was introduced, *Popular Mechanics* reported that "ENIAC is equipped with 18,000 vacuum tubes and weighs 30 tons." And then the magazine took a wild flight of fancy, daring to suggest that on some extraordinary day in the future, a computer of equal power could be constructed with "only 1,000 vacuum tubes and perhaps only weigh one and a half tons." Today, says Platt, "the computer power in those thirty tons of ENIAC can fit in your pocket . . . in fact, your pocket calculator is more powerful."

So hold on to your hard drives. It's going to be a hell of a ride. PHOTOGRAPH FROM NASA

A 20th century view of Earth, as seen from *Apollo 17:* Our world is smaller, yet immeasurably more complex, than at the millennium's start.

	'00	'10	'20	'30	'40	'50

1000
- **1008** *Tale of Genji,* world's first novel, p. 34

1100
- **c. 1100** Gunpowder weapons developed, p. 156
- **1117** Earliest account of nautical compass, p. 150
- **1120** First known restaurants, p. 77
- •c. 1

1200
- **1211** Genghis Khan invades China, p. 120
- **1215** Magna Carta signed, p. 134

1300
- **1324** Mansa Musa's pilgrimage to Mecca, p. 26
- **1325** Aztecs establish Tenochtitlán, p. 60
- **1348** Bla
- •c. 1

1400
- **1407** Public banking, p. 32
- **1413** Brunelleschi adds perspective, p. 62
- •c. 1

1500
- **1509** First slaves brought to New World, p. 146
- **1517** Luther launches Protestant Reformation, p. 162
- **1537** Europeans introduced to pota
- **1543** Vesalius revea
- **1535** Europeans introduced to tobacco,
- **1545** Peruvian s

1600
- **1601** First welfare program, p. 41
- **1603** Shakespeare's *Hamlet,* p. 109
- **1605** Cervantes's *Don Quixote,* p. 16
- **1609** First regularly printed newspaper, p. 72
- **1610** Galileo proves Earth revolves around sun, p. 159
- **1610** Tea imported to Europe, p. 122
- **1628** Harvey explains circulatory system, p. 90
- **1633** First child-rearing book, p. 78

1700
- **1722** Bach's *The Well-Tempered Clavier,* p. 96

1800
- **1804** Haiti wins independence, p. 22
- **1812** Canned food, p. 91
- **1819** Bolívar liberates Colombia, p. 47
- **1826** First photograph, p. 106
- **1829** First water filtration, p. 93
- **1830** First all-steam railway, p. 126
- **1834** Refrigeration, p. 82
- **1838** Rise of labor movement, p.
- **1839** Goodyear vulcanizes rub
- **1844** Marx meets
- **1844** Morse's tele
- **1846** Anesth
- **1848** Bi
- •1

1900
- **1900** Freud's *Interpretation of Dreams,* p. 116
- **1901** Marconi sends transatlantic wireless message, p. 126
- **1903** Wright brothers fly, p. 123
- **1905** Einstein's $E=mc^2$, p. 108
- **1906** Rise of Pentecostal movement, p. 58
- **1907** Baekeland synthesizes plastic, p. 24
- **1908** Ford builds Model T, p. 138
- **1914** World War I begins, p. 124
- **1914** Sanger founds birth control movement, p. 76
- **1917** Russian Revolution begins, p. 94
- **1928** Fleming discovers penicillin, p. 130
- **1928** First regular TV broadcasting begins, p. 144
- **1933** Hitler takes power, p. 152
- **1934** Mao leads Long March to Chinese re
- **1945** U.S. drop
- **1947** Tran
- **1947** India

he past 1,000 years—and an index to this book.

'60 **'70** **'80** **'90** **'00**

• **1088** First modern university, p. 88

• **1095** Crusades begin, p. 136

of Angkor Wat completed, p. 52

• **1169** Ibn Rushd translates Aristotle, p. 32

• **1260** Chartres Cathedral completed, p. 46

p. 130

fashion, p. 48

brewed, p. 42

ns take Constantinople, p. 20

455 Gutenberg's Bible, p. 166

• **1492** Columbus's voyage, p. 164

• **1582** Gregorian calendar, p. 10

y's secrets, p. 56

• **1588** Spanish Armada defeated, p. 19

• **1596** Flush toilet, p. 70

s Spanish empire, p. 38

• **1656** First pendulum clock, p. 84

• **1674** Microorganisms observed, p. 95

• **1666** Newton's law of gravity, p. 128

• **1683** First public museum, p. 18

• **1769** Industrial Revolution begins, p. 160

• **1789** French Revolution begins, p. 110

• **1776** U.S. Declaration of Independence, p. 154

• **1796** Smallpox vaccine, p. 145

• **1799** Rosetta Stone found, p.13

• **1865** Civil War ends U.S. slavery, p. 86

• **1886** Coca-Cola bottled, p. 36

• **1866** Mendel's Law of Heredity, p. 98

• **1895** First motion picture, p. 114

ery, p. 20

• **1867** Nobel invents dynamite, p. 65

• **1895** Röntgen discovers X rays, p. 68

's suffrage movement, p. 100

• **1868** Rise of Japan, p. 29

• **1896** Modern Olympics, p. 14

s sewing machine, p. 59

• **1869** Suez Canal opens, p. 40

4 Otis's elevator, p. 43

• **1876** Bell invents telephone, p. 132

4 Bessemer refines steel, p. 66

• **1876** Edison opens laboratory, p. 148

• **1859** First oil well drilled, p. 92

• **1880** Cézanne paints Mont Sainte-Victoire, p. 28

• **1859** Darwin's *Origin of Species,* p. 142

• **1882** Germ theory of disease proved, p. 158

• **1962** Carson's *Silent Spring,* p. 54

• **1969** Armstrong walks on moon, p. 112

on Hiroshima, p. 140

y to computer age, p. 118

dence, p. 30

nd Watson map structure of DNA, p. 44

4 Birth of rock 'n' roll, p. 12

PHOTO CREDITS

PICTURE SOURCES ARE LISTED BY PAGE.

JACKET: Front Cover: Napoléon: Paul Delaroche; Astronaut: Gregory Heisler; Dolly: Stephen Ferry/Gamma-Liaison; Gutenberg Bible: Craig Cutler; Women's suffrage: Smith College Collection; **Back Cover:** X Ray: Film Bank; Joan of Arc: Corbis-Bettmann; Don Quixote: David Levinthal; Rock 'n' roll: Don Wright; Declaration of Independence: Robert Lewis; **Spine:** Factory girl: Lewis Hine; A-bomb: Corbis-Bettmann; *Hardcover edition only:* **Front flap:** Toilet: Neil Winokur, Janet Borden, Inc.; Airplane: Wright State University; **Back flap:** Potato: Wolfgang Kunz/Bilderberg/Aurora & Quanta Productions; Compass: Neil Winokur.

CONTENTS: Page 5: Camera, courtesy Matthew R. Isenburg Coll.; costume designer, Laura Drawbaugh; assistant, Jennifer Arnold; prop stylist, Anthony Gasparro; assistant, Siobain Flaherty; hair and makeup, Monica Costea, Anna Kromdyas, Annie Chamblis, Eve Chubb. Models: Scott Chappell (astronaut); Al Tarantal for Gilla Roos (Einstein); Jamie Laverdiere (Daguerre); Esteban Martinez (Gandhi); Dorien Garry (Joan of Arc); Scott Hull (Columbus); Francesco Rosetti (Shakespeare); Sean Patrick Reilly for Cunningham Escott, Dipene (Napoléon); Leslie Simitch PhotoProduction.

INTRODUCTION: Page 9: Pierpont Morgan Library/Art Resource.

EVENTS: Page 12: *Palm Beach Post;* **14:** Ministère de la Culture, France/AAJHL; **16:** courtesy Janet Borden, Inc.; **18:** Museum of the History of Science, Oxford; **20:** Image Bank; **21:** courtesy Aryeh Shander, M.D., Chief of Anesthesiology and Critical Care Medicine, Englewood Hospital and Medical Center, N.J.; **22:** Magnum; **25:** Bakelite Collection of "Radio Ray" Carroll; **28:** photo: ©Sabine Rewald; painting: Giraudon/Art Resource; **29:** Blackstar; **30:** Magnum; **32:** Tony Stone Images; **34:** scrolls, courtesy East Asian Library, Columbia University; **38:** Gamma-Liaison; **42:** GLMR/Gamma-Liaison; **44:** Gamma-Liaison; **47:** The Image Works; **48:** stylist, Kevin Scott; props, Faith Meade; makeup, Grazia Riverduti/Garren, NYC; **52:** Howard Greenberg Gallery, NYC, & Kenro Izu/Friends Without A Border; **54:** Magnum; **56:** Art Resource; **59:** Corbis-Bettmann; **60:** Yancey Richardson Gallery, NYC; model courtesy El Museo Nacional de Anthropologia, Mexico City; **62–63:** courtesy PPOW, NYC, & Torch Gallery, Amsterdam; **65:** Controlled Demolition Inc., Phoenix, Md.; **68:** University of Rochester Medical Center/Film Bank Archives; **70:** Janet Borden, Inc.; **74:** Aurora & Quanta Productions; **76:** courtesy Smith College; **77:** Tony Stone Images; **81:** ©1974 by Irving Penn; **82:** courtesy Vogue ©1977 Condé Nast Pub., Inc.; **84:** PPOW, NYC & Torch Gallery, Amsterdam; **86:** *The Civil War in Depth: History in 3-D,* by Bob Zeller, Chronicle Books, 1997; **90:** Howard Schatz/Ornstein, *Passion & Line: Photographs of Dancers,* Graphis Press Publishers, 1997; dancer: Richard Witter, Alvin Ailey American Dance Theater; **92:** courtesy Drake Well Museum, Pennsylvania Historical & Museum Commission; **93:** Janet Borden, Inc.; **100:** Western Union Collection; **102:** Bilderberg/Aurora and Quanta Productions; **106:** Magnum; **112:** courtesy NASA; **115:** Sonnabend Gallery, NYC; **120 & 122:** National Geographic Image Collection; **123:** Wright State University; **126:** St. John's Newfoundland; **128:** PPOW, NYC, & Torch Gallery, Amsterdam; **131:** Saba; **132:** Vogue ©1950 (renewed 1978) by Condé Nast Publications, Inc.; **138:** Henry Ford Museum & Greenfield Village Collections; **141:** Courtesy Hiroshima Peace Hospital; **142:** Tony Stone Images; **144:** Matrix; **147:** ©1976, Presidents and Fellows of Harvard College; Peabody Museum, Harvard Univ.; **156:** Harold & Esther Edgerton Foundation, 1998, courtesy Palm Press, Inc.; **158:** clockwise from top left: J.L. Carson; Alfred Pasieka/SPL; CNR/SPL; Dr. Kari Lounatmaa/SPL; **159:** Art Resource; **160:** courtesy George Eastman House; **163:** Foto-Studio; **164:** Cosmos; **166:** *Biblia Latina,* Mainz: Johann Gutenberg & Johann Fust, 1455; printed on paper, courtesy Pierpont Morgan Library, NYC.

PEOPLE: All images are details, from left to right, by page: **168:** Mathew Brady/Granger Collection (2); Corbis-Bettmann; Mansell Collection, Time Inc.; Da Vinci/Granger Coll.; **169:** Culver Pictures; Art Resource; Granger Coll. (2); Corbis-Bettmann; **170:** Mary Evans Picture Library; painted by Paul Delaroche, *Napoléon at Fontainebleau,* courtesy Le Musée des Armées, Paris; Archive Photos; Chung HWA Book Co., Ltd., Taiwan; Library of Congress; **171:** Archive Photos; Culver Pictures; Granger Coll., Archive Photos; Library of Congress & Mansell Coll., Time Inc.; **172:** Goesta P.G. Ljungdahl; Wallace Kirkland; Brown Brothers; Granger Coll. (2); **173:** Granger Coll. (2); Edga[...] Eupra GmbH.; Don Uhrbrock; **174:** Brow[...] Culver Pictures; Neal Peters Coll.; Scala[...] Bros.; **175:** Culver Pictures (2); Art Re[...] Brown Bros., Archive Photos; **176:** Grang[...] Scala/Art Resource; Brown Bros.; Library[...] gress; courtesy National Palace Museum, [...] **177:** Corbis-Bettmann; Granger Coll.; St[...] Museen zu Berlin—Preußischer Kulturbesi[...] um für Islamischekunst; Mansell Coll., Ti[...] Culver Pictures; **178:** Archive Photos; Gira[...] Resource; Brown Bros., Corbis-Bettmann; [...] Coll.; **179:** courtesy Musée du Louvre, Paris[...] Bros. (2); from Fan Kuan's *Travelers Amid[...] and Mountains,* courtesy National Palac[...] um, Taipei, and Metropolitan Museum of A[...] Culver Pictures; **180:** British Museum; Li[...] Congress; Culver Pictures; Archive Phot[...] ver Pictures; **181:** Brown Bros.; Library[...] gress; Bridgeman Art Library; Anton Brueh[...] (renewed 1963, 1991) Condé Nast Pub. [...] Pictures; **182:** Granger Coll.; Pierre Bou[...] mos; Granger Coll.; Archive Photos; Brow[...] **183:** Brown Bros.; Archive Photos; Gr[...] Granger Coll.; Archive Photos; **184:** Po[...] to/Archive Photos; Everett Coll.; Grang[...] Culver Pictures; Pictures, Inc.; **185:** Hulto[...] Gamma-Liaison; Mansell Coll., Time Inc.; [...] photos (2); Kobal Coll.; **186:** Peter Mag[...] UPI/Corbis-Bettmann; Brown Bros.; Geo[...] ger; Granger Coll.; **187:** Everett Coll.; Cu[...] tures; Library of Congress; Ghana Info[...] Services/Accra, Ghana; Corbis-Bettmann[...]

ACKNOWLEDGMENTS

The advice and knowledge of several hundred scholars and other experts guided our selection, ranking and estimation of events and people of the past millennium. We thank them for their cooperation, apologize for sometimes ignoring their suggestions and list many of them below:

Penny Adcock, U.S. Centers for Disease Control and Prevention; Stanley Ash, Greenville Tool & Die Co.; Peter Awn, Columbia Univ.; Bryant Bachman, Univ. of Southwestern Louisiana; Mike Bauer, Thames Water Utilities; Barbara Beatty, Wellesley College; Ted Becker, New York Psychoanalytic Institute; Gregory Blue, Univ. of Victoria; Gérard Bonnier, Musée Nicéphore Niépce; Frederick Brandauer, Univ. of Washington; William Brinkman, Lucent Corp.; Carolyn Brown, Rutgers Univ.; Felix Browder, Rutgers; Richard Bulliet, Columbia; Bonnie Burnham, World Monuments Fund; Russell Burns, Nottingham Trent Univ.; Jerome Bylebyl, Johns Hopkins Univ.; Charles Calomiris, Columbia; James E. Candow, Parks Canada; Norman Cantor, New York Univ.; Jean Antoine Caravolas, Canadian Society of Comenian Studies; W. Bernard Carlson, Univ. of Virginia; G.S. Cavanaugh; Paul Ceruzzi, National Air & Space Museum; Cindy Clark, Scripps Oceanographic Institute; Gregory Clark, Univ. of California, Davis; I. Bernard Cohen, Harvard Univ.; David Coleman, Univ. of Texas, Austin; Melissa J. Crimp, Michigan State Univ.; Dana Dalrymple, U.S. Office of Agriculture and Food Security; John Daverio, Boston Univ.; Dan Davis, Kingsborough Community College, CUNY; Phyllis J. Day, Indiana Univ. East; Lloyd deMause; Karie Diethorn,

Independence Historic National Park; Reidar Dittman, St. Olaf College; Susan Douglas, Univ. of Michigan; Mary Ann Dzuback, Washington Univ.; Kurt Eissler; Susan Tolby Evans, Pennsylvania State Univ.; J.V. Field, Univ. of London; Bernard Finn, Smithsonian Institution; David E. Fisher; Marshall Jon Fisher; Dennis Flynn, Univ. of the Pacific, Stockton; James W. Fraser, Northeastern Univ.; Joshua Freeman, Queens College, CUNY; John Gaston; Alex von Gernet, Univ. of Toronto, Mississauga; George Gerbner, Univ. of Pennsylvania; Charles Glenn, Boston Univ.; Andy Goldstein, IEEE Center for the History of Electrical Engineering; Gary Goldstein, National Coffee Association; Linda Gordon, Univ. of Wisconsin, Madison; Michael E. Gorman, Univ. of Virginia; Stephen Jay Gould, Harvard; Henry Graff, Columbia; Kenneth Gray, UNICEF; Claudio Grossman, Washington College of Law; Lenworth Gunther, Essex County College; Talat Sait Halman, NYU; Christopher Hamlin, Notre Dame Univ.; Carl Haub, Population Reference Bureau; Susan Hazen-Hammond; Kelly Healey, Signal Hill National Historic Site; Maxwell Hearn, Metropolitan Museum of Art; James Henle, Smith College; Robert Himmerich y Valencia, Univ. of New Mexico; Roy Hindle, Bohler Uddeholm; David Hochfelder; Sheldon Hochheiser; Anne Hollander; David Hollenback, SUNY, Cortland; Sharon Hollenback, Syracuse Univ.; Benjamin Hunnicutt, Univ. of Iowa; Paul Israel, Rutgers; Helen Ibbitson Jessup; Glenn Johnson, Vassar College; Annette Juliano, Rutgers; Edward Kamens, Yale Univ.; Ted Kaptchuk, Harvard; Lori D. Karan, Medical College of Virginia; Joy Kenseth, Dartmouth;

Linda Kerber, Univ. of Iowa; Alice Kessler-Harris, Rutgers; Richard Koszarski, Film History; Richard Kremer, Dartmouth; Alan Ladwig, NASA; Robert LaFleur, Colby College; John Lanci, Stonehill College; David Landes, Harvard; Gari Ledyard, Columbia; Andre Lee, Michigan State; Jacques Le Houezec, Society for Research on Nicotine and Tobacco; Darlene Levy, NYU; Douglas Lewis, National Gallery of Art; Tony Lewis, Maritime Museum, Newport News; Ken Lipartito, Univ. of Houston; Pauline Maier; Enrique Madrigal, World Health Organization; John Major, Book of the Month Club; Manning Marable, Columbia; David Marc, Syracuse Univ.; Robert Martin, Bard College; Roger Masters, Dartmouth; Rick Mastroianni, Freedom Forum; Sarah Maza, Northwestern Univ.; Ali Mazrui, SUNY, Binghamton; William McNeill, Univ. of Chicago; Admiral Robert W. McNitt, ret.; Emily Mechner, National Bureau of Economic Research; Everett Mendelssohn, Harvard; Jean-Jacques Meusy, National Center for Scientific Research, Paris; David Montgomery, Yale; John E. van Courtland Moon, Fitchburg State College; John Muller, Juilliard; Craig Murphy, Wellesley; Azim Nanji, Univ. of Florida; Bruce Nelson, Dartmouth; Eric Newton, Newseum; Marybeth Norton, Cornell Univ.; Don Ohadike, Cornell; Robert Olby, Univ. of Pittsburgh; Robert Paarlberg, Wellesley; Vance Packard; Joel Palka, Univ. of Illinois, Chicago; Andrew Paterson, Texas A&M Univ.; Patricia O'Brien, Univ. of California, Irvine; Daniel Purdy, Columbia; Raj Reddy, Carnegie Mellon Univ.; Susan Reverby, Wellesley; Robert Richards, Univ. of Chicago; Pedro Rincones, Bolivarian Society of the U.S.; Cecil M.

Robeck Jr., Fuller Theological Seminary; Da[...] Environmental Defense Fund; Bob Rosen, Un[...] & Television Archive; Robert I. Rotberg, Harv[...] othy Rub, The Hood Museum, Dartmouth; K[...] man, Michigan Technological Univ.; Jeffrey [...] Univ. of California, Santa Barbara; Harry S[...] Brooklyn College, CUNY; John Sankey; Joh[...] fer, WNYC; David A. Schattschneider, Mora[...] ological Seminary; Jürgen Schlimper, Univ. o[...] Patricia M. Sears, Population Action Inter[...] George T.M. Shackelford, Museum of F[...] Boston; Jerry Shestack, American Bar Ass[...] Walter Simons, Dartmouth; Elliot Sivowitc[...] sonian; John Slade, Robert Wood Johnsor[...] School; Timothy Smeeding, Luxembourg [...] Study; Joel Snyder, Univ. of Chicago; Pa[...] Jonathan Spence, Yale; Peter Stearns, Carn[...] lon; Valerie Steele, Fashion Institute of Tec[...] Rudolf von Steiger, International Space Scie[...] tute, Bern; Carlene Stephens, Smithsonian [...] Stephens, NYU; Susan Strasser; John Stubl[...] Monuments Fund; Florian Stuber, FIT; Dou[...] Edison National Historic Site; Wayne Titch[...] Investment Counsel; Donald Ugent, Southe[...] Univ.; Eduardo Urbina, Texas A&M; Harold[...] Smithsonian; Jack Weatherford, Macalester[...] Carol Weil, Time Inc. Research Center; Step[...] Univ. of California, Berkeley; Charles Westo[...] ton Univ.; William L. Withuhn, Smithsonian; [...] loch, Columbia; Charles Wood, Dartmou[...] Wood, Monterey Institute of International Po[...] ies; Wu Tong, Museum of Fine Arts, Bosto[...]